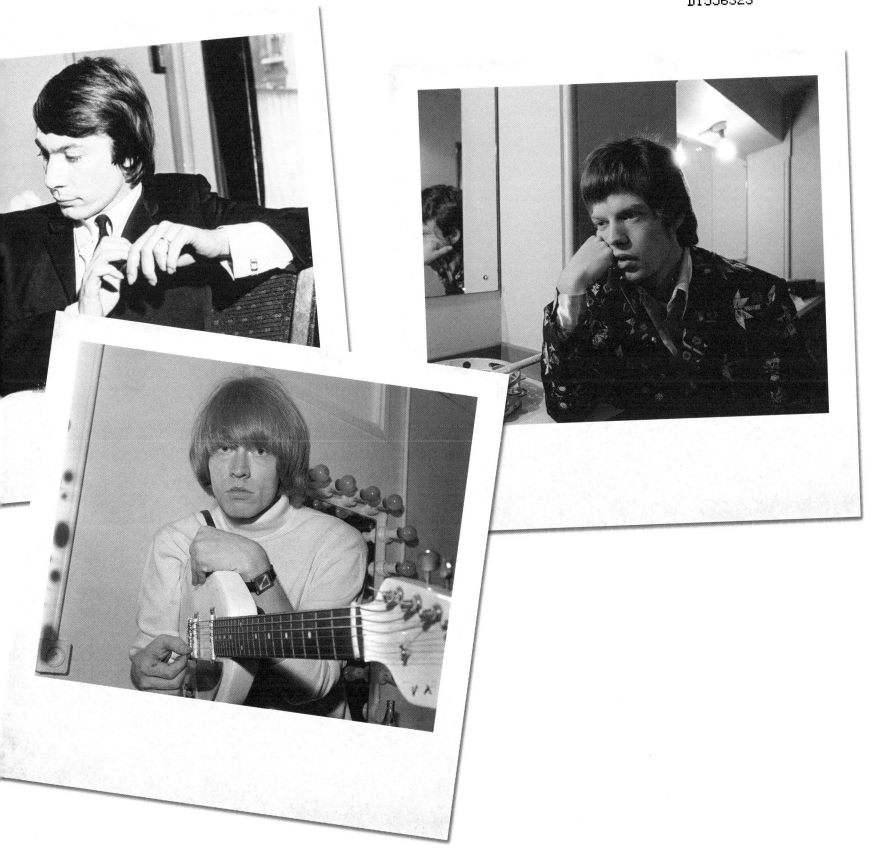

THE ROLLING STONES

ON CAMERA, off guard 1963–69

MARK HAYWARD WITH MIKE EVANS

THE ROLLING STONES
ON CAMERA, off guard 1963–69

PAVILION

CONTENTS

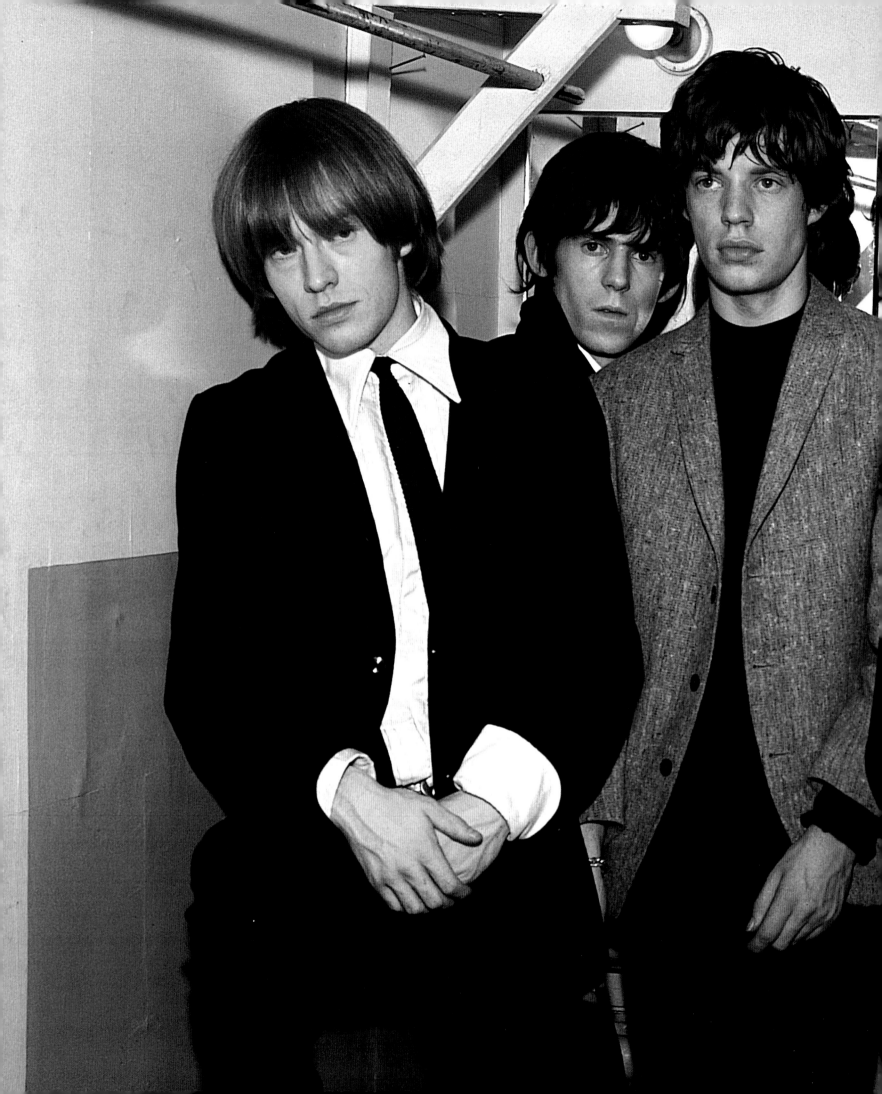

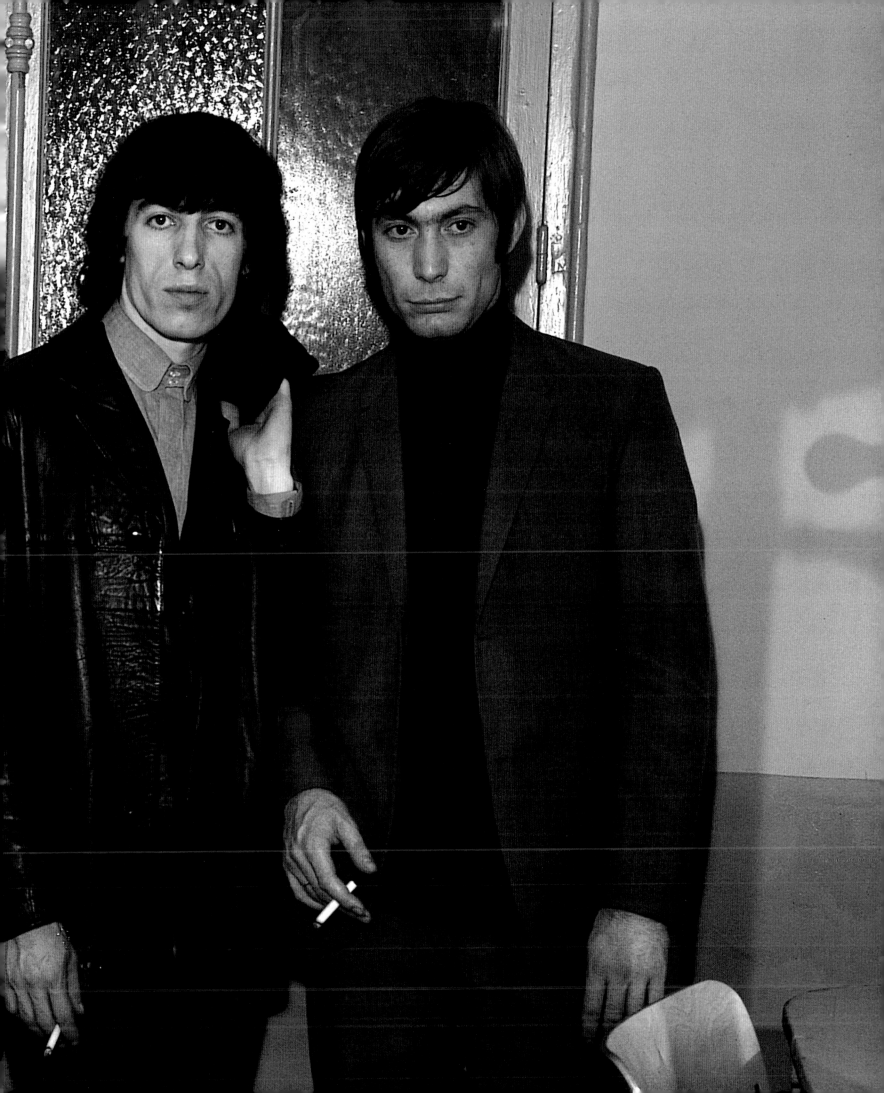

INTRODUCING

THE ROLLING STONES *

"COME ON!"

BRIAN MATTHEW SAYS:- "...A WILDLY
EXCITING GROUP WHO DESERVE TO
HAVE A BIG SUCCESS WITH THIS THEIR
FIRST RECORD."

INTRODUCTION

OVER RECENT YEARS THE IMAGE OF THE ROCK ICON has become big business, really big business. The visual style of rock 'n' roll is to be found in clothes, design, commercials, and on merchandise on a scale never seen before. The major icons in rock 'n' roll have become brand names in their own right, none more so than the group billed as 'The Greatest Rock 'n' Roll Band In The World' – the Rolling Stones. In fact the Stones are now a bigger brand name than many consumer goods.

Over a twenty-year period I have been fortunate in being able to purchase fantastic photographs of the Rolling Stones, and with the addition of Matt Lee's impressive collection of memorabilia, have compiled a unique photographic record that covers the career of the original Stones from 1963 to the death of Brian Jones in 1969.

The book features many images that have never been seen widely before, accompanied by text information drawn from a variety of sources including newspapers, magazines, auction catalogues, books, fan club newsletters, and interviews with many of the photographers themselves.

As we can see through the pictures presented here, the Rolling Stones soon tired of the straightforward posed shots favoured by traditional 'show-biz' photography. As they assumed more and more control over their working lives – and consequently their image – the photographs increasingly reflect how they saw themselves, and wanted to be seen.

Some of the world's top photographers, such as David Bailey and Gered Mankowitz, were responsible for images of the Stones that would become familiar worldwide via album covers and publicity material. But the pictures here, some by photographers of whom there is not even any record, are equally compelling by virtue of their unfamiliarity. From the fuzzy but fascinating screen grabs of 8mm home movies to the absolute camera mastery of Cecil Beaton, these pictures offer a wonderful insight into the Rolling Stones during their 1960s heyday; on camera and in these intimate shots, sometimes off guard.

Mark Hayward

THE EARLY YEARS

1961–1962

LITTLE WOULD MICHAEL JAGGER AND KEITH RICHARDS imagine when they bumped into each other on a train in 1960, that the meeting would forge a musical relationship that would still be active half a century later. Jagger (born 26 July 1943) and Richards (born 18 December 1943) had known each other in the early 1950s, as classmates at Wentworth Primary School in Dartford, Kent, but it was the chance encounter on the train that would bring them together again.

Richards was travelling to Sidcup Art College, where he was a student, and Jagger was commuting to London where he studied at the prestigious London School of Economics. Keith noticed that Mick (or Mike as he preferred to be called) was carrying a bunch of albums under his arm, including long-players by Chuck Berry and Muddy Waters; in the ensuing conversation they discovered that they were both fans of rhythm and blues.

' We started talking about Berry and people like that. I had only a few records at the time, but Mick had a fantastic collection, so we decided to get together and listen to them.'
Keith Richards, *New Musical Express* 1964

Soon after, the two formed a group, Little Boy Blue and the Blue Boys, along with Richards' art school pal guitarist Dick Taylor (later of the Pretty Things). In the lineup, Taylor played drums behind Keith on guitar, Mick provided vocals and harmonica, with Bob Beckwith on guitar and Allen Etherington on maracas.

In December 1961 another young R&B enthusiast, Brian Jones (born 28 February 1942) and his friend Dick Hattrell went to Cheltenham Town Hall to see the Chris Barber jazz band in concert. Alexis Korner (at the time one of only a handful of electric blues guitarists in the UK) played in the interval, and Brian told him how impressed he was. Korner gave him his phone number, telling Jones

to stop by next time he was in London. Soon Jones was regularly hitch-hiking to London from his native Cheltenham to hear Alexis Korner's seminal band Blues Incorporated which had a weekly residency at the Ealing Jazz Club.

By this time Jagger was singing occasionally with the Korner outfit, which also included Charlie Watts (born 2 June 1941) on drums. The Ealing blues nights were a true catalyst in the coming together of the Rolling Stones, after Brian started getting up and jamming with the Korner group on harmonica and guitar.

It was Jones who actually brought the Stones together, after placing an ad in the weekly *Jazz News* for R&B musicians. First to respond was pianist Ian 'Stu' Stewart – who was a crucial member of the Stones, on and off stage, until his death in 1985 – later joined at rehearsals by Jagger and Richards, the latter at Mick's invitation. By June 1962, a regular lineup consisted of Jagger, Richards, Stewart, Jones, Dick Taylor (on bass), and drummer Tony Chapman, and on Thursday 12 July they played their first gig together as the Rollin' Stones, at the Marquee club, deputising for the Korner band, which had been offered a radio show. Through the rest of the year, regular gigs included the Marquee and a Saturday residency at the Ealing Jazz Club.

By December 1962, Dick Taylor had left the band to continue his studies, having graduated to the Royal College of Art, and was replaced by Bill Wyman (born 24 October 1936) as bass guitarist. With the recruitment of Korner's drummer Charlie Watts in January 1963 the jigsaw was complete, and the Stones began to establish themselves as a permanent outfit on the burgeoning R&B scene. In the wake of the Beatles' phenomenal success through the early months of the year, groups were suddenly 'in'. Now managed by Eric Easton and Andrew Loog Oldham, on 7 May the Rolling Stones signed a three-year recording deal with Decca Records' A&R man Dick Rowe – the man who had turned down the Beatles the previous year – and three days later recorded their first single, 'Come On'.

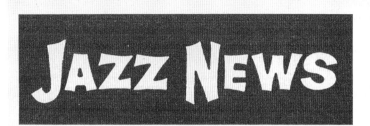

ABOVE AND OPPOSITE: A copy of *Jazz News*, carrying an ad for the Rollin' Stones' weekly Saturday residency at the Ealing Jazz Club.

JAZZ MART

BAND CALL

TUITION

ACCOMODATION

JAZZ MARKET

azzing Around

INCE this is our Rag-
time issue this might
a good time to mention
ere Britain's Ragtime
anists can be heard this
eek.

Ron Weatherburn with
e Kenny Ball band can
found at Kidderminster
wn Hall on Thursday
th, then at the Royal Al-
rt Hall, Saturday 29th.
is gig, incidentally, is at
zzshows Autumn Jazz
rade. On Sunday, as us-
l, you can hear the band
"Easy Beat".

Ray Smith is playing
ree gigs this week. On
iday he is playing at the
orfolk Arms, North
embley; the following
y (29th) at Rickmans-
rth Jazz Club; and at
e Viaduct, Hanwell on
nday 30th.

Duncan Swift, pianist
th Bill Nile's Delta Jazz-

men, plays very fine Rag-
time piano all over the
West Country. He returns
with the band to the Mar-
quee on Friday 28th. If
you ask him he'll do a cou-
ple of Ragtime numbers
during the evening.

**Another acknowledged
Ragtime pianist is Ray
Foxley. We have no idea
where he is but John
Merrydown gives a reason
why we don't know, on
page 5.**

There we are. These are
the Ragtime pianists and
where they are, so — go
out and hear them.

BONNIE Manzi is ex-
tending foreign influ-
ence along the South coast
next month when he and
his Oriental friends open
another Chinese Jazz Club,
this time at Weymouth.
Joining Brighton, Crawley,
Bristol and Swindon this

one will make five in the
circuit.

I think he should throw
a dinner in honour of the
occasion. A bit of the old
sweet and sour with flied
lice would go down nicely.

Rhythm and Blues is
getting bigger. Now that
Alexis Korner is establish-
ed at the Marquee with a
regular audience of 700,
new groups are springing
up at the drop of a har-
monica.

Keith Scott's recently
formed **BLUES PLUS SIX**
open a regular session at
the Colyer Club on Sunday
(30th) between 4 p.m. and
6.30 p.m.

The ROLLING STONES,
yet another one, take over
from Alexis at the Ealing
Club now that Alex is so
busy that he can't do the
residency any more.

John Williams' club at
Acton celebrates its first

anniversary this week.
They are having along
Kathy Stobart for the oc-
casion. Thinking of the
difficulties of holding a
semi-pro big band together,
I have nothing but admi-
ration tinged with awe for
John.

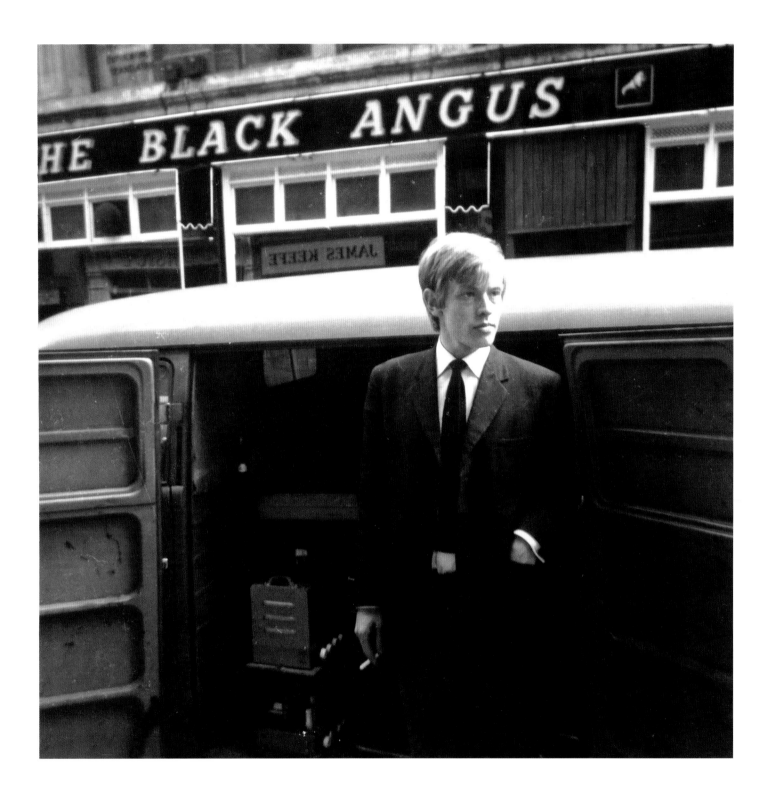

ABOVE: Brian Jones standing by the Stones' van outside Studio 51, across the road from the Black Angus pub.

STUDIO 51,
GREAT NEWPORT STREET,
LONDON
SUNDAY 14 APRIL 1963

ON 3 MARCH 1963, THE STONES PLAYED the first of a series of Sunday afternoon gigs at Studio 51, a basement club in Great Newport Street near London's Leicester Square. Since the late 1950s the club had been known as Ken Colyer's Jazz Club, named after the British trumpeter and pioneer of the UK 'trad' jazz scene whose band was resident there. The Rolling Stones' dates were arranged by Giorgio Gomelsky to be followed each week by an evening appearance at their regular venue, Gomelsky's Richmond Jazz Club at the Station Hotel, Richmond – from April '63 known as the Crawdaddy Club.

On Saturday 13 April the Stones, with Charlie Watts now firmly in place behind the drum kit, were elated to read their first press write-up, a rave review in the *Richmond and Twickenham Times* headlined 'The Stones Will Go On Rolling', in which writer Barry May enthused 'A musical magnet is drawing the jazz beatniks to Richmond. The attraction is the Crawdaddy Club...'

The next day, these photographs were taken (when I acquired them they were simply credited to 'A. Milton') of the Stones' now-complete lineup at the Ken Colyer club. Gomelsky himself was in Twickenham at a recording of the TV show *Thank Your Lucky Stars* on which the Beatles were appearing. Giorgio invited the four Liverpool stars – then in the flush of their first UK success – to come and see the Stones in Richmond. The Beatles turned up, and were welcomed by Brian Jones' girlfriend Pat Andrews.

'*The Beatles' visit was prearranged. Brian asked me if I could put them somewhere where they could see. It was one of the scariest moments of my life. I remember seeing this leather cap coming round the door. I think it was Ringo. They were all dressed in black leather, and I hid them in the shadows.*'
Pat Andrews

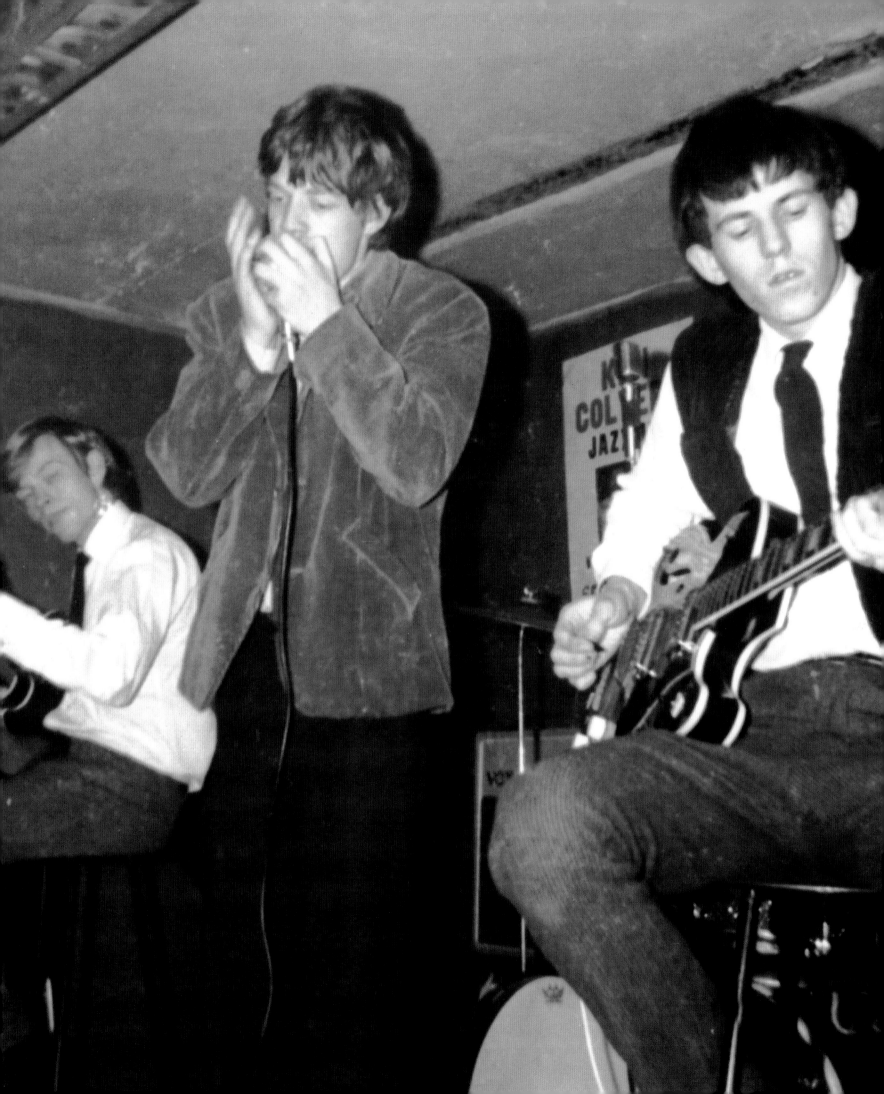

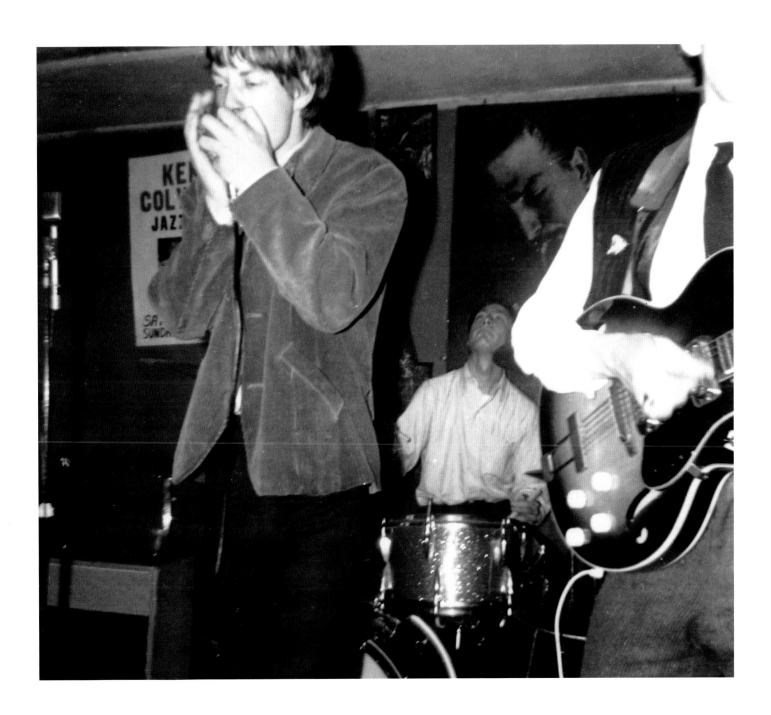

ABOVE, OPPOSITE, AND OVERLEAF: The Rollin' Stones – as they were then billed – and other rhythm and blues groups were a new feature on the London jazz scene, where the old guard still held sway to a large degree. Note the poster and picture of Studio 51 resident Ken Colyer in the background.

'When I first met them I was 17 and Mick was still at the LSE. They were just playing a few gigs on weekends, very much as a hobby in their spare time. There were only about three or four people in the audience so I wouldn't say there was a lot of excitement then, but the reputation built up quite quickly.

I can remember very clearly Mick telling me on a Sunday afternoon in Ken Colyer's club that Stu was out. He said it was Andrew who had insisted on it. I recall being really shocked and feeling bad about it, because of the way he looked. He didn't look like them, he looked much older, a very different type, very sturdy, heavy limbed while they were very thin. You understand how he didn't quite fit in with the image, and I remember thinking how awful that was, to be ostracised for the way you looked.

I was embarrassed by it too, because I knew him as this funny bloke who they all really liked, who kind of held them together, did all the humping of all the gear and was slightly paternalistic towards them. I remember Mick saying "He's alright. He's going to be our roadie, and he'll play on some of our recordings" – which he did.'
Mick's girlfriend Chrissie Shrimpton, on the removal of pianist Ian Stewart from the on-stage band on the instruction of Andrew Loog-Oldham, quoted in *Stu* by Will Nash

'I first met the Stones at a club, the 51 in Great Newport Street, London, they used to play there every Monday evening (sic.). It was the thing to go along and see them. They would get down on the floor and ask girls to dance with them during the interval.'
Ready Steady Go! TV presenter Cathy McGowan interviewed in *Rolling Stones Book*, November 1965

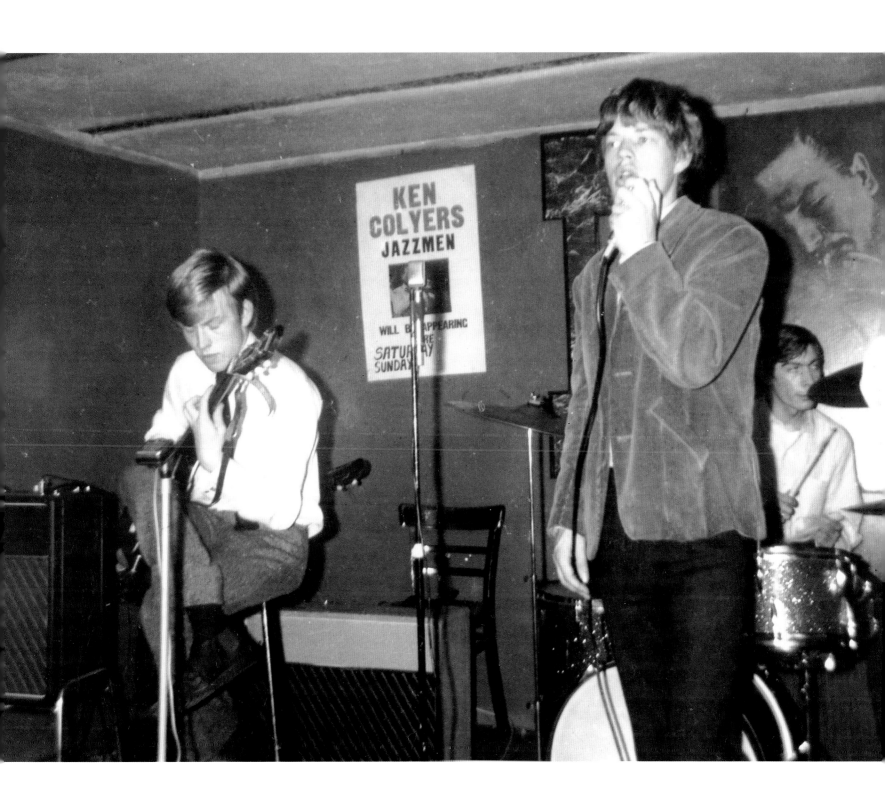

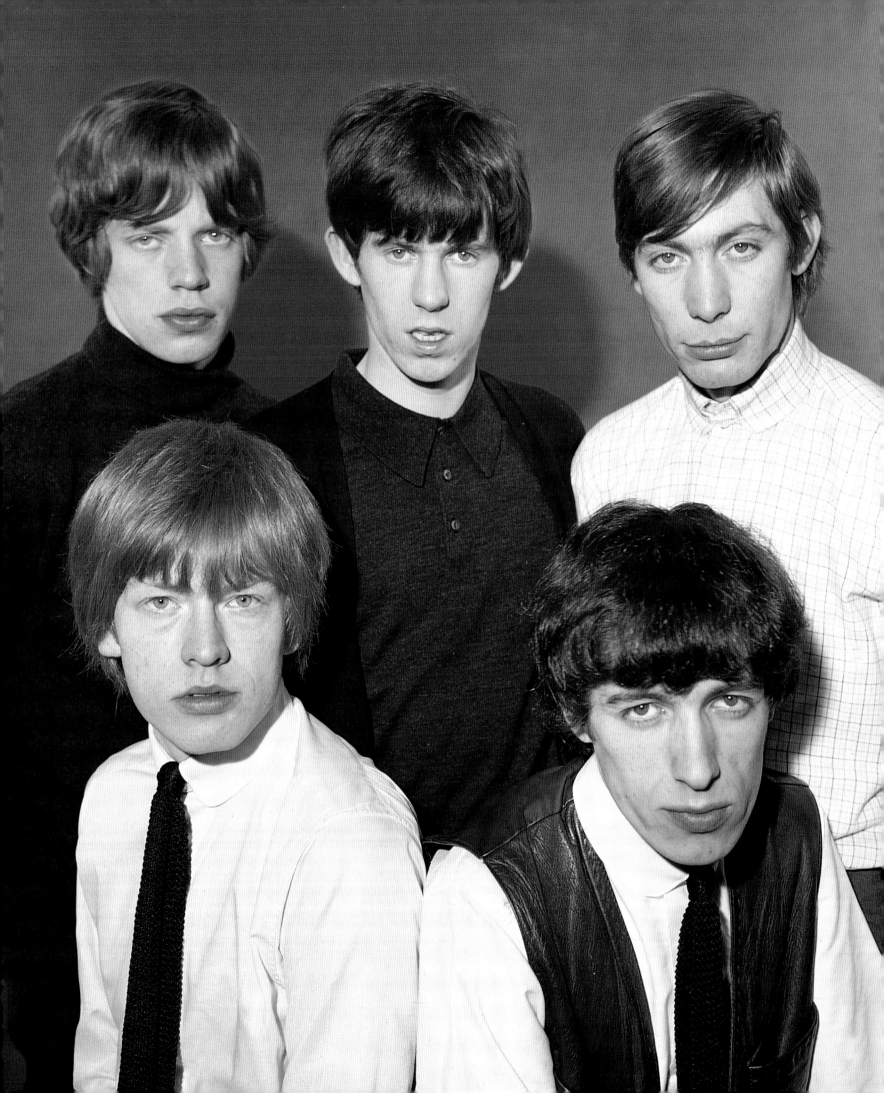

MIRABELLE MAGAZINE
JUNE 1963

AS SOON AS THE ROLLING STONES HAD A RECORD RELEASED, they were thrust into the hectic world of publicity, public relations, and promotion. *Mirabelle* was typical of the magazines for teenagers – or more specifically teenage girls – that proliferated from the mid-1950s and through the 1960s. With titles like *Jackie, Romeo* and *Valentine*, they featured a mix of romance-oriented comic strip stories (featuring trendy-looking Mary Quant-attired teenagers), beauty tips, advice columns, and of course lots of articles about pop stars and pin-up pictures – the latter one of their main selling points. *Mirabelle* was first published in 1956, and by 1963 belonged to C. Arthur Pearson Limited, the publishers of the *Daily Express.*

Most of the pin-up pictures, like these colour shots of the Rolling Stones, were created in straight studio sessions by uncredited staff photographers, or freelancers who granted the publishers the copyright as part of the deal. But every pop star and record company of the day looked upon these magazines as a key part of their marketing – David Bowie, for instance, had his own 'diary' column in *Mirabelle* during the 1970s. The final issue of the magazine was published in 1977.

OPPOSITE: From *Mirabelle*, a typical pop magazine shot of the Stones, staring straight at the camera, which the group soon got tired of and tried to avoid on photo shoots.

Mirabelle THE ROMANTIC PICTURE STORY WEEKLY

G. Arthur Pearson Ltd.
TOWER HOUSE
SOUTHAMPTON STREET
LONDON W.C.2
Telephone Temple Bar 4363

August 15th. 61.

Dear Maureen,

 Thanks for writing.

 I'm enclosing my leaflet on running
a fa nclub. Hope it's some help to you.

 Good luck!

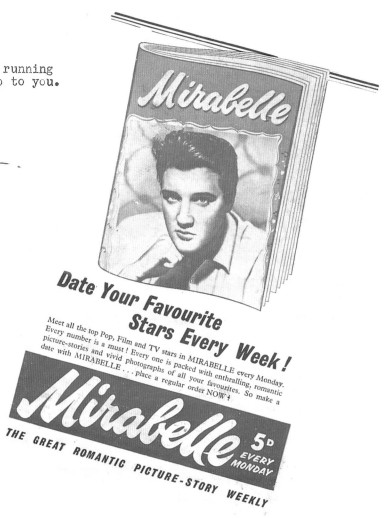

Date Your Favourite Stars Every Week !

Meet all the top Pop, Film and TV stars in MIRABELLE every Monday. Every number is a must ! Every one is packed with enthralling, romantic picture-stories and vivid photographs of all your favourites. So make a date with MIRABELLE . . . place a regular order NOW !

Mirabelle 5D EVERY MONDAY

THE GREAT ROMANTIC PICTURE-STORY WEEKLY

ABOVE: Very conscious of its pop-fixated readership, *Mirabelle* even supplied a leaflet on how to run a fan club –
hence this 1961 reply to a follower of a 'top Merseyside group', the Beatles!

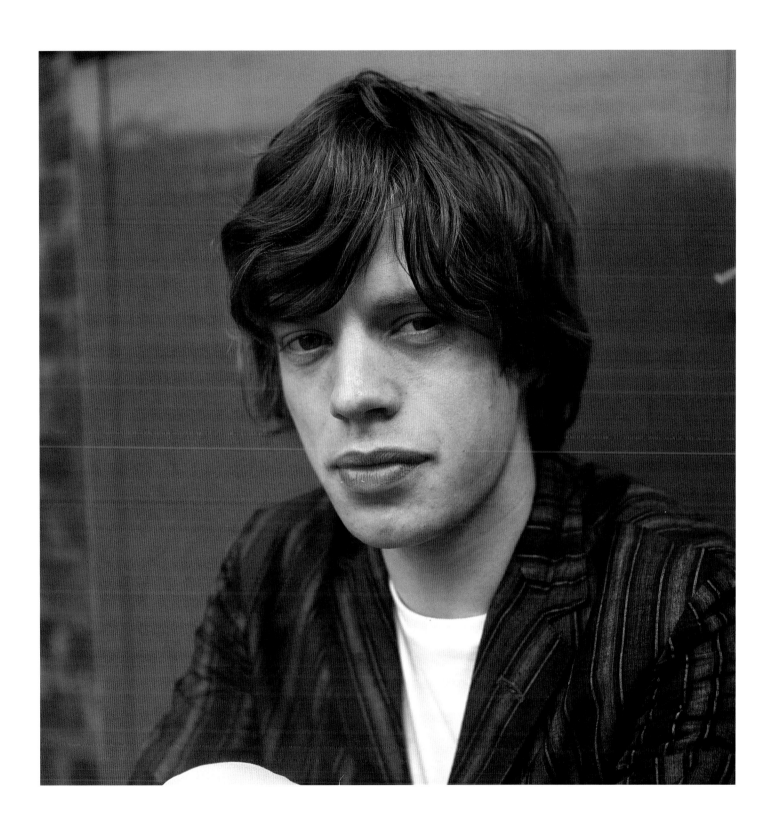

ABOVE: A portrait of Mick Jagger from an edition of *Mirabelle*.

THE FIRST TOURS
JULY 1963–MARCH 1964

WITH A SINGLE TO PLUG, THE TOURING REALLY STARTED in earnest for the Rolling Stones. In the eight months between mid-July 1963 and early March 1964 they undertook five huge treks of the UK – on some they were headlining, and on others in a support capacity.

Their first tour was more exhausting than any other for the simple reason that each concert would either involve sleeping in the back of Ian Stewart's van or a return trip from London to the venue and back again, often returning at four in the morning. It opened with a 500-mile return drive in Stu's van on 13 July to the Alcove Club in Middlesbrough to support the Hollies. After criss-crossing the country, 76 days later it ended at the Assembly Hall in Walthamstow, north London.

Next came an exciting prospect for the Stones, a support slot on a package tour that was joint-headlined by one of their R&B heroes, Bo Diddley. On the 30-date tour, promoted by Don Arden, the Flintstones were on first, followed by Mickie Most, then the Rolling Stones followed by joint bill-topper Bo Diddley. After the interval, the Flintstones returned, followed by Julie Grant and the other headliners, the Everly Brothers. It ran from 29 September at London's New Victoria theatre until 3 November, closing at the Hammersmith Odeon (now the Apollo), London. After the first five dates, the rock 'n' roll pioneer Little Richard was also added to the bill.

No sooner had they completed the Everly Brothers–Bo Diddley package than the Stones were headlining again – the very next day in fact, when a ballroom date in Preston, Lancashire, kicked off another tour which would take them through to 5 January 1964. A variety of support acts included the Yardbirds (with Eric Clapton), Georgie Fame and the Blue Flames, and the Graham Bond Quintet.

OPPOSITE: A letter from the Roy Tempest agency to a promoter in Wales, advertising the various pop acts on offer including a 'very unusual group', the Rolling Stones.

Licensed Annually by the L.C.C.

Directors
R. K. Jeffries
Lorna Wallis

THE
ROY TEMPEST
ORGANISATION LTD.
Representing Britain's Leading
BANDS
CABARET
and
VARIETY ARTISTS

Telephones:
GERrard 5404 / 5, and 6366

34 - 36, Wardour Street,
London, W.1.

RT/HC

9th July, 1963.

Mr. R.E. Tattersall,
31, Old Barn Way,
ABERGAVENNY,
Mon.

Dear Mr. Tattersall,

We would like to offer the following attractions for September and October:-

THE SWINGING BLUEGENES – at present number 26 in the Hit Parade and should prove a top attraction for Abergavenny. Available August 10th and September 28th, fee £100.

THE ROLLING STONES – this very unusual group is proving a top attraction and are drawing capacity crowds wherever they appear. Their record "Come On" is already number 30 in the Hit Parade. Available September 21st only. Fee £90.

JOHNNY THUNDER AND THE THUNDERMEN – Hit American recording star, who reached number one in America with is record "Loop de Loop". He is appearing in Britain for fourteen days and is available on September 21st only. Fee £150.

ROCKIN' HENRI AND THE HAYSEEDS – Decca recording stars who have a very unusual comedy act and are proving a top attraction on ballrooms throughout the Country. Available during October only, fee £50.

If you are interested in booking any of the above attractions, I shall be pleased to hear from you in the near future,

Yours sincerely,
ROY TEMPEST

ANY OFFER CONTAINED IN THIS LETTER DOES NOT CONSTITUTE A CONTRACT.

THE ROLLING STONES – this very unusual group is proving a top attraction and are drawing capacity crowds wherever they appear. Their record "Come On" is already number 30 in the Hit Parade. Available September 21st only. Fee £90.

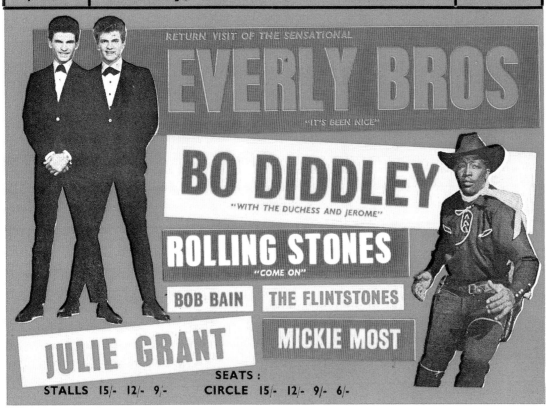

Again there was no let-up. The day after the headlining trek ended, another package show began. Called 'Group Scene '64', the Stones and the Phil Spector girl group the Ronettes were joint headliners, supported by Dave Berry, the Swinging Blue Jeans, Marty Wilde, the Cheynes, and, added to some dates, Johnny Kidd and the Pirates. It ran from 6 January through to 27 January.

Lastly there was the 'All Stars '64' package, supporting John Leyton, Mike Berry, and the Swinging Blue Jeans, plus Mike Sarne, Jet Harris, and Billie Davis. Preceded by five dates before the package began, they played two shows a night for 28 nights, between 9 February and 7 March.

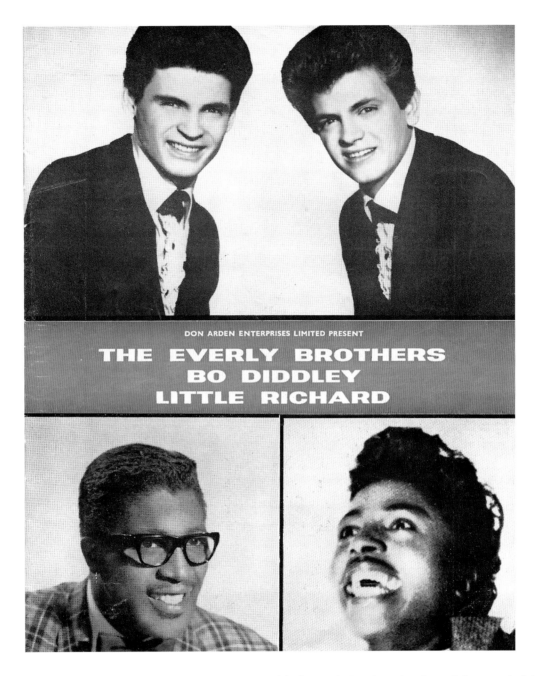

DON ARDEN ENTERPRISES LIMITED PRESENT

THE EVERLY BROTHERS
BO DIDDLEY
LITTLE RICHARD

'An agent asked me if the Stones would go on tour with the Everly Brothers. I reckoned they needed the experience of playing theatres so I agreed. But the boys weren't knocked out by the Everlys... what shattered them was that their old idol Bo Diddley had been booked for the same tour... I think the boys would have worked that tour for nothing – just to be with and see Bo Diddley. The Stones were well down the bill of course. They'd only had one record behind them. But it was a start. A respectable start. "A step in the right direction" said Brian Jones.' Eric Easton, *Rolling Stones Book*, February 1965

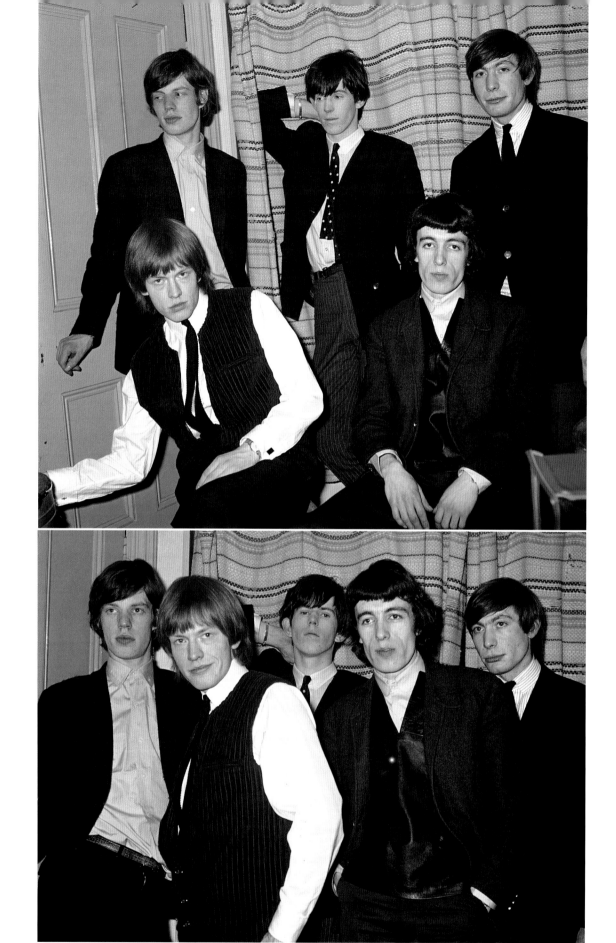

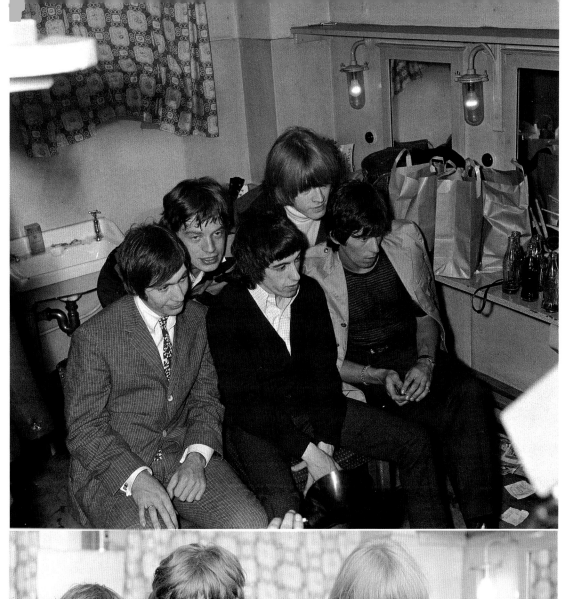

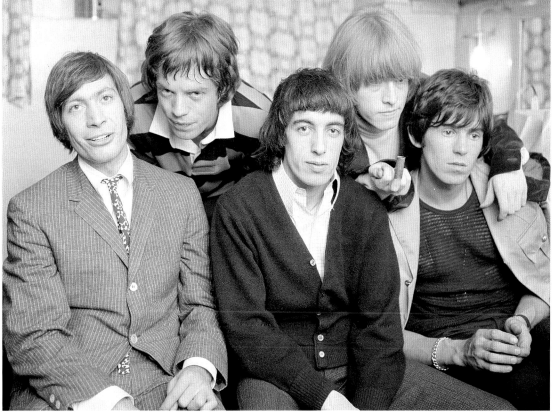

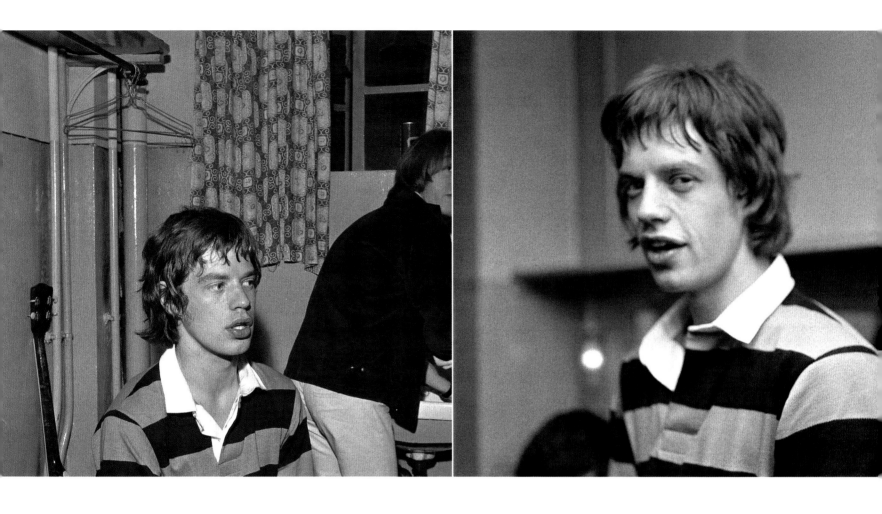

THIS AND PREVIOUS PAGES: These pictures, and those on the previous two pages – photographers unknown – of
the Stones backstage on early tours, were sold by auction at Christie's in 1989. The colour pictures are the earlier,
while the black-and-white images are thought to be at a concert in Scotland.

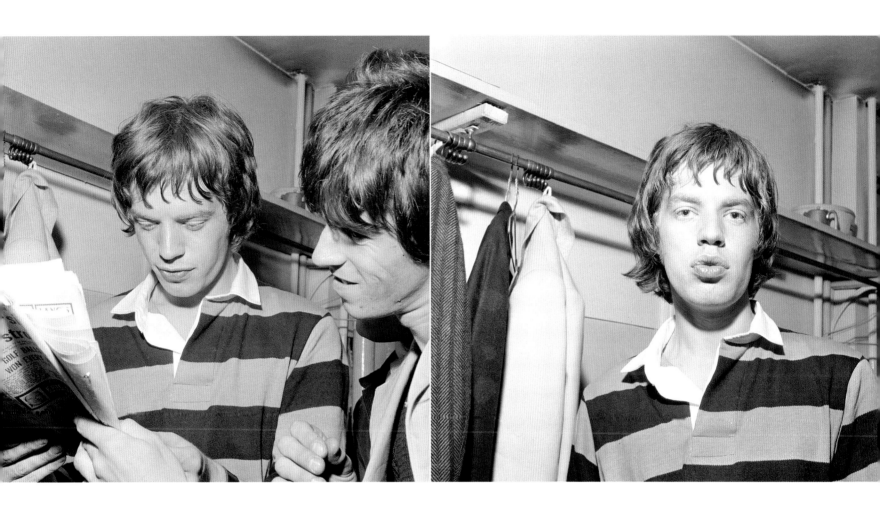

LOCARNO BALLROOM, STEVENAGE
WEDNESDAY 1 APRIL 1964

THE OCCASION, ON APRIL FOOL'S DAY, was the George W. King Apprentice Association All Fools Charity Beat Ball, and the photographs here were taken by a member of the audience – Miss Eve Bowen – who had them published in the *Rolling Stones Book* fan magazine. The previous night had seen the Stones fight off several girls during their appearance at the West Cliff Hotel in Ramsgate. Taking it all in their stride, they turned up to play the Stevenage Locarno, where the crowd were more restrained than the night before. Nevertheless, the April edition of *Rave* magazine reported 'Jeers, insults, abuse. But the Stones couldn't care less.'

The radio disc jockey Alan 'Fluff' Freeman observed, also in the *Rolling Stones Book*: '"Dirty scruffy layabouts, long-haired thugs", that's the kind of talk you get when you mention that wonderful group the Rolling Stones.' To which Brian Jones added: 'We seem to arouse some sort of personal anxiety in people. They think we are getting away with things they never could. It's a sort of frustration. A lot of men would like to wear their hair long, but they daren't. Mums and dads say "We wouldn't let our kids watch that scruffy lot". I am one of these few people who is doing what he wants. I took a gamble, forsaking study at university for R and B, and it paid off.'

OPPOSITE: As can be seen from this photograph of Charlie and those of Mick, Brian, and Keith overleaf, the Stones were anything but scruffy on this particular occasion.

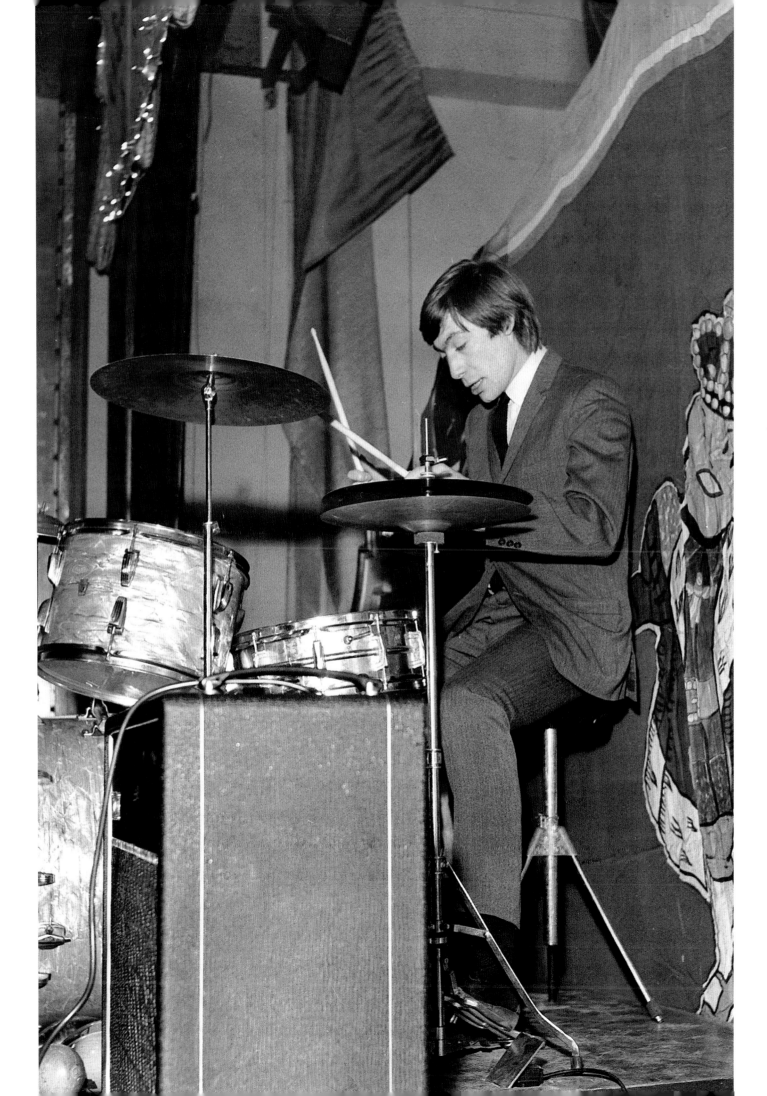

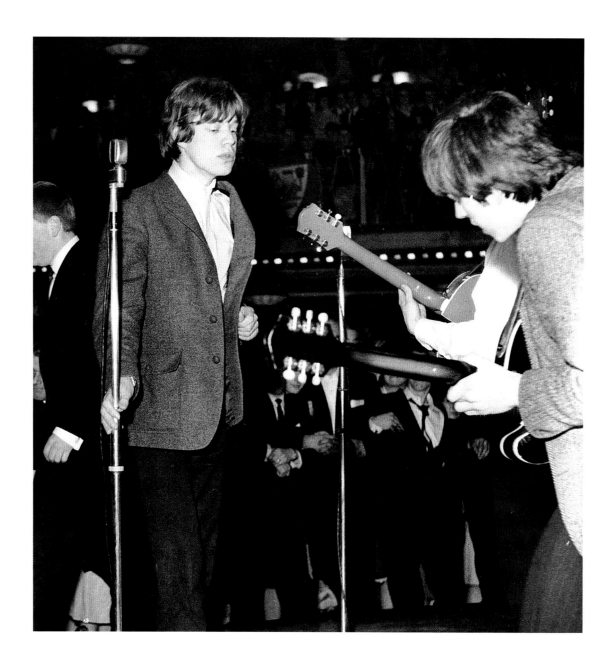

Esther Chamberlain wrote to the *New Musical Express* after watching the Stevenage concert, her letter was published on 3 April: '*The Rolling Stones corrupting teenagers? Ridiculous. I know them personally and they are well mannered, and appreciative of the things done for them. They should be held up as good examples for young people.*'

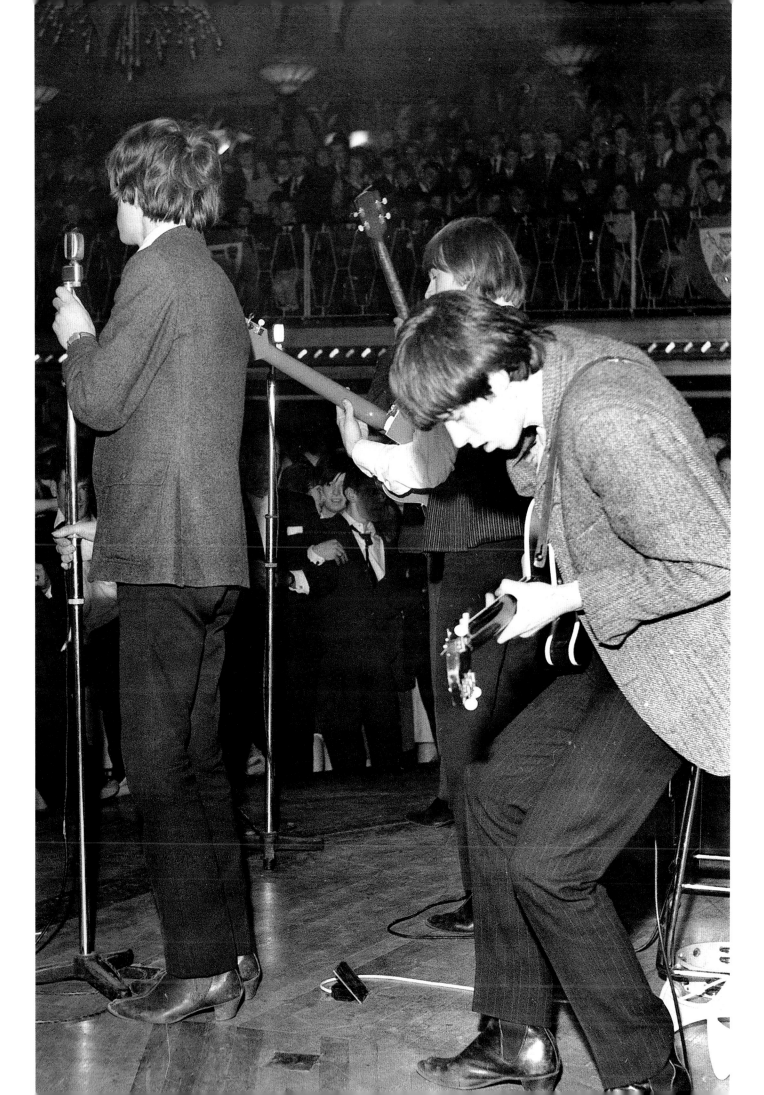

READY STEADY GO!
STUDIO 9, TELEVISION HOUSE, KINGSWAY, LONDON
FRIDAY 7 AUGUST 1964

THE STONES' JOINT MANAGERS AT THE TIME, ex-theatre organist Eric Easton and Andrew Loog Oldham, had the band booked in to appear on *Ready Steady Go!*, Britain's premier TV music programme for young people. The Friday evening show, with its opening slogan 'The weekend starts here!', was independent television's answer to the BBC's *Top Of The Pops* which went out every Thursday. Freelance photographer Richard Rosser had an 'in' to many *RSG* sessions, including this one, and captured some exclusive images as a result.

Journalist Richard Green was working for the *NME (New Musical Express)* at the time, and caught up with the Rolling Stones after waiting 40 minutes to get into the TV studio, where the band were rehearsing all afternoon: 'The Stones' backstage dressing room was crammed to breaking point with fans, instruments, friends, cases, road managers, empty bottles and cigarette ends. Outside in the corridor attendants were fighting a losing battle with even more fans. Cameramen and journalists stood poised waiting for the slightest hint of a piece of long hair emerging.'

Finally the Stones played live, as was the remit for artists on *Ready Steady Go!* Once their set was finished, there was a rush back to the dressing room to start the party celebrating the show's first year. Also in attendance were the Beatles' manager Brian Epstein, singer Jess Conrad, and the Animal's future manager Mickie Most; vocalist Elkie Brooks poured champagne. Bill Wyman chatted up singer Lesley Duncan, while Keith and Mick were running around and Charlie vanished into the dense crowd.

The host of *Ready Steady Go!* was archetypal mod-girl Cathy McGowan, who enthused about the Stones' appearance on the show:

'It was only my second week with the show... and I was awfully nervous. They had the confidence of a group that knew they had a following. Appearing regularly could make a group – it's happened that way since with the Who and Georgie Fame. Didn't matter that you may not be a big attraction in, say, Newcastle – if you were drawing 'em in in London, you were well set.

'They were confident without being big headed. They were fantastic, absolutely marvellous. The girls were really going mad. People in Birmingham who hadn't seen them or heard of them before, raved about them. And older people, like parents, immediately started writing letters saying the Stones were disgusting and horrible, and objectionable – all those corny old adjectives.

'We were even told it was obviously a mistake putting them on the show, but the reaction to the Stones' performance was so great that within three months they were regulars on RSG.

'They really are a Ready Steady Go! *group. That's a group that is a favourite in the office, and with the people who watch the show. And it's not so darned easy getting a mixture of the two. They are true professionals, and I don't think they ever get nervous. They just act themselves and never pretend to be what they're not.'*

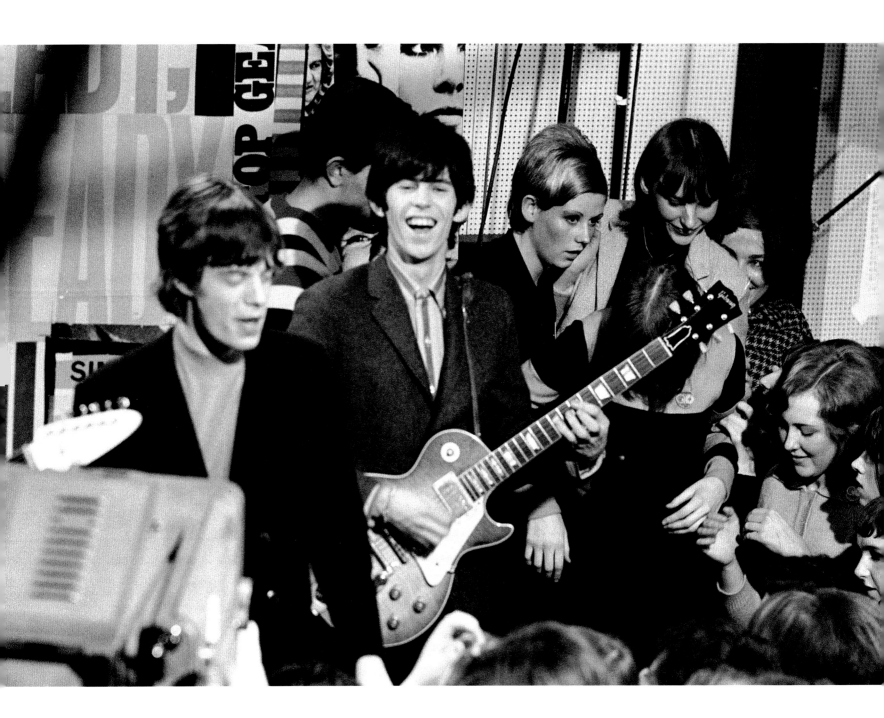

Cathy McGowan on Mick: ' *He is the most shy, quiet and normal person I've ever met. He is sarcastic, but never cruel. He is so kind to the fans, it's just not true. He always asks if you're OK if he sees you on your own, and I like the way he looks after his girlfriend. A very sincere character is Mick, and I like him very much.* '

Cathy McGowan on Keith: ' *He is quite definitely the mod of the group and he is very aware of clothes, I think a lot of the Stones' success can be attributed to Keith.* '

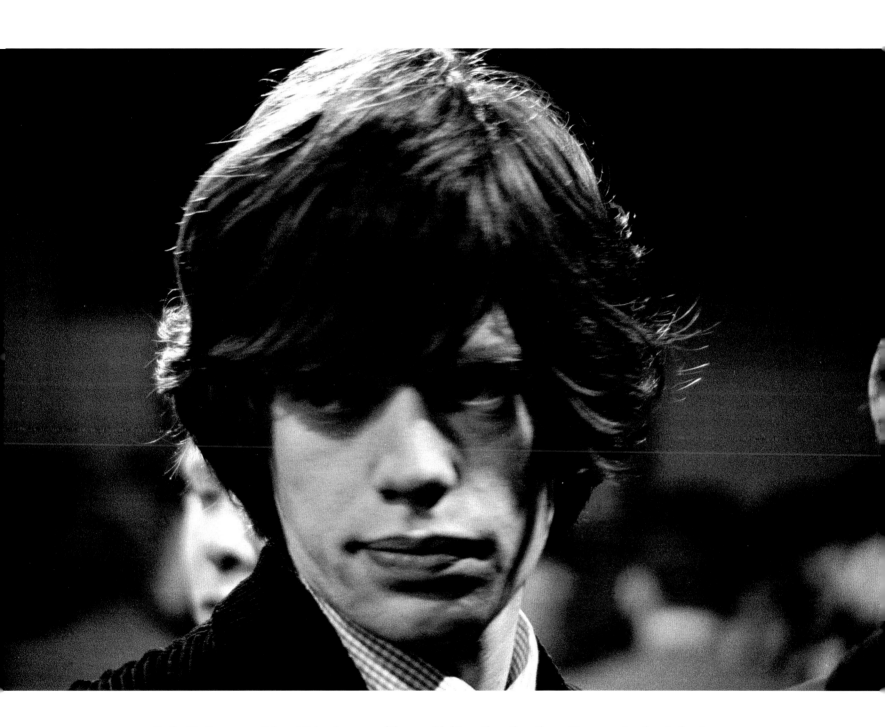

Cathy McGowan on Brian: '*Brian is more of the pop idol type than the others. He seems to glow in front of the cameras. He loves it. He can chat a lot and has a heap of ideas about life, himself and the group. He is very strong willed and tends to speak his mind. That's why he gets a lot of criticism. He's a bit like John Lennon in that respect. A lot of the things said about him recently just aren't true, I'm sure of that. But I suppose the main thing is the way he loves every minute of what he's doing.*'

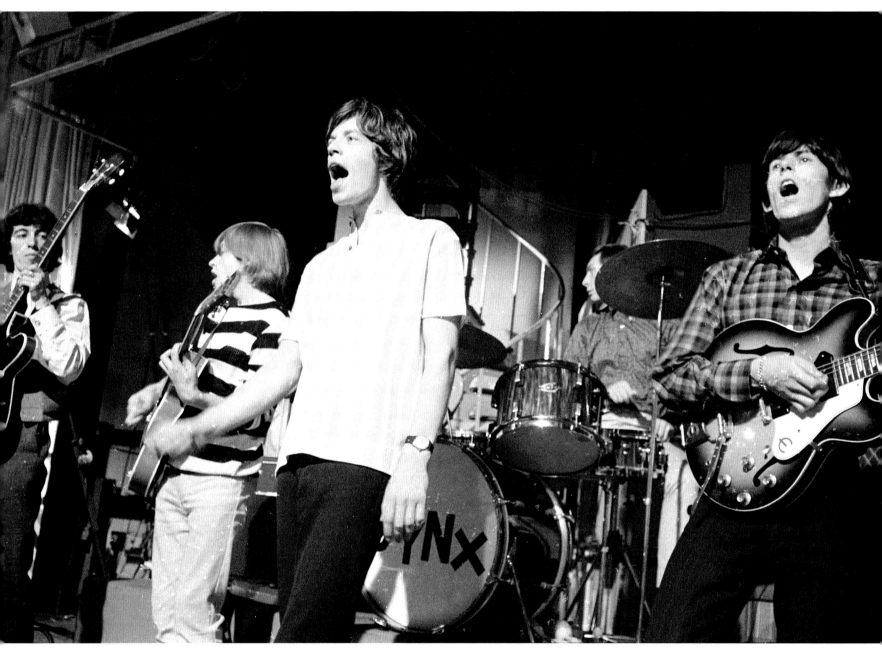

Cathy McGowan on Charlie: '*He is so modest he never thinks of himself as a famous person. And he's kind to everybody. If you catch Charlie with a modern jazzman... well, the talk is all sewn up for the whole evening.*'

OPPOSITE: Marianne Faithfull (seen here with compère Keith Fordyce at the after-show party) was at the *RSG* studio with Andrew Loog Oldham, who had recently 'discovered' her. Her first hit 'As Tears Go By', penned by Jagger and Richards, was just about to enter the UK charts. It would be a couple of years, however, before Marianne hooked up romantically with Mick.

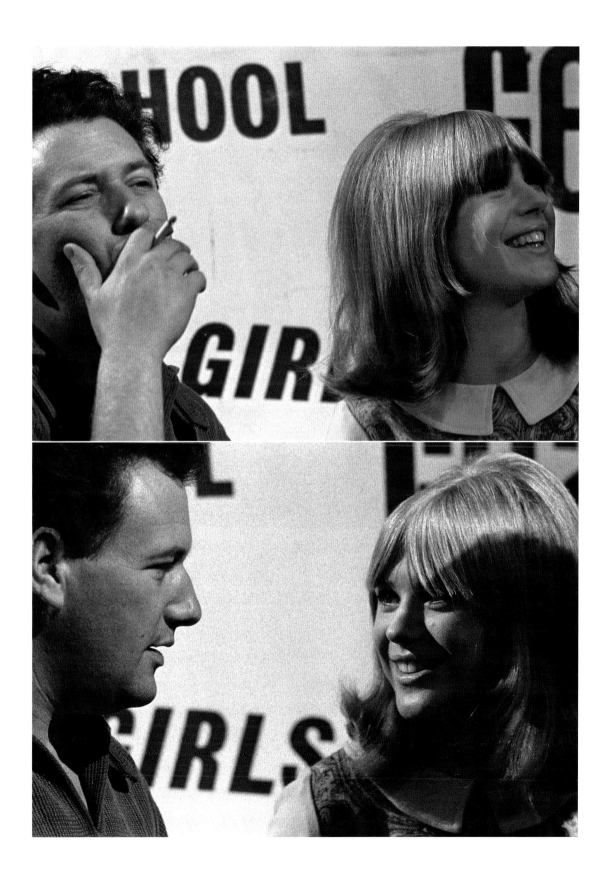

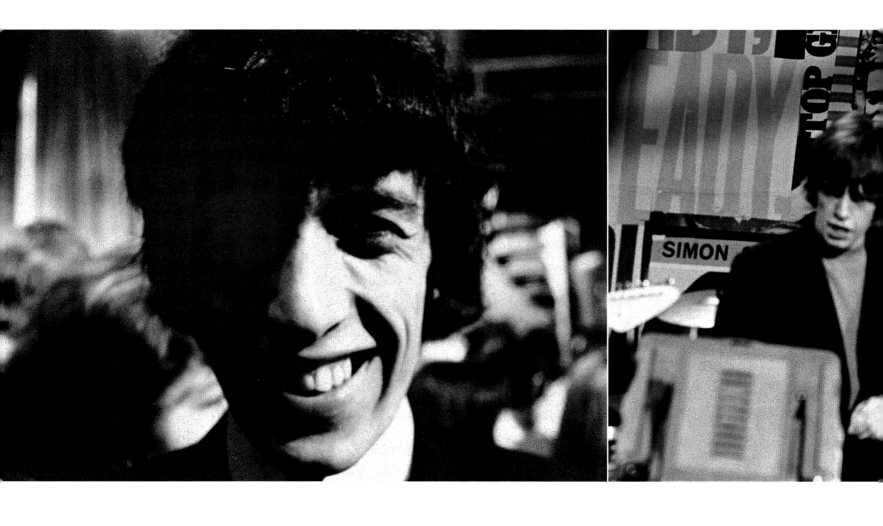

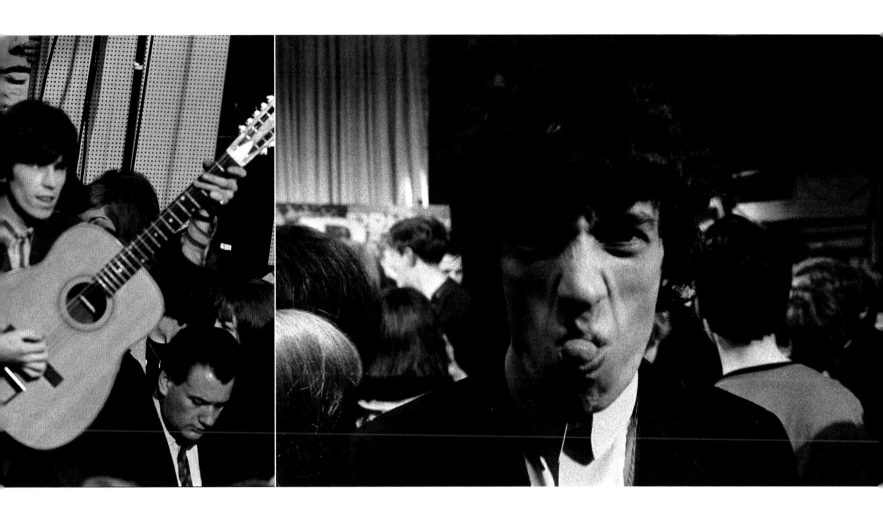

' Things are great, we can't go anywhere without masses of people trying to get hold of us. Do you think I'd look any good bald ?' Bill Wyman, backstage at *Ready Steady Go!*

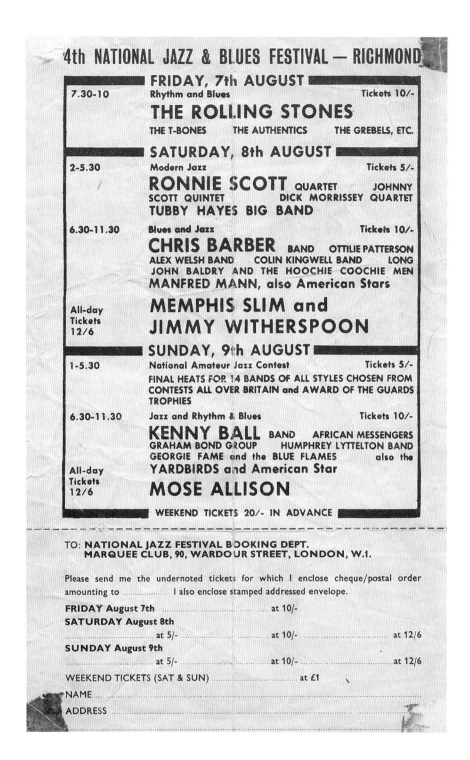

ABOVE: As can be seen from the flyer, jazz of one kind or another still dominated the Festival in 1964.

NATIONAL JAZZ &
BLUES FESTIVAL,
RICHMOND ATHLETIC
ASSOCIATION GROUNDS,
RICHMOND, SURREY
FRIDAY 7 AUGUST 1964

THE NATIONAL JAZZ FESTIVAL HAD BEEN ORGANISED by the National Jazz Federation – who also ran the Marquee Club in London – since 1960, but now it had the word 'blues' added to reflect the accommodation of more popular groups like the Rolling Stones who were part of the current rhythm and blues boom.

The Stones were booked to appear as headliners on the opening night of the three-day festival (still running today as the annual Reading Festival), for which an ecstatic Eric Easton received a cheque for £500 (below), a considerable sum in those days.

TAKE IN THE JAZZ & POP SCENE...

- Complete classified advertisement guide to — musicians wanted, vocalists wanted, instruments for sale, instrument repairs, accessories, tuition, and services.
- Expert record reviews, exclusive interviews, special articles, and all the behind-the-scenes news!
- Top news coverage on bands, artists, engagements, tours concerts — all over the scene!

...AT A GLANCE IN

Melody Maker
EVERY THURSDAY 9d

4th NATIONAL

JAZZ AND BLUES

FESTIVAL

Richmond, Surrey

Official Programme

Welcome to the Fourth of the annual Summer Festivals presented by the National Jazz Federation on this famous ground.

This year the accent is on Rhythm and Blues, a style we first introduced three years ago at our west end club, The Marquee. Almost all the R&B groups featured this weekend were with us last year including the Rolling Stones, who from last year's lowly position have now risen to a right of their own.

A newcomer this year is B.B.C. Television. On the Saturday an hour of the festival is being transmitted live from 10.20 to 11.20 p.m. on Channel 1 and on the Sunday a telerecording is being made for "Jazz 625" which will be shown on Tuesday 11th August on Channel 2.

We are also particularly happy to welcome, for the first time, American star guests and we feel sure you will enjoy Memphis Slim, Jimmy Witherspoon and Mose Allison.

Enjoy yourselves—and see you again next year.

HAROLD PENDLETON, Festival Director

Artistes appearing include:

ALEX WELSH BAND
CHRIS BARBER BAND
COLIN KINGWELL BAND
DICK MORRISSEY QUARTET
GEORGIE FAME AND THE BLUE FLAMES
GRAHAM BOND ORGANISATION
HUMPHREY LYTTELTON BAND
JIMMY WITHERSPOON
JOHNNY SCOTT QUINTET
KENNY BALL BAND
LONG JOHN BALDRY AND HIS HOOCHIE COOCHIE MEN
MANFRED MANN
MEMPHIS SLIM
MOSE ALLISON
OTTILIE PATTERSON
RONNIE SCOTT QUARTET
THE AFRICAN MESSENGERS
THE AUTHENTICS
THE GREBBELS
THE NIGHT SHIFT
THE ROLLING STONES
THE T-BONES
THE YARDBIRDS
TUBBY HAYES BIG BAND

4th NATIONAL

JAZZ & BLUES FESTIVAL

sponsored by
THE EVENING NEWS & STAR

Including the Finals of the
2nd GUARDS NATIONAL AMATEUR JAZZ CONTEST

sponsored by
CARRERAS LTD.
Makers of GUARDS Cigarettes

RICHMOND

7 · 8 · 9 AUGUST 1964

Jazz notes by Benny Green

Photography by David Redfern
29 Museum Street, W.C.1

Programme designed and published by
J. K. Smith, 78 Hampden Road,
Hornsey, London, N.8

Printed by T. W. Pegg & Sons,
Effie Road, London, S.W.6

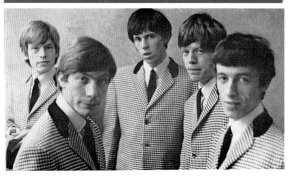

● THE ROLLING STONES

There was a time — not so long ago — when, at least in the jazz-world, no-one wanted to know about rhythm and blues and rock'n'roll was a dirty word. What then were the chances to succeed for a bunch of young people from South London whose unorthodox tastes ranged from Muddy Waters to Bo Diddley? Very few, and they knew it; but instead of chucking it in they went rolling on and it is this almost incredible determination which gave The Stones the kind of backbone no-one in show business can do without.

I remember the first "gig" we offered the Stones at the old Station Hotel, Richmond. For some time we'd had a jazz-based R&B group resident there every Sunday. This band never really got off its feet so I decided to break with the existing jazz-scene and look for new people with fresh ideas and unbending determination. These were the very early days of R&B and groups were very scarce. After some investigation and against many of my colleagues' advice I made my mind up to book The Stones. At that time their sound was still somewhat "loose" but they knew what they wanted and that, in my opinion, was half the battle.

It is said quite often that the Station Hotel was gloriously unique. I agree. We, at least, tried to create there the sort of atmosphere this music needed in order to get across. We encouraged band and audience alike to "be themselves", even if, at times, it meant reaching certain extremes. We raved like hell and we enjoyed it. Not all was rosy though: there were moments of crisis, competition at Eel Pie Island, uneasy landlords, The Stones' doubts as to whether they were going to make it. Many times we did "our nut" trying to solve problems which seemed insurmountable. In the end, it all "happened". Barry May, a journalist now working for the Record Mirror, came down one evening. A few weeks later I managed to get The Beatles to pop in . . . The rest is Rolling Stones and Crawdaddy history.

I think The Stones had a natural talent to succeed. They always had the temperament of real "pros". I think they are now "real pros" and very successful ones. I never doubted they were going to make it and I am glad they did. Without any reservation of any kind: they deserved it.

GIORGIO GOMELSKY, The Crawdaddy R&B Club.

● THE T-BONES
● THE AUTHENTICS
● THE GREBBELS

Every year the National Jazz and Blues Festival attempts to set new groups on the road to stardom. Last year it was the Rolling Stones and Georgie Fame, this year it's the turn of the T-Bones. The Authentics and the Grebbels, three groups with a bright future ahead of them.

ABOVE: The programme for the National Jazz & Blues Festival, which included an article with a photo of the be-suited Rolling Stones.

OPPOSITE, TOP: A letter to the office of the National Jazz Federation, promoters of the Richmond festival, from a mother applying for a ticket refund as her son could not attend due to an accident.

OPPOSITE, BOTTOM: At the festival a variety of tickets were available. There was one ticket for Friday afternoon only, one for Friday evening, one for Saturday and Sunday, one for the whole weekend, and so on. This led to confusion for many fans, who often found that the ticket they purchased didn't allow them to watch the band they wanted to see.

43 Ramsay Road
Forest Gate
London E.7
6-8-64

N.J.F. Office.

To Secretary,

Dear Madam,
　　With reference refund to the
telephone call I made to your office
this afternoon — I am enclosing the
ticket purchased by my son.
　　Unfortunately, he met with an
accident which has resulted in a
broken leg and is now unable to
attend the Jazz Festival this
week-end,

After discussing the matter with
your co-directors, it was agreed
that I should return this ticket
(No. 41) with an explanatory letter
to enable your office to make
a re-fund on same.
　　Many apologies for any
inconvenience,
　　　　　Yours faithfully,

　　　　Mrs. Michael King

Registered Mail.

RICHMOND ATHLETIC ASSOCIATION GROUNDS
KEW FOOT ROAD · RICHMOND · SURREY

THE NATIONAL JAZZ FEDERATION presents the

4th NATIONAL JAZZ FESTIVAL

7th, 8th & 9th AUGUST, 1964

FRIDAY EVENING | 10/- | Nº 1024

THIS PORTION TO BE GIVEN UP ON
FRIDAY 7th AUGUST
7.30 to 10 p.m.

FRIDAY/SATURDAY/SUNDAY

A

ARENA
USE GATE 2

Moisten around edge of this side
and apply to inside of window

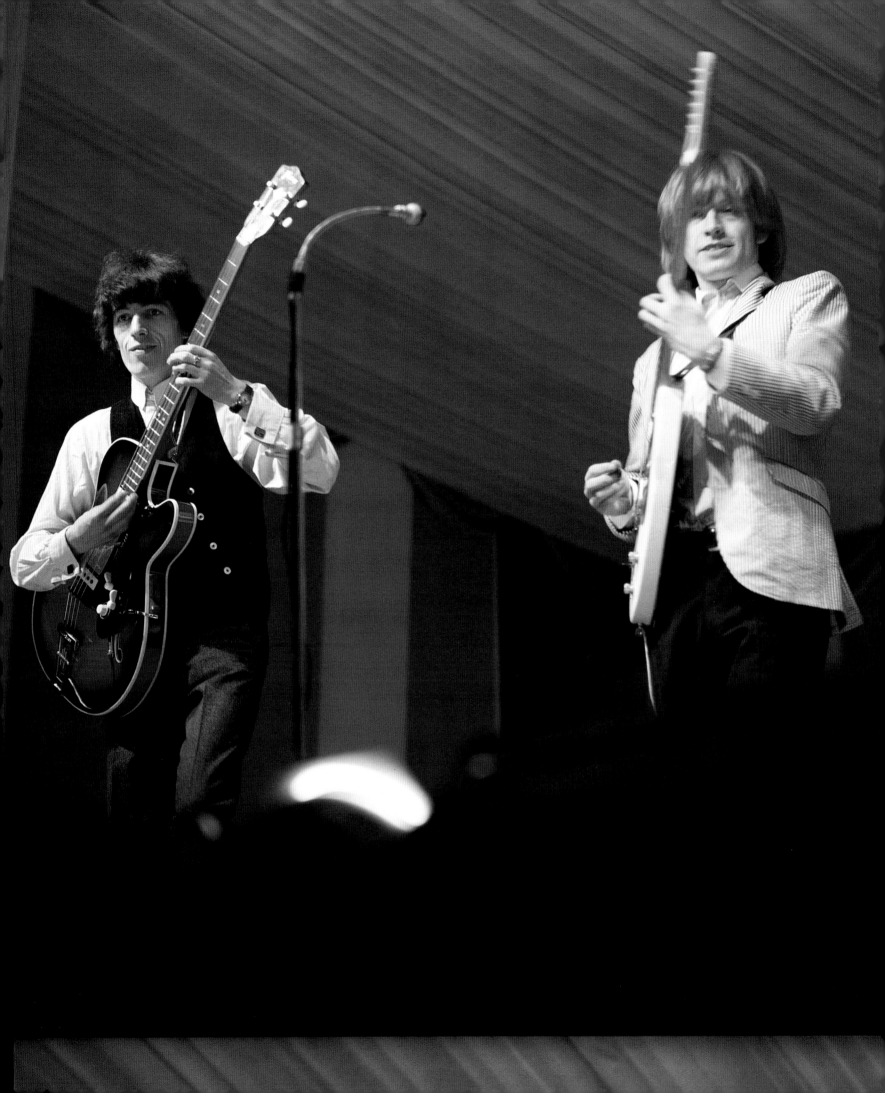

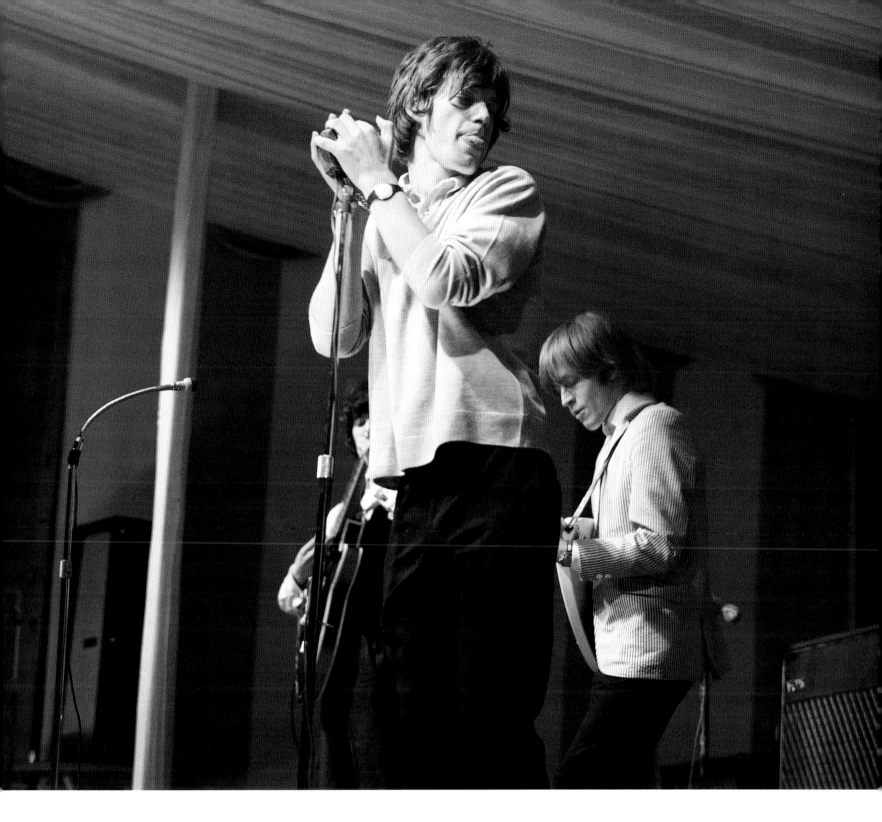

OPPOSITE AND ABOVE: After a downpour, with Giorgio Gomelsky as the compère, the Stones appeared, following R&B group the T-Bones, who had received an enthusiastic reception. The Stones walked on one by one, before playing a 45-minute set which included Rufus Thomas' 'Walking the Dog', Tommy Tucker's 'Hi-Heel Sneakers', 'It's All Over Now', and 'I'm All Right'. The fans went wild.

ODEON THEATRE, LUTON
WEDNESDAY 9 SEPTEMBER 1964

THIS PIECE OF HISTORY CAME INTO MY HANDS while working at my shop Vinyl Experience at 18 Hanway Street in London, where I specialised in pop memorabilia and rare records. A customer came in with two reels of 8mm home movie which he had filmed, the first being of the Yardbirds (with Eric Clapton) and the Kinks. The second spool featured this fascinating colour film of the Rolling Stones live at the Odeon Theatre, Luton, in September 1964, on the fourth night of the Stones' fourth UK tour. Although silent, I think the footage would capture the imagination of anyone interested in the history of the group or indeed of the era.

On the tour, which commenced on 5 September at the Astoria, Finsbury Park, the band were supported by American brother and sister R&B stars Charlie and Inez Foxx, UK rocker Mike Berry, Liverpool group the Mojos, and Simon Scott. Don Spencer was the compère. The Stones opened their top-of-the-bill set with 'Not Fade Away', followed by 'I Just Wanna Make Love to You', 'Walking the Dog', 'If You Need Me', 'Around and Around', 'King Bee', 'I'm Alright' and 'It's All Over Now'. The 32-night tour – which involved two shows each night – ended on 11 October at the Brighton Hippodrome.

' Some days spent learning to lip-read in a country hospital five years ago stood me in good stead on Saturday when the Rolling Stones' tour opened at Finsbury Park Astoria. From my seat in the front row of the circle, I could just hear the group's beat and rarely ever did more than five consecutive song words get through to me. Charlie sat amid a huge battery of amplifiers which, in normal circumstances, would have enabled people in the pub across the road to hear. But on Saturday customers in the stalls strained to catch the music.'

From a review of the first night by Richard Green, *New Musical Express*, 11 September 1964

ABOVE: Screen grabs from the 8mm home movie footage of the Rolling Stones in Luton.

Inez and Charlie Foxx were an appropriate choice for the support slot on the tour. From North Carolina, they'd had a huge hit in the USA wth their single 'Mockingbird' in August 1963, and compared to UK R&B groups were considered 'the real thing'. Charlie Foxx was adamant about the different sound of 'genuine' R&B and that of the Rolling Stones.

'You can tell they're English. Don't get me wrong, you can tell any white group. The Rolling Stones may have a coloured sounding voice, but they still have an English accent. They still say words like you would know it was an English accent. They say "yeah" – just to take one example – and it don' t sound like an American Negro group. I can pick this out of maybe 100 records and be right every time. Don' t misunderstand me, I rate the Rolling Stones.'
Charlie Foxx, *New Musical Express*, 9 October 1964

' This tour is the biggest thing the Stones have done yet. Our repertoire for the tour consists of about twenty numbers from which we choose eight every night.'
Mick Jagger, *Melody Maker*, 12 September 1964

OPPOSITE: A personal piece about the tour by Mick Jagger in *Disc* magazine, plus a review of the opening night. The top picture features (l to r) Simon Scott, Mick Jagger, Charlie Foxx, and Brian Jones; centre, Brian is with the show's promoter Robert Stigwood and Bill Wyman; and bottom are Inez and Charlie Foxx.

ON TOUR WITH THE STONES

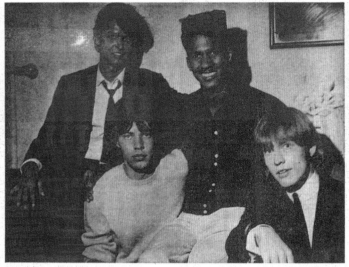

MICK and BRIAN relax in the dressing-room at the Finsbury Park Astoria on Saturday. With them are Simon Scott (top left) and Charlie Foxx.

by MICK JAGGER

WELL, at last it's under way. The biggest thing to date in our pop career—our first national tour as top-of-the-bill artists.

I know I speak for all of us when I say that we hope it continues as well as it has done in these opening days. We sincerely hope that there won't be any trouble where anyone gets hurt, but that does not mean that we don't want everyone to enjoy themselves at the show.

We admit that we go out on stage with the idea of working up a frenzy of enjoyment and it doesn't really worry us when the audience screams throughout the numbers so much that they can't possibly hear us. We are used to that by now.

Personally, I don't really think it makes all that much difference if they don't hear most of our numbers because they have probably got the records and know the tunes.

In fact, you can notice the difference between when we sing numbers that are released as singles and when we do lesser known songs. They are very much quieter during the lesser known ones because they WANT to hear them.

In all, our repertoire for the tour consists of about 20 numbers, from which we choose eight each night.

Touring is perhaps the hardest part of our work, but I think it's not as bad here as in the States. There we had to do radio shows all day followed by the one-nighters in the evening.

I don't mind the travelling part of it, but I get very bored cooped up in the dressing room between shows. We just sit around talking and answering letters because there is nothing else to do. We try to answer as many fan letters as possible, but obviously can't reply to them all.

I hope we can meet a lot of our fans during this tour, but whether this will be possible or not I don't know.

We don't arrive at the theatre until a few minutes before the show starts—that's a request the police made to us. It's difficult, so don't blame us too much if we can't meet you as often as we would like!

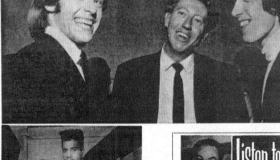

Rod Harrod was at the opening

MICK says this tour is the biggest thing The Stones have yet done, and having been deafened by the screams at Saturday's opening at the Finsbury Park Astoria, I'm not going to argue with him!

But, if you do want to hear what Mick and Co. are playing, here's a tip—half plug your ears! It cuts down the screams and by watching the boys closely you can just about make out what's going on!

Saturday night was Stones night, of course, but it will also be remembered by all at the Astoria for the night when an American act almost stole the limelight.

Taking the spot before the bill-toppers, Charlie and Inez Foxx received tumultuous applause and shouts for "more."

Although they were the last but one act of the show they were the first to get the audience hand-clapping throughout each of their numbers. The audience knew they were watching a performance of great talent and professionalism—and my how this brother and sister controlled the fans.

I hope that Simon Scott, the latest prodigy from Robert Stigwood Associates, who promoted the tour, was standing watching Charlie and Inez from the wings—he should be able to pick up a few tips on showmanship.

Although all the stops were pulled out to present this new boy, he impressed few.

The Mojos, who closed the first half, came over quite well with "What'd I Say," but did not inspire much enthusiasm with their latest "Seven Golden Daffodils."

Mike Berry handled Buddy Holly's "Tell Me How" quite well but overall it was only the last two acts for which the show will be remembered.

(Above) BRIAN and BILL share a joke with tour promoter Robert Stigwood. (Below) CHARLIE and INEZ FOXX, who really got the audience going and nearly stole the show.

THE STONES ON CAMERA

MAYFAIR / CHELSEA BRIDGE / VICTORIA STATION, LONDON
SUNDAY 11 OCTOBER 1964

AS A FREELANCE PHOTOGRAPHER, RICHARD ROSSER would use his contacts in the pop world of mid-1960s London to get work. He'd already photographed the Stones informally, including on the set of *Ready Steady Go!* as featured earlier in this book, but had yet to work with them in a directly commissioned capacity. After several phone calls to Andrew Loog Oldham's office, a photo shoot opportunity finally came Rosser's way. He was told to be present at the Stones' offices in Maddox Street, in London's smart Mayfair area. The band had to play in Brighton that evening but had the day free for a photo shoot around London. Rosser and the Stones decided on a selection of locations, starting near the office, which would bring them to Victoria railway station. Richard Rosser obviously liked the ambience of railway stations for a shoot — he had worked with the Beatles during the filming of *A Hard Day's Night* at London's Marylebone station six months earlier, in April 1964.

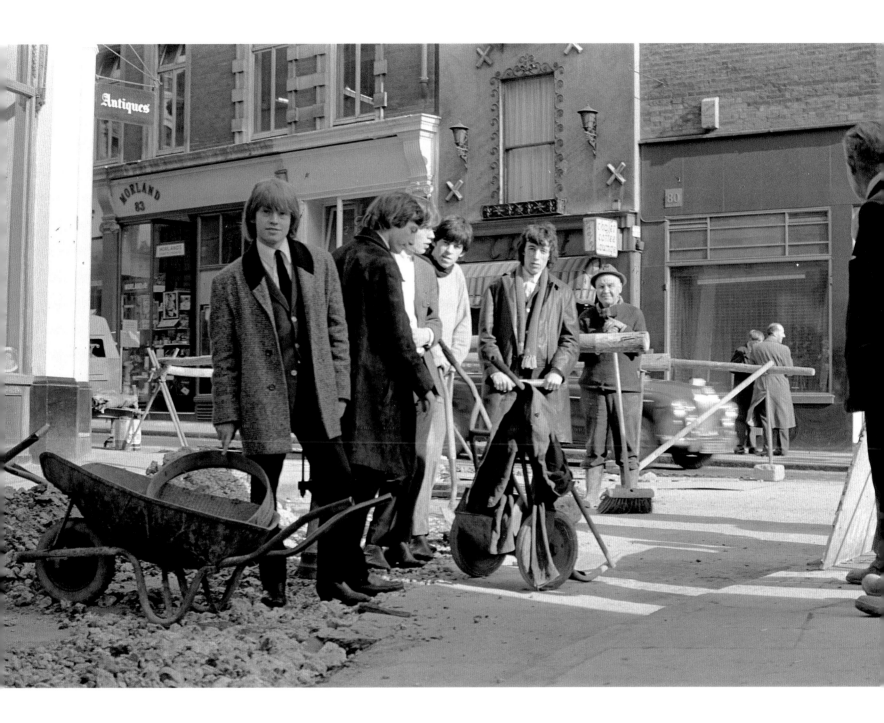

ABOVE AND OVERLEAF: Outside 3 Grosvenor Street, a few yards across Bond Street from Maddox Street, where the local Westminster Council were having the road paved over. The shop was then the site of an opticians, L.K. Leon; although the frontage has been preserved as it was in 1964, the premises itself is, at the time of writing, now a branch of Starbucks.

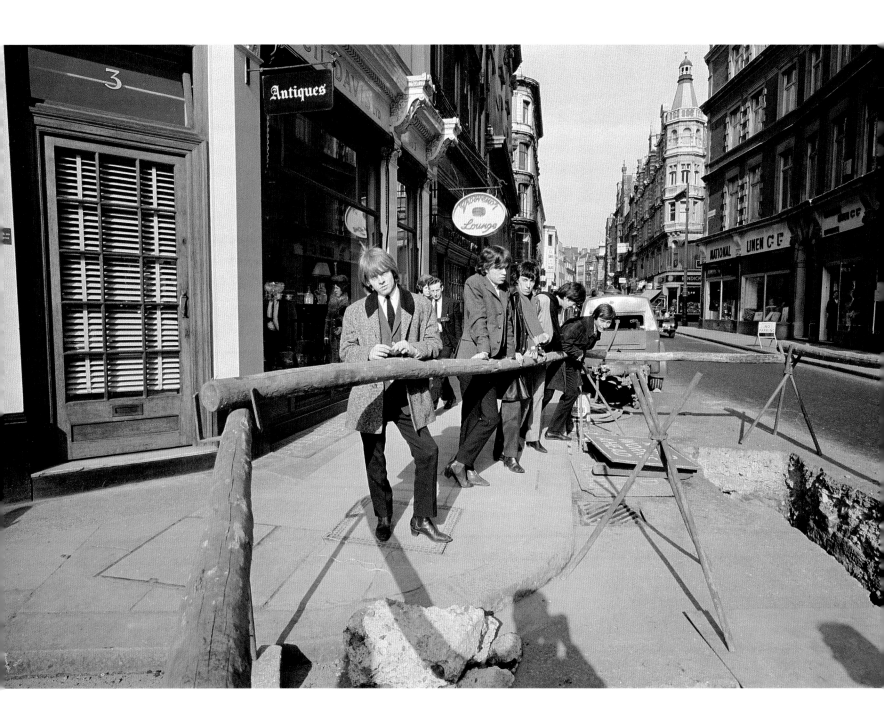

OPPOSITE: Lotus was a very trendy shoe shop chain in the 1960s. Here the Stones pose outside the flagship store in fashionable Bond Street.

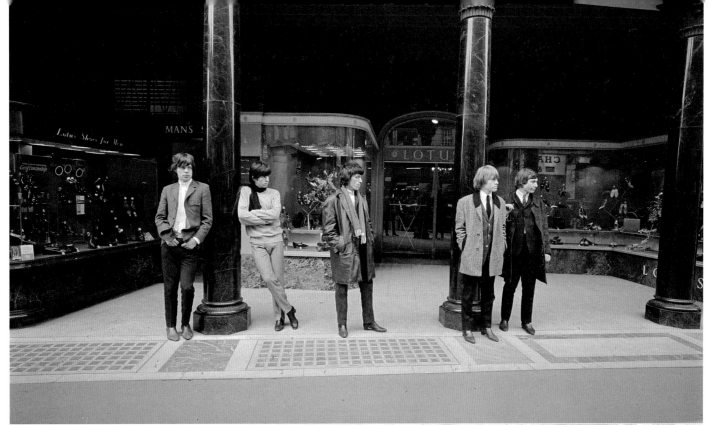

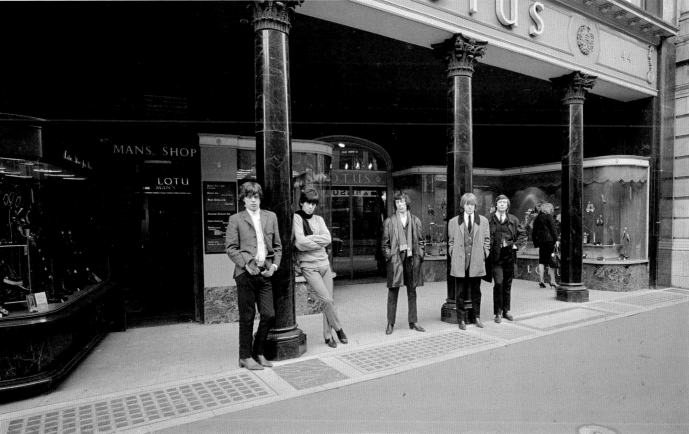

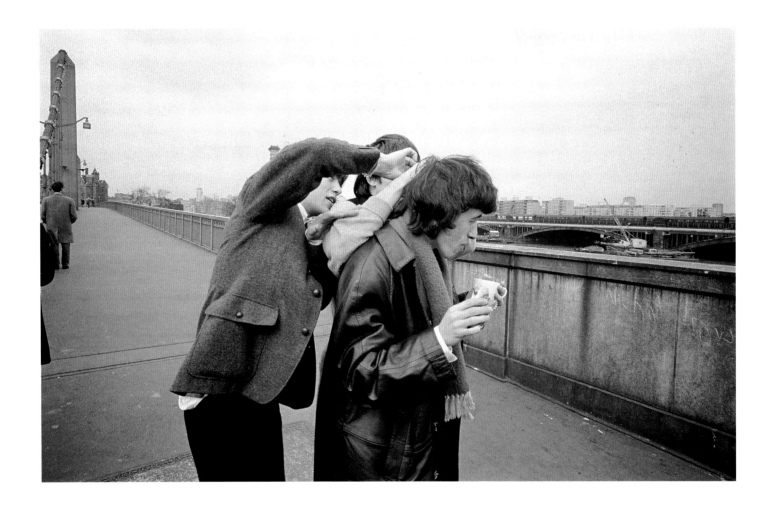

When the Stones first settled in London, they occupied a seedy flat in Edith Grove, Chelsea, not far from the River Thames. Their old flat-mate James Phelge recalled how they would sit up at night playing records until one in the morning or so: 'Then they would get up and go out, with one voice saying "Who fancies a trip to the pie stall then?"' They would make their way down Edith Grove to the Chelsea Embankment, then follow the river east to Chelsea Bridge. There an all-night stall served pies, sandwiches, and cups of tea to nocturnal customers such as taxi drivers, musicians, and homebound club-goers. The Stones and Rosser made it the last port of call on the shoot before ending up at Victoria Station.

ABOVE: Fooling around on Chelsea Bridge.
OPPOSITE, TOP: The legendary pie stall, still a feature on the south side of the Bridge in the 21st century.
OPPOSITE, CENTRE: Mick views Battersea Power Station from the Bridge.
OPPOSITE, BOTTOM AND OVERLEAF: Tea and pies all round.

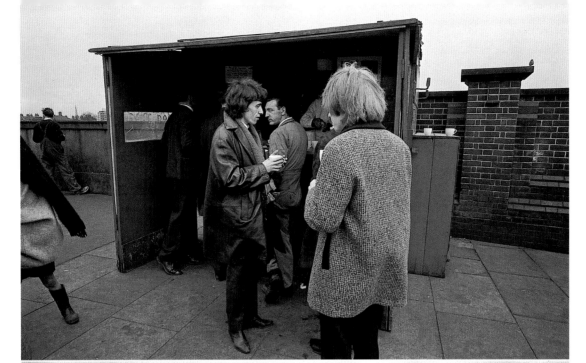

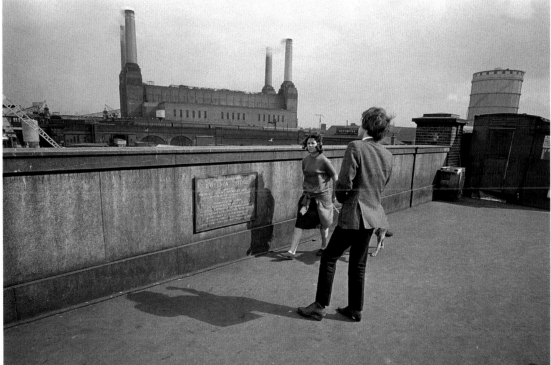

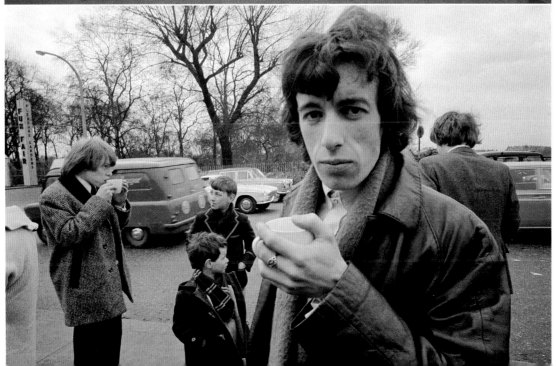

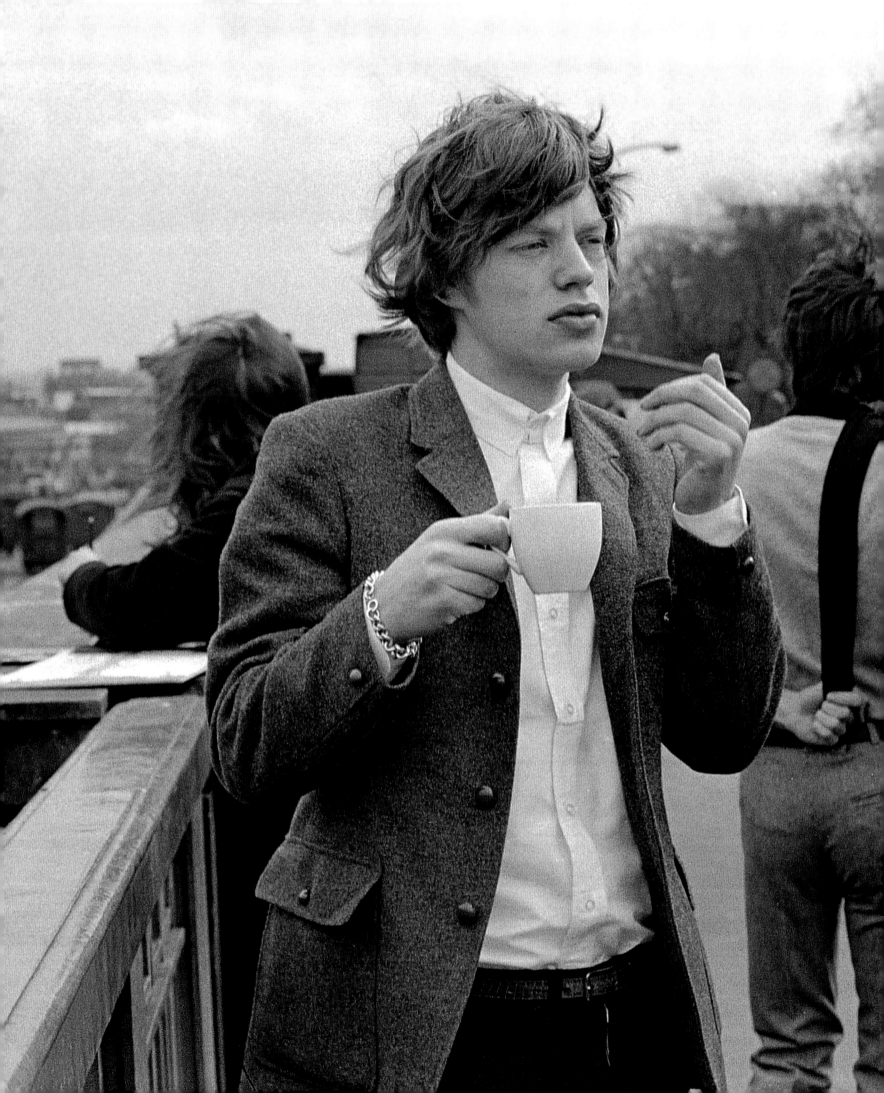

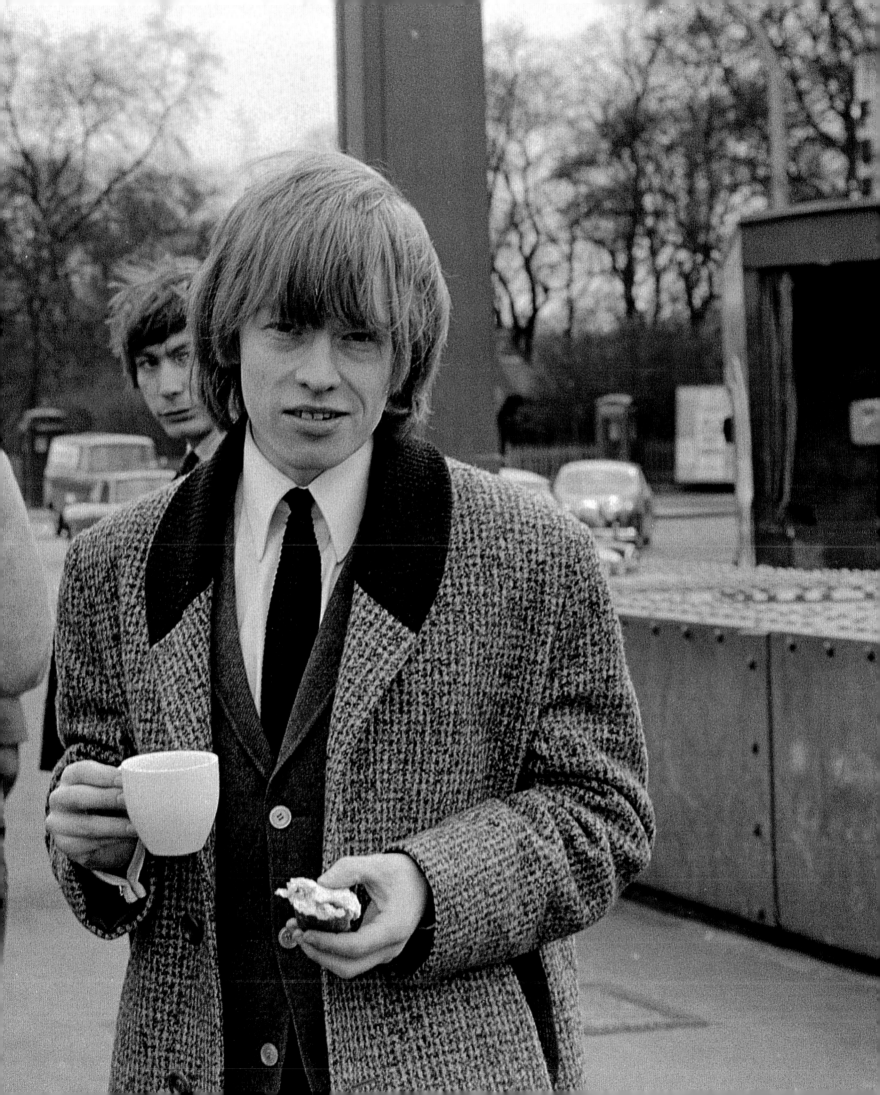

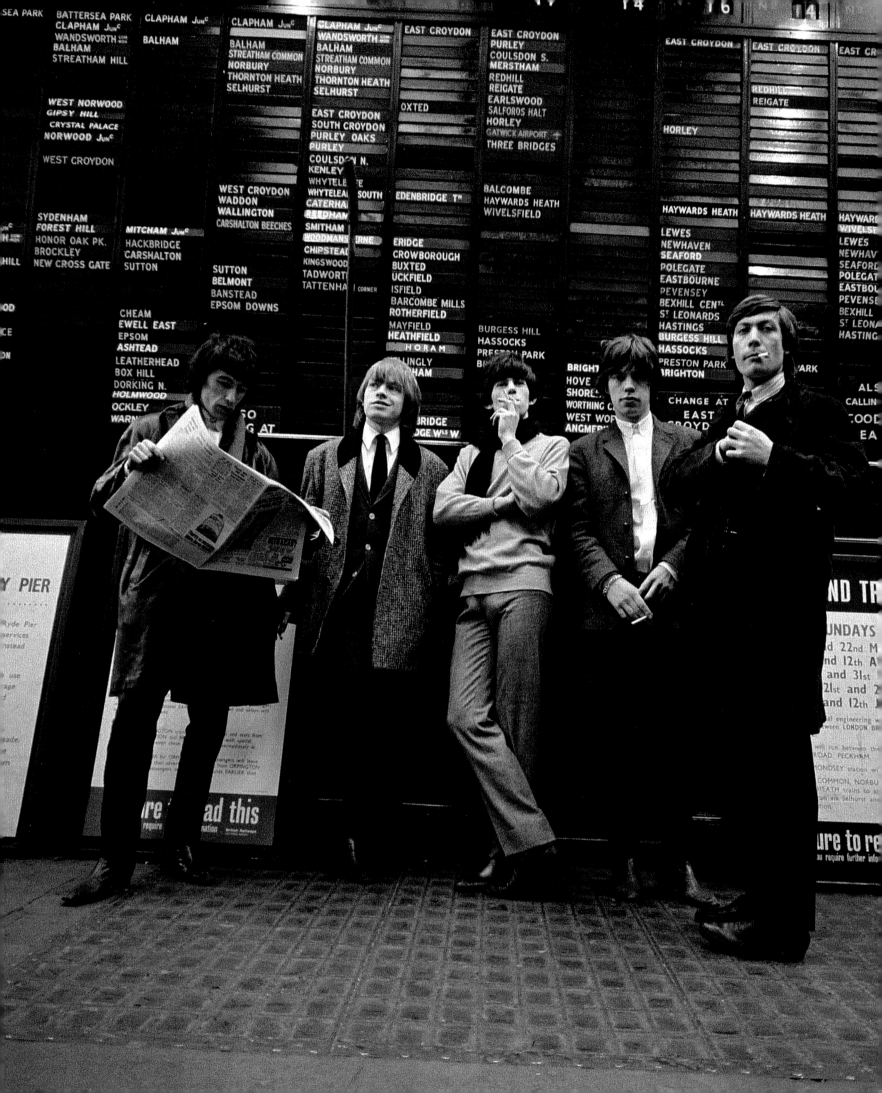

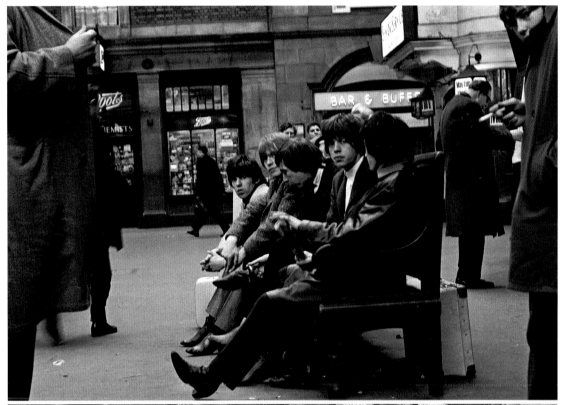

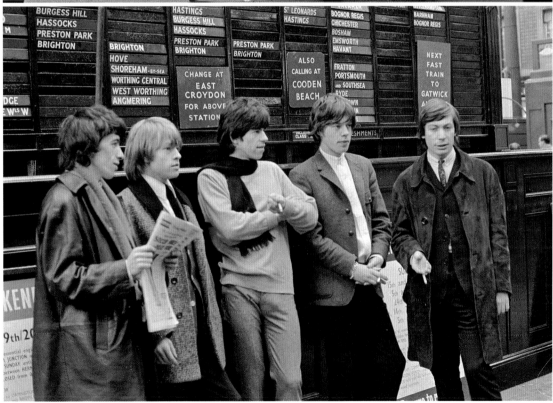

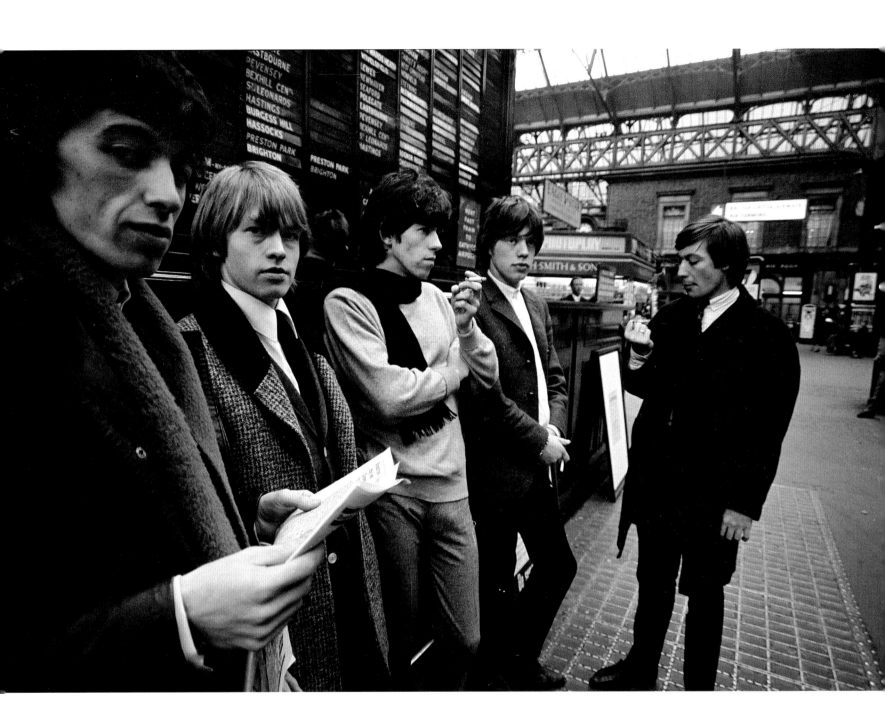

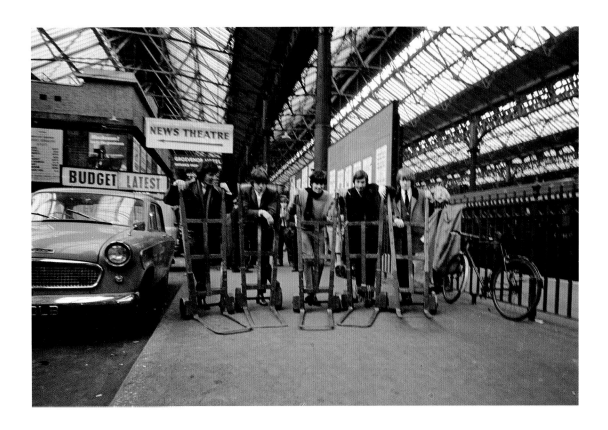

ABOVE: Victoria Station provided some good settings for photographs, like the Stones in front of the timetable boards which include the route they are about to take to Brighton, and the obligatory 'fooling around' shot – here with station porters' trolleys – beloved of pop group photo sessions of the period. Not so expected would be the shot of them in the men's toilets at Victoria (**OVERLEAF**), a harbinger, perhaps, of the much-publicised occasion in March 1965 when three members of the band were fined £5 each for relieving themselves against the wall of a London petrol station.

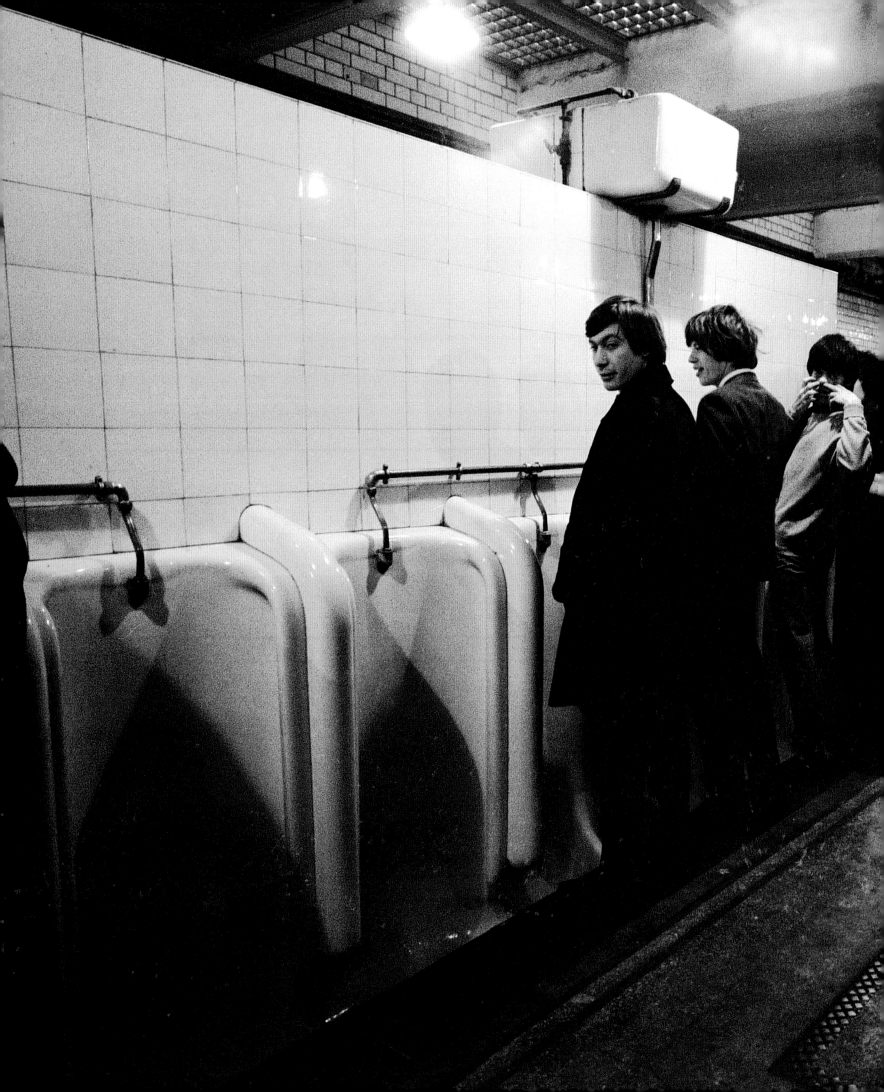

MIDLAND HOTEL, MANCHESTER
SUNDAY 7 MARCH 1965

Born 30 April 1939, photographer les chadwick had attended Liverpool Art College two years prior to John Lennon, where he was a friend of Bill Harry, later the founder and editor of Liverpool's own music paper *Mersey Beat*. Les was to be one of the regular photographers featured in *Mersey Beat*, and covered the Liverpool music scene, including a number of memorable sessions with the Beatles. Les clearly remembers leaving his equipment with the Cavern cloak room girl, who would later find fame as Cilla Black, while he watched the bands play before taking photographs in the club. His work was represented by the local Peter Kaye agency – although there was no such person as Peter Kaye, the company being part-owned by the late Bill Connell. Bill's widow gathered together the negatives of these particular photographs, which I purchased when she put them on sale at Sotheby's.

The night before the photo session, on 6 March 1965, the Rolling Stones had been playing at the Liverpool Empire theatre, where they were supported by the Hollies, Dave Berry and the Cruisers, the Checkmates, and Goldie and the Gingerbreads. As soon as the show was finished, they piled into a van and dashed to Manchester – where they were playing the Palace Theatre the following night – to stay at the city's premier hotel, the Midland. Before leaving the Empire, the Stones asked Les to join them at the Midland to take some pictures. Chadwick jumped into his car with his Leica IIIg camera, drove to Manchester and stayed overnight to photograph the band again the next morning.

Les remembers that the Stones were still a great act to watch, with a raw feel which he felt the Beatles had lost by this time. He recalled them being very intelligent and talkative, interested in all manner of subjects, 'a breath of fresh air' compared to some of the other bands he'd photographed.

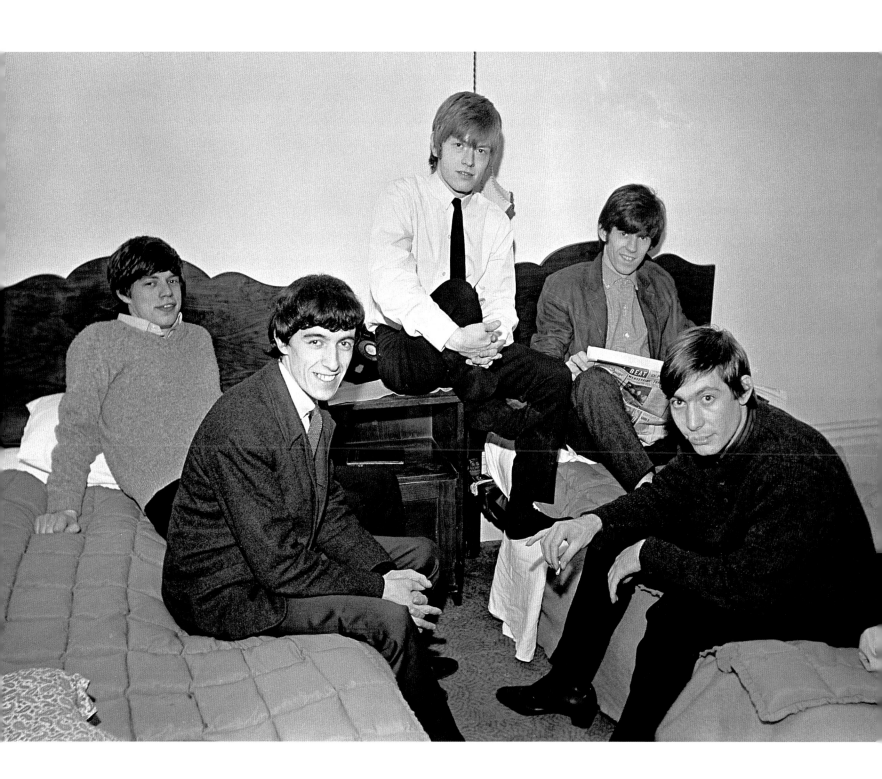

ABOVE: The Stones relaxing in Mick and Keith's shared bedroom at the Midland Hotel in Manchester; Keith reads a copy of the Liverpool music paper *Mersey Beat*.

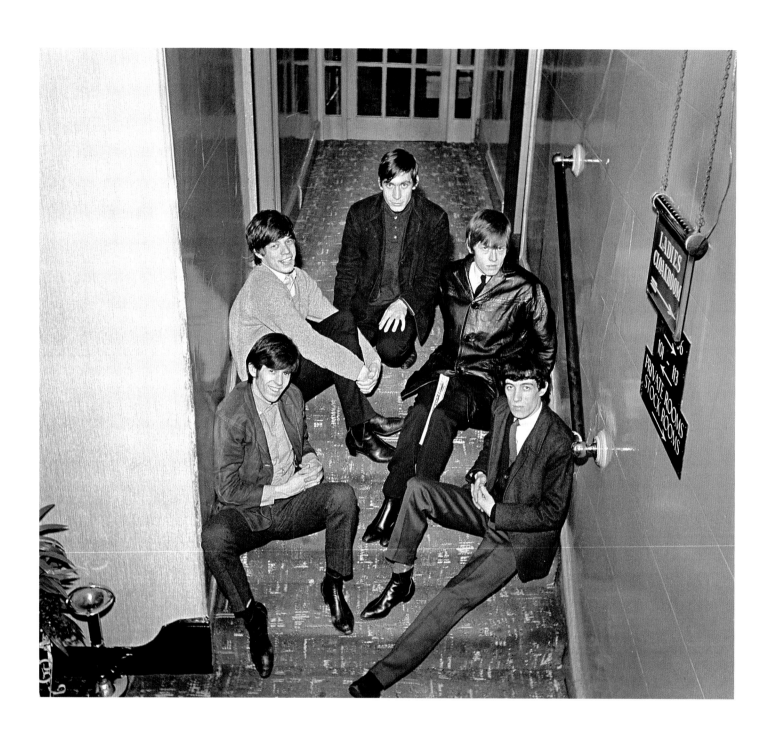

ABOVE: Les Chadwick photographed the band in the corridors of the Midland Hotel.

OPPOSITE AND NEXT FOUR PAGES: And in the hotel lounge where, over breakfast tea and coffee, the Stones browsed through copies of *Mersey Beat* – provided, no doubt, by photographer Chadwick.

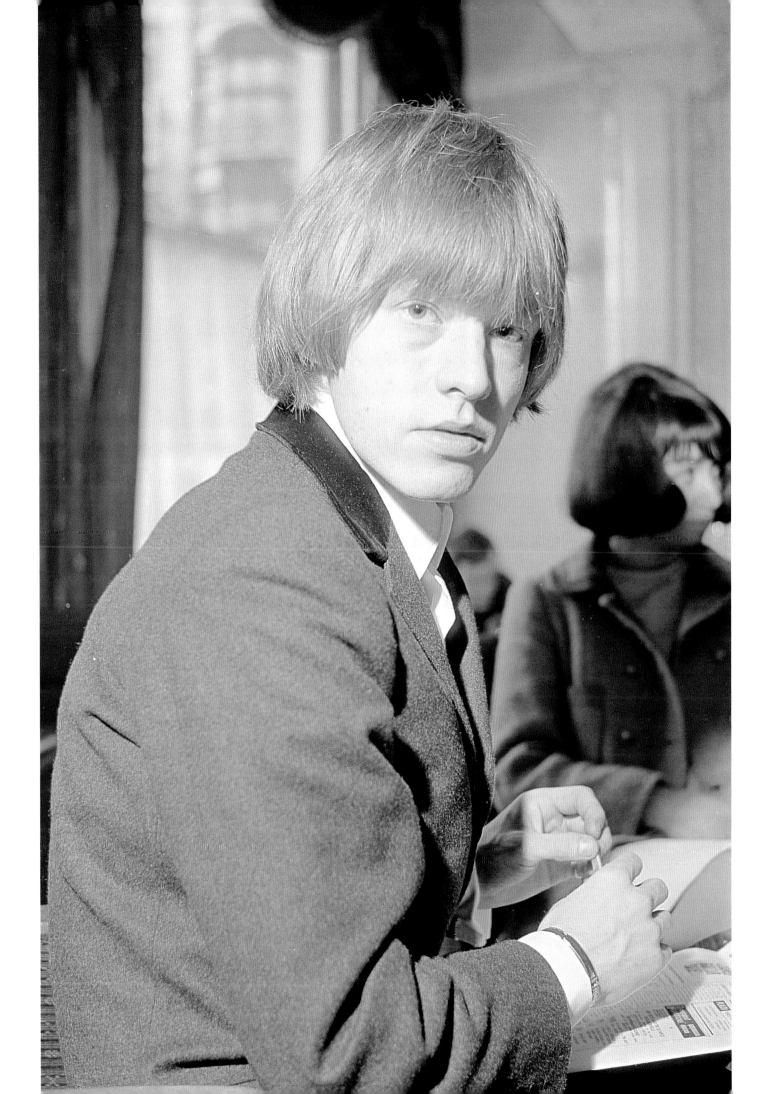

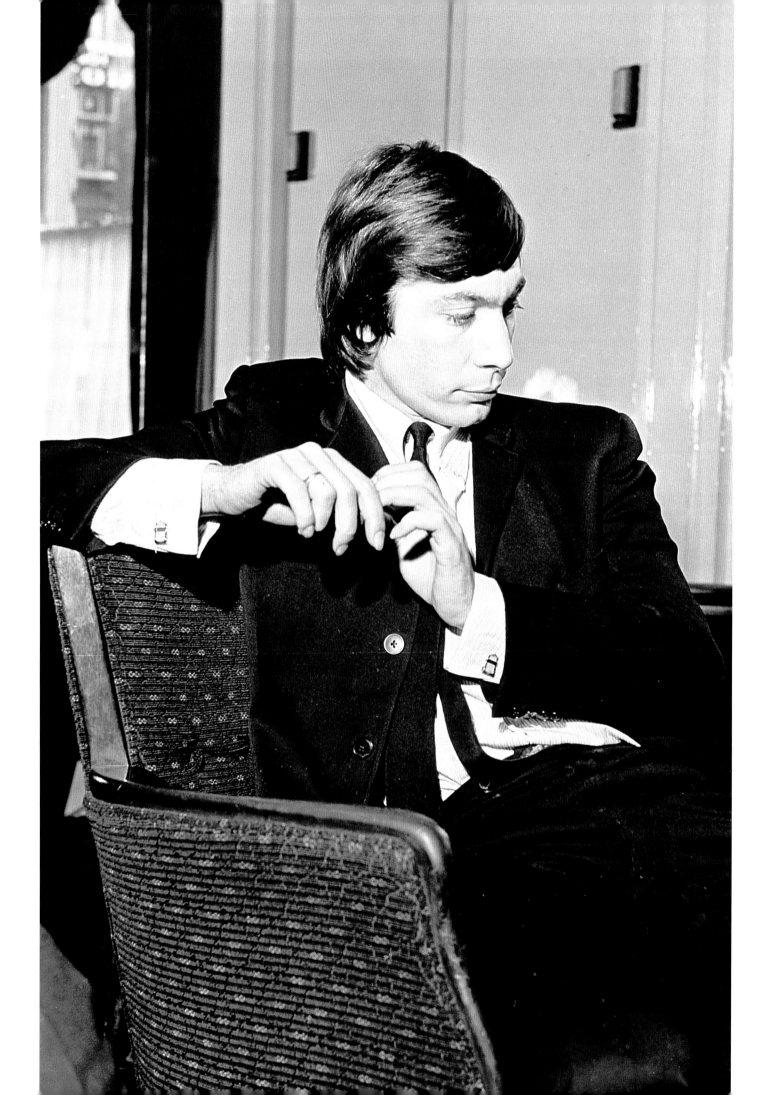

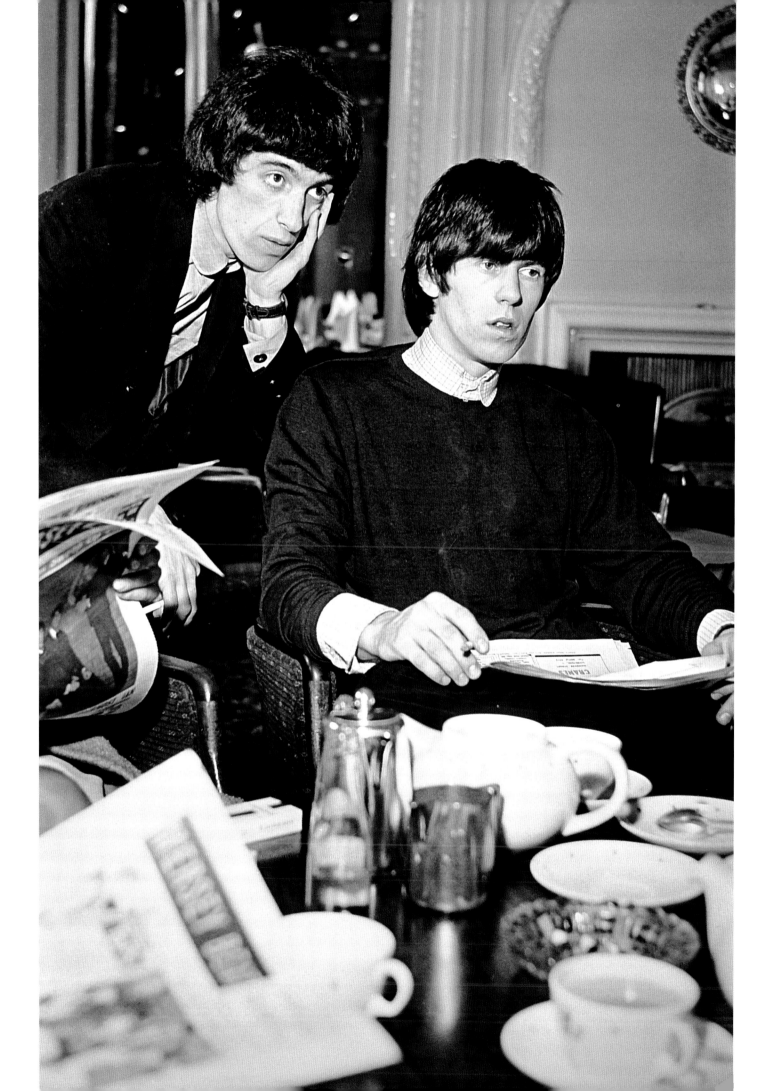

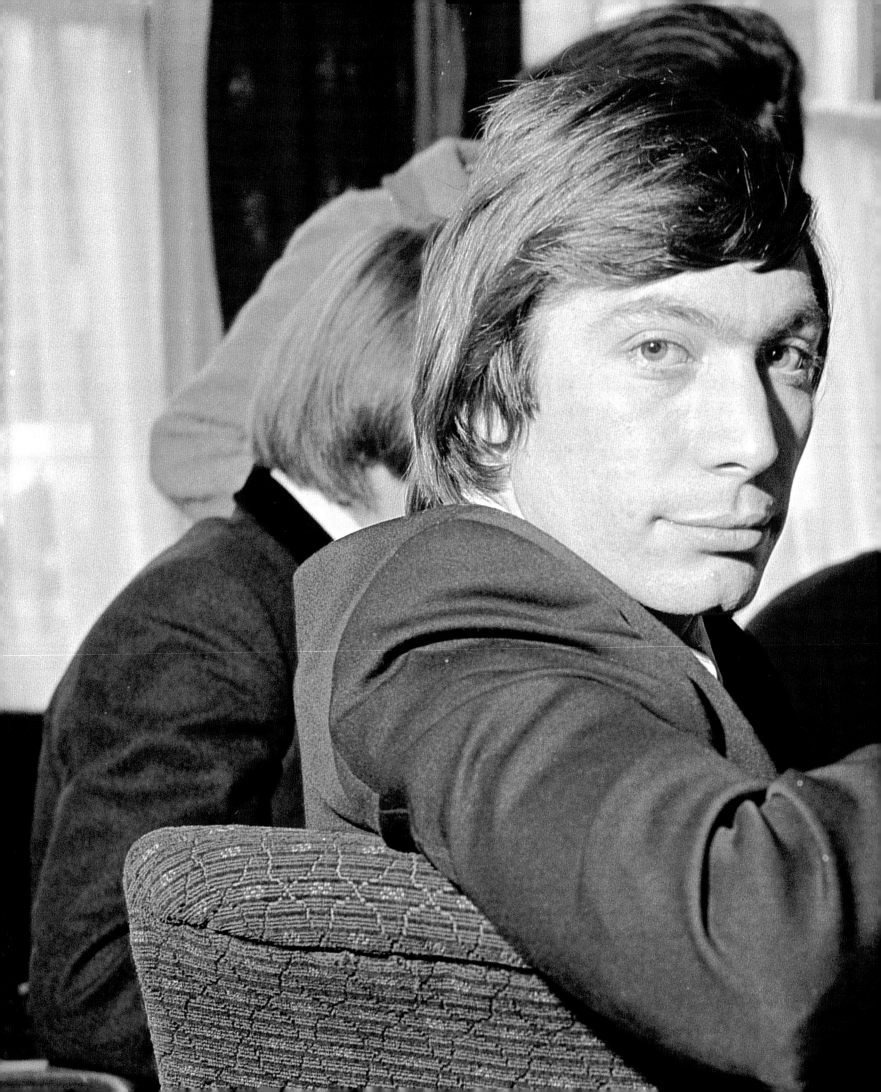

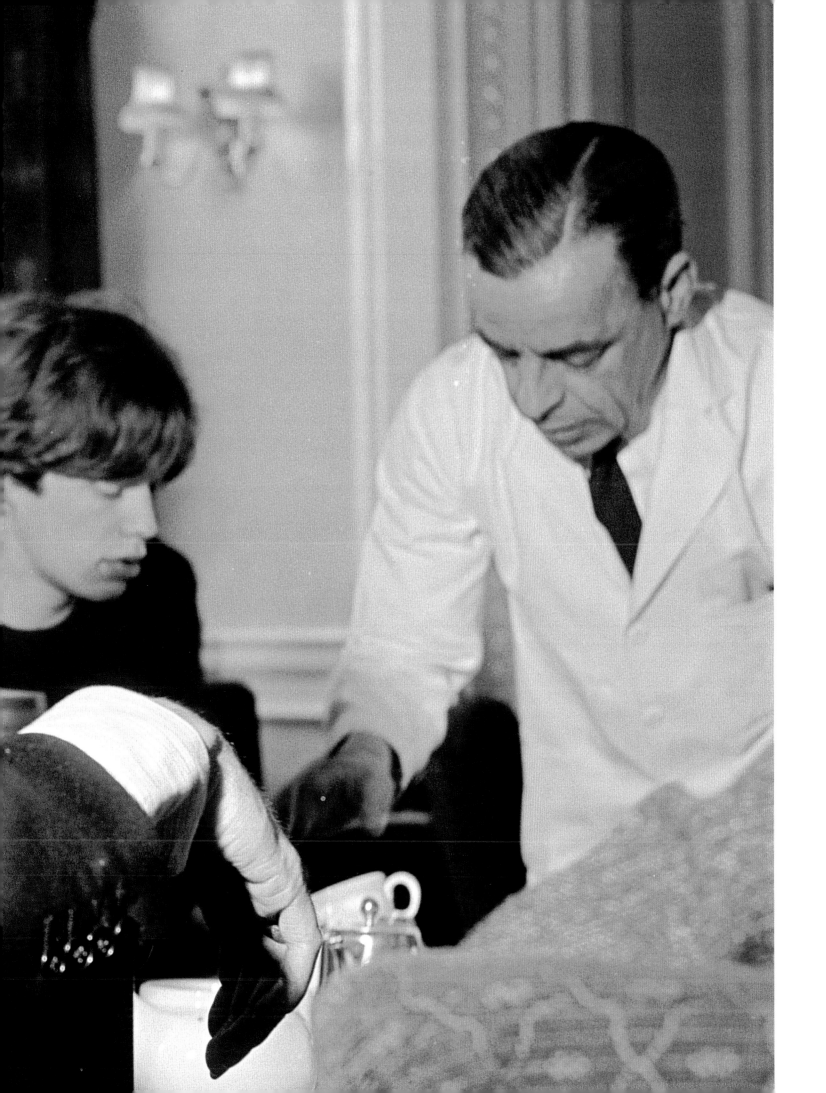

PALACE COURT HOTEL, BOURNEMOUTH

SUNDAY 18 JULY 1965

BILL WEST WAS THE STAGE DIRECTOR FOR the Rank Organisation, a company which owned the hundreds of Odeon and Gaumont cinemas throughout Britain. This privileged position allowed him access to the acts which played the Rank venues, and he took advantage of this when the Rolling Stones played the Gaumont, Bournemouth, by having his 8mm home movie camera at hand. Clearly he had a special entrée to the group in as much as the rare footage shown on the following pages was actually shot in the Stones' suite at the Palace Court Hotel the afternoon prior to the gig. Bill Wyman is to the left of Bill West, Keith is photographing Charlie Watts, and a crowd of young girl fans are waiting outside the hotel.

I purchased this historical document at Bonham's auctioneers. The vendor and original owner of the film was Bill's daughter Gillie (now Gillie Coghlan, married to the original Status Quo drummer John Coghlan). Gillie was probably a much-envied girl at school, given that her father could get her into any concert she wanted to attend.

The concert that night also featured Tommy Quickly, a Brian Epstein signing who never quite made it like some of his fellow Liverpudlians, the Steam Packet, which included Long John Baldry and a young Rod Stewart on vocals, leading R&B veterans John Mayall's Bluesbreakers, Decca Records' pop starlet Twinkle, and a hastily added name on the bill, the Paramounts.

Keith opened the Rolling Stones set with his vocals for 'She Said Yeah', which was followed by 'Mercy Mercy', 'Cry To Me', and 'The Last Time'. Brian Jones then put his guitar down to play organ on 'That's How Strong My Love Is', laughing every time the spotlight found him on stage. 'I'm Movin' On' came next with Mick and Keith holding the spotlight and Mick almost doing the splits, then it was 'Talkin' About You', 'Good Thing Going', ending with 'Satisfaction'.

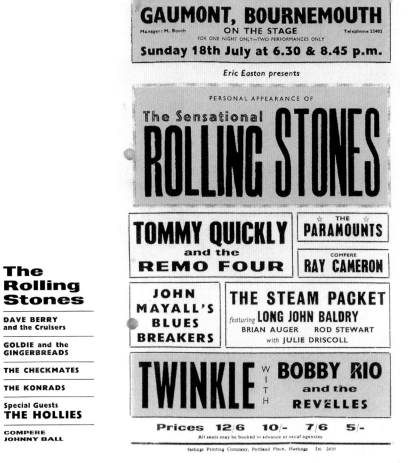

GAUMONT, BOURNEMOUTH

Manager: M. Booth
ON THE STAGE
Telephone 21402

FOR ONE NIGHT ONLY—TWO PERFORMANCES ONLY

Sunday 18th July at 6.30 & 8.45 p.m.

Eric Easton presents

PERSONAL APPEARANCE OF

The Sensational ROLLING STONES

TOMMY QUICKLY and the **REMO FOUR**

☆ THE ☆ **PARAMOUNTS**

COMPERE **RAY CAMERON**

JOHN MAYALL'S BLUES BREAKERS

THE STEAM PACKET *featuring* **LONG JOHN BALDRY**
BRIAN AUGER ROD STEWART
with JULIE DRISCOLL

TWINKLE W I T H **BOBBY RIO** and the **REVELLES**

Prices 12/6 10/- 7/6 5/-

All seats may be booked in advance at usual agencies

Hastings Printing Company, Portland Place, Hastings Tel 2450

ERIC EASTON
PRESENTS

The Rolling Stones

DAVE BERRY
and the Cruisers

GOLDIE and the
GINGERBREADS

THE CHECKMATES

THE KONRADS

Special Guests
THE HOLLIES

COMPERE
JOHNNY BALL

ERIC EASTON presents
THE SENSATIONAL
ROLLING STONES

YOUR ONLY OPPORTUNITY TO SEE THE STONES IN PERSON BEFORE SPRING 1966

THE CHECKMATES : RAY CAMERON

SPENCER DAVIS GROUP : THE END

CHARLES DICKENS and THE HABITS

UNIT FOUR + 2

ASTORIA - Finsbury Park
Manager: W. L. WEBB
Telephone ARChway 2224

Friday. 24th September at 6.40 & 9.10
PRICES 12/6 10/6 8/6 6/6 4/6

Two Performances
ON THE STAGE
One Night Only

BOOK NOW

POSTAL BOOKING FORM
Rolling Stones Show
Friday, 24th September

Date

Please forward SEATS: 12/6 10/6 8/6 6/6 4/6
for the EVENING 6.40/9.10 performance on (Block letters, please)
I enclose stamped addressed envelope and P.O. Cheque value £ d

NAME ..

ADDRESS Use this form if inconvenient to call. The best available seats will be allotted to you

BOX OFFICE
ASTORIA
FINSBURY PARK

Hastings Printing Co., Portland Place, Hastings. Tel. : 2450.

ABOVE: The Bournemouth concert (top right) was part of a five date mini-tour. The Stones had already toured the UK earlier in the year, with a bill that included Manchester's Hollies and the US all-girl band Goldie and the Gingerbreads (programme top left), and would do so again in the Autumn when the main support would be the Spencer Davis Group (above).

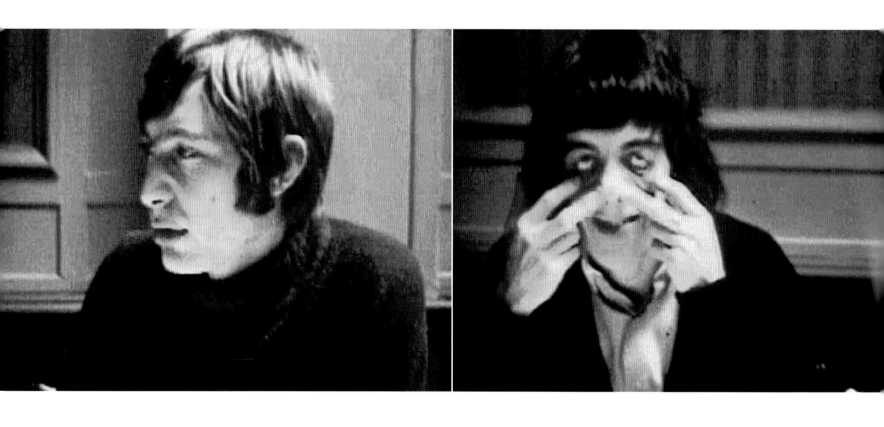

ABOVE AND FOLLOWING PAGES: Screen grabs from Bill West's home movie. Bill used to like jazz,
which was music to Charlie Watts' (far left) ears. Over the years, they went on to see many jazz artists together at
Ronnie Scott's club, before Bill died.

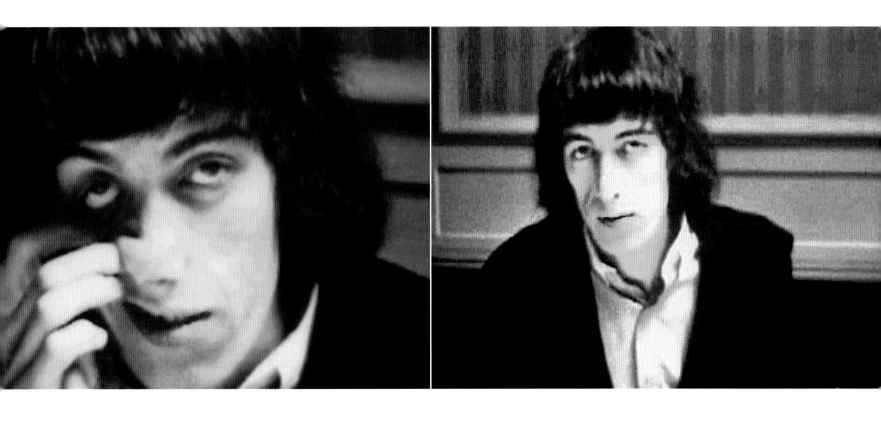

PALACE BALLROOM, DOUGLAS, THE ISLE OF MAN
WEDNESDAY 8 SEPTEMBER 1965

I WAS WORKING AT AN AUCTION HOUSE specialising in pop memorabilia, Cooper Owen, based in Egham, Surrey, when I received a letter from Irene Holmes in Liverpool. Irene claimed to have many great photographs from the 1960s taken in the Merseyside area featuring the Beatles and others. The next day I travelled by train to Liverpool to meet Irene, who it transpired was originally married to the photographer Graham Spencer. By this time she had remarried Joe Holmes, a retired businessman.

Upon my arrival, the couple brought out a cardboard box full of photographs, many unidentified. Three hours and several cups of tea later, having gone through the entire contents labelling up the artists featured in the negatives, my work was done. Irene and Joe agreed to sell the negatives with copyright at auction, and Cooper Owen featured the negatives in a sale of pop memorabilia where I purchased these great shots.

These fantastic photographs of the Rolling Stones in the Isle of Man, a small 'tax haven' island west of Liverpool in the Irish Sea, were produced as a set of twenty-five 2.5 x 2.5 inch black-and-white negatives, rolled up. Other artists featured in Graham Spencer's collection included the Zombies, the Kinks, and the Beatles, to name but a few.

'At that time we had only just met, and, other than recalling that he had an horrendous flight in a thunderstorm to the Isle of Man, there is really nothing else I can remember about that particular trip.

'Graham was a professional photographer with a studio based in South Liverpool. During those early days it was quite common for all sorts of up-and-coming pop stars to call in for their "studio shots" for handout purposes. Whenever we bump into some of the old-time singers today, they all seem to recall

with fondness those days of dropping in for pics. Graham was an outgoing, full-of-life person. Photography was his life; he ate, slept and drank photography, covering all aspects of social, commercial and press photography. There can't be many people who would grab their camera and give chase after a fire engine – whilst on honeymoon in North Wales! He was certainly a born photographer.

'Above his Childwall Fiveways [a famous local road junction] shop he made the boldest of banner claims, "Liverpool's leading photographer". And it's true to say that the statement was not over-egged. He was one of the best, technically and artistically, of his day. He was well respected by fellow photographers and journalists alike. He had the knack of producing wedding photographs which the customer was delighted with, and while wearing a different hat, he could produce pictures for regional newspapers which editors were more than satisfied with.

'He did not have an agent. As far as I can recall he used Rolleiflex, Hasselblad and 35mm cameras. We were married in late 1966 and had two children, a boy in 1970 and a girl in 1974. He died at the age of 42 in 1983.'

Irene Holmes

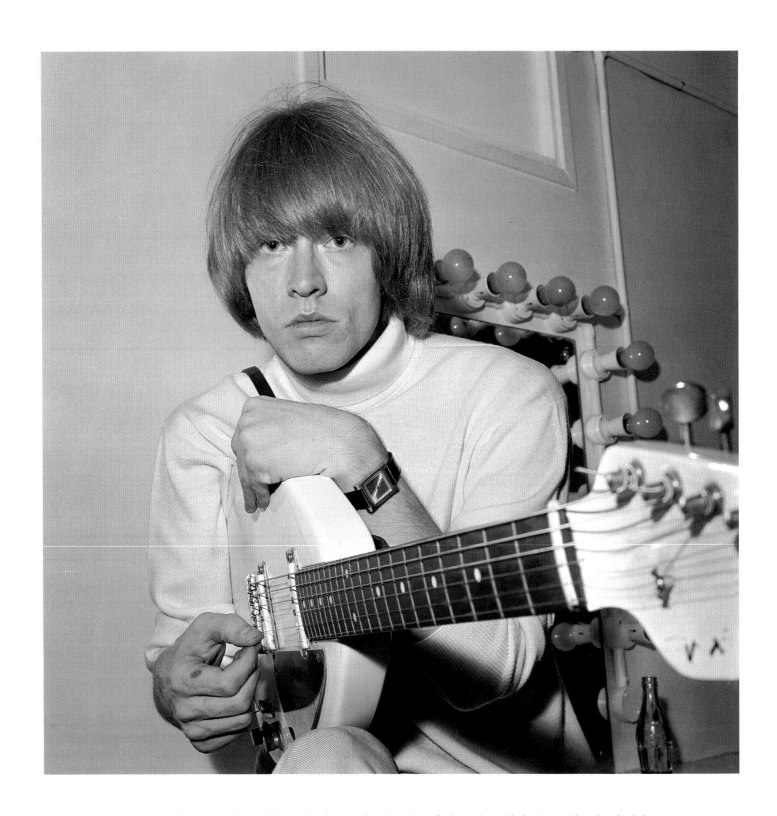

ABOVE: Brian in the Palace Ballroom band room, showing signs of exhaustion with the Stones' hectic schedule, which never seemed to let up.

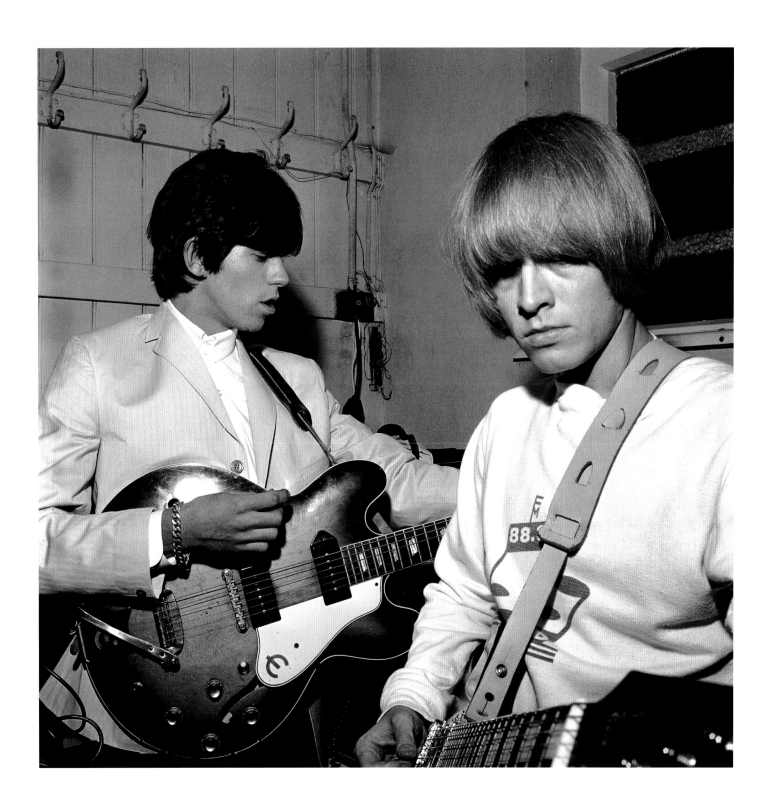

ABOVE: A quiet moment as Keith and Brian tune up before the Stones' Isle of Man appearance.

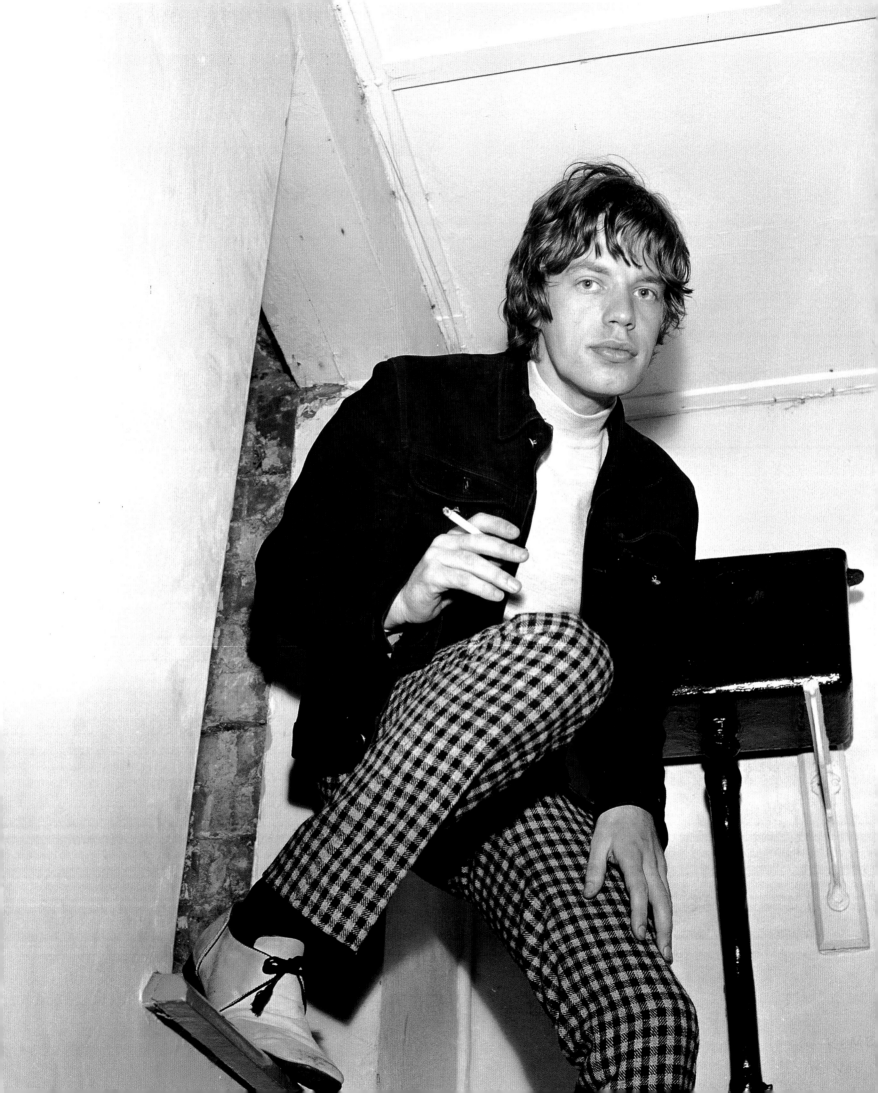

WESTERN UNION INTERNATIONAL INC. F 301

CABLEGRAM 13 AM 12 53
DB CXC

RECEIVED AT 22 GREAT WINCHESTER STREET, E.C.2. (LONdon WALL 1234)

PC196 P NA568 31 INTL FR=

NEW YORK NY 12 734P EDT=

CXC

ERIC EASTON= 42

1 LITTLEARGYLE ST

LONDONW1 (ENGLAND VIA WUI)=

=IT IS IMPOSSIBLE TO DO ISLE OF MANN ON 8 WE NEED RECORD

MUST RECORD BETWEEN 5TH AND 10TH CANCEL DATE=

MICK KEITH AND ANDY=

ABOVE: The Isle of Man date was the concert that nearly never was. The Stones had played Dublin and Belfast, recorded in Los Angeles, and returned to London, all in the previous four days. They asked for the date to be cancelled as they also wanted to record, and sent manager Eric Easton a cable from the States to that effect, but the contract had been signed.

OVERLEAF: Despite looking, and feeling, exhausted, the Stones still turned in an energetic performance.

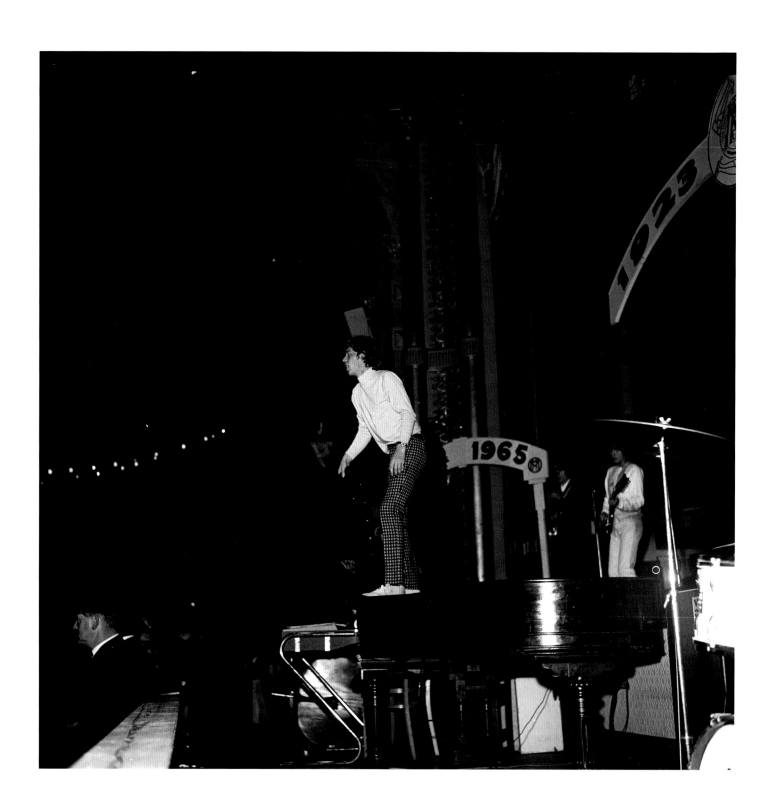

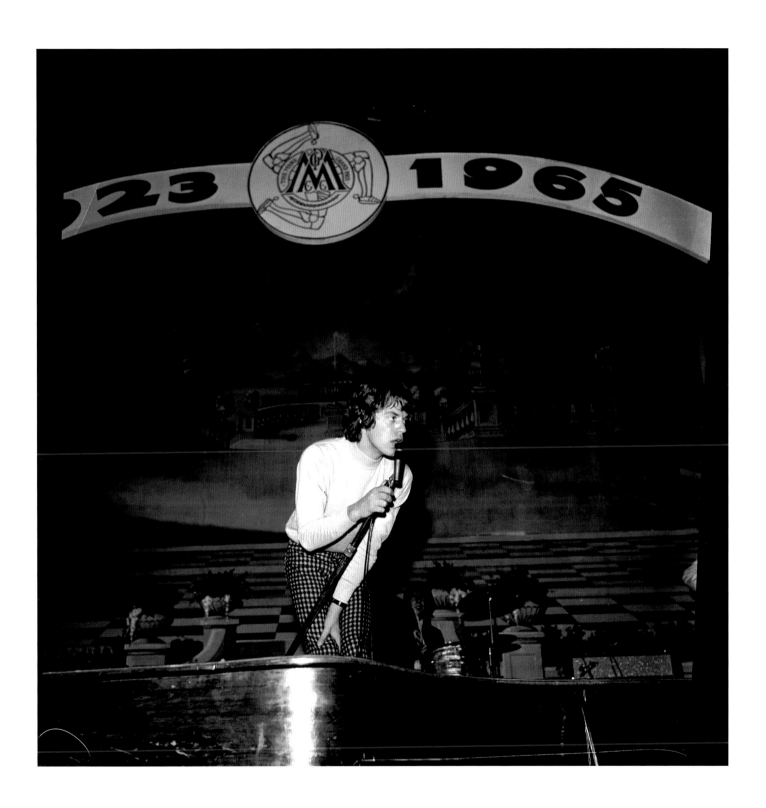

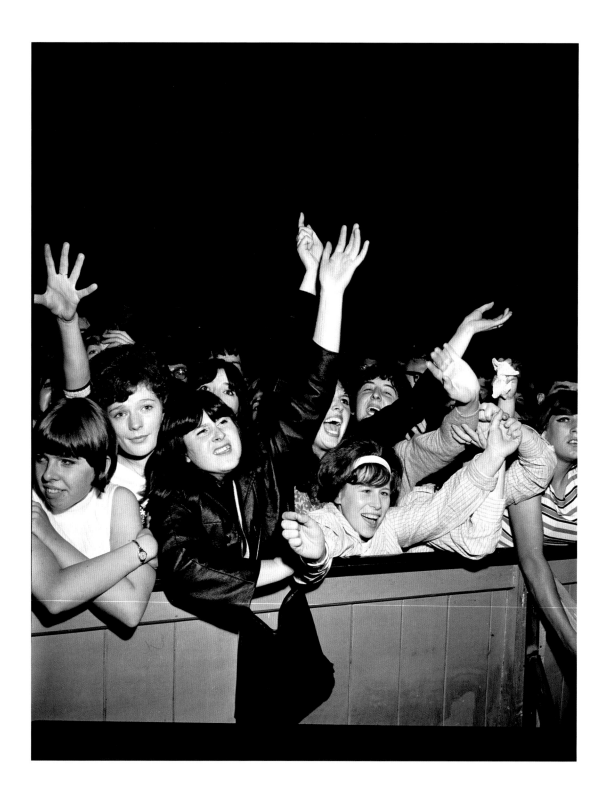

'I suppose anyone who saw a photograph of the audience would have thought it complete hell, but it's difficult to explain an atmosphere which drives you to scream and yell when you originally went to listen...'

'...Perhaps it's 'cos I don't really understand it myself – it just didn't seem to be me that was hollering

like that.' A fan recalling the Isle of Man concert in the monthly *Rolling Stones Book*.

ROYAL ALBERT HALL, KENSINGTON GORE, LONDON
FRIDAY 23 SEPTEMBER 1966

THE ROYAL ALBERT HALL IN 1966 WAS (AND STILL IS) one of the most prestigious venues in the United Kingdom, making the first night of a Stones tour one of the social events of the year. Tito Burns of the Harold Davison organisation had announced the full itinerary of the Rolling Stones' twelve-date concert tour featuring the Yardbirds and Ike and Tina Turner on 22 July 1966. American rhythm and blues stars Ike and Tina – wrongly described in the *NME* as a brother and sister duo – had been added to the bill after a request from the Stones via their manager Andrew Loog Oldham.

The UK press announced that the concert was being recorded for an album. During the show the band were to be presented with twenty gold discs, four for each member, for sales worth more than a million dollars on each album. The presentation, by Decca executive William Townsley, was eventually postponed until the after-show party that was to be filmed for BBC's *Top Of The Pops*. Film director Peter Whitehead, who was already well known to the band after his work on their 1965 Irish tour, culminating in the yet-to-be-released movie *Charlie Is My Darling*, got a request from Mick Jagger to film the event for *Top Of The Pops*. Whitehead, realising he couldn't film and take photographs, invited his friend Anthony Stern to come along at lunchtime and start photographing the band rehearsing, backstage, on stage, and at the party in the Kensington Hilton afterwards.

' *Peter Jay and the New Jaywalkers featured an 18-year-old Terry Reid (who was to be Led Zeppelin's front man but lost out in the last minute to Robert Plant). The Yardbirds with Jeff Beck were first on, playing "Shape of Things" and "Over Under Sideways Down", but for the most part Beck's guitar drowned out the vocals. Next up, the Ike and Tina Turner Revue opened with the Otis Redding number, "Can't Turn You Loose" and Sam and Daves' "Hold On I'm Coming", while the three gorgeous Ikettes danced on stage. Tina then appeared in a blue figure-hugging dress, opening with "Shake" then*

"It's Gonna Work Out Fine", finishing off with their Phil Spector-produced hit "River Deep, Mountain High".'

Anthony Stern

The minute the Stones appeared on stage after the interval, all the rehearsals went out of the window as hundreds of screaming girls pushed their way past the security guards in the front row of the stalls, jumping up on to the platform stage. Keith was knocked to the ground, Mick was almost strangled as seen in the video footage shown on *Top Of The Pops*, Bill and Brian ran for backstage, while Charlie, the cool one, sat and watched from his drum kit. Tito Burns, the Troggs' manager Larry Page, the Stones' publicist Les Perrin, and Andrew Loog Oldham all rushed forward from the back of the stage to help the stewards restore order. It was announced that unless everyone returned to their seats the show would be cancelled. The stage was cleared, the fans went back to their seats, and the Stones returned.

Anthony, now with a career as a glass blower behind him, cannot remember too much else from the concert other than to say it was the 1960s and everything was a lot looser then. He was paid by Lorimer Films to take the stills while Whitehead made his 16mm *Top Of The Pops* promotional film – such 'promo films' being the precursor to today's pop videos.

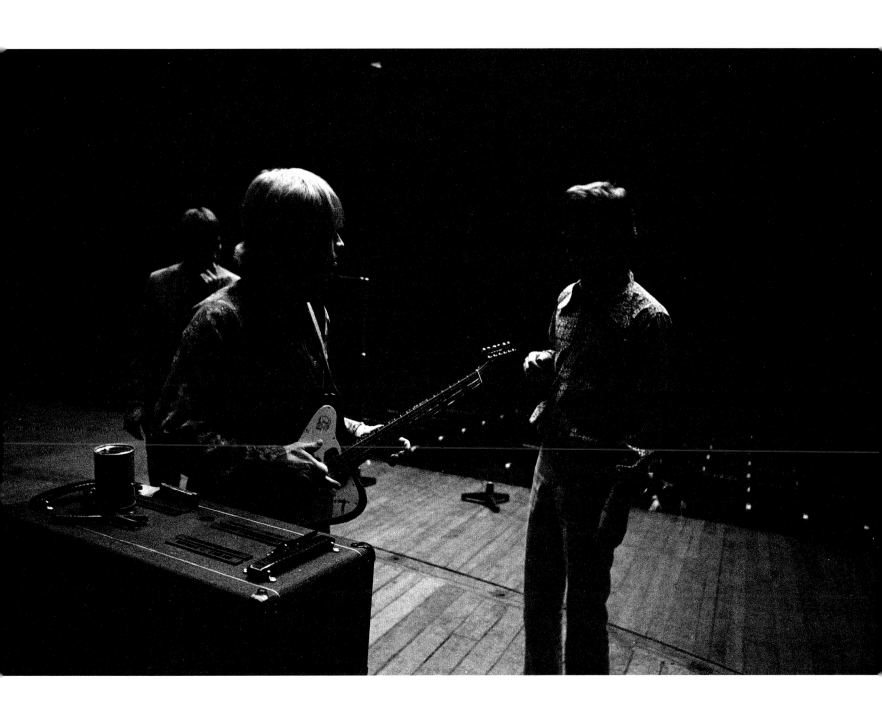

ABOVE: The Stones on the stage of the Albert Hall during the afternoon rehearsals in which they played
through 'Under My Thumb', 'Get Off My Cloud', and 'Lady Jane', among other numbers.
OPPOSITE, TOP: Filmmaker Peter Whitehead outside the Royal Albert Hall.
OPPOSITE, BOTTOM: Photographer Anthony Stern in his studio.

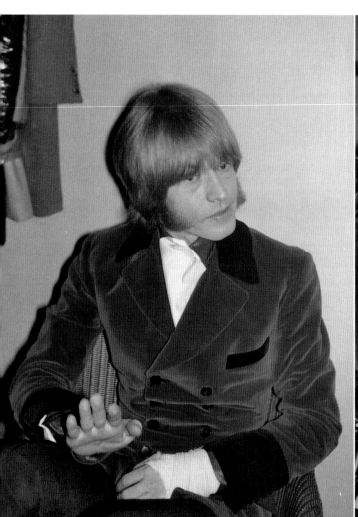

ABOVE AND OPPOSITE: These colour pictures (and the one of Keith on page 103) were taken by the Stones'
friend from Rome, Ronnie Thorpe. The picture of Bill Wyman is the same one he is seen signing during
the Stones' visit to the Piper Club in Rome, shown on page 128.
Backstage at the Albert Hall, a piano, chairs, cigarettes, and cups of tea were supplied as per the rider on the
Stones' contract – a modest request compared to bandroom demands later in their career.

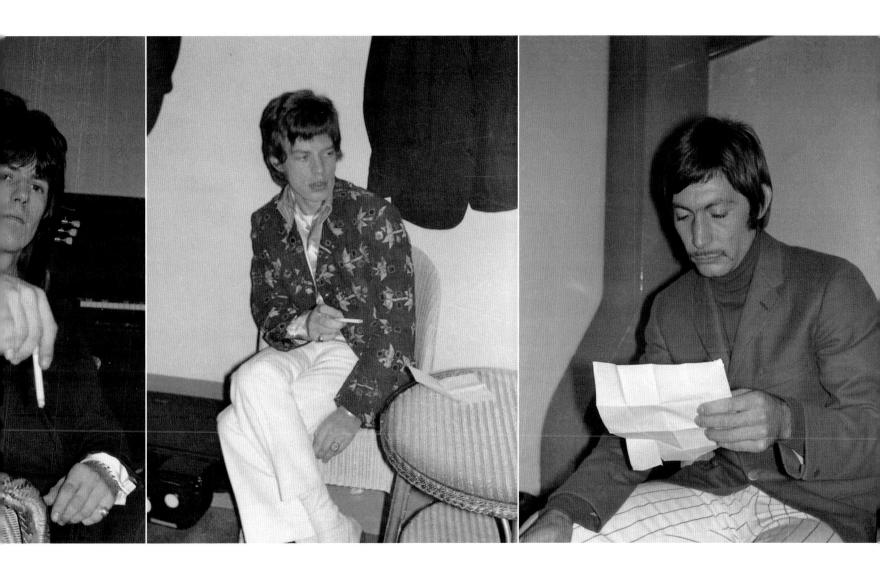

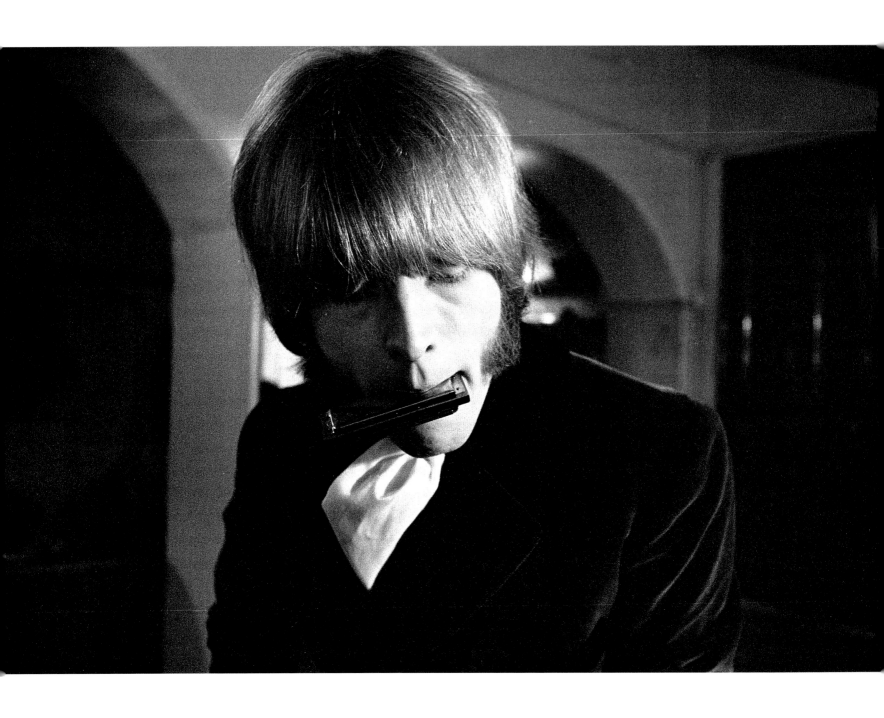

ABOVE AND OPPOSITE: Brian Jones tunes up pre-performance. His left hand can be seen wrapped in bandages after a climbing accident in Tangiers two months earlier. The plaster cast was removed by his doctor on 8 September, revealing less damage than anticipated.

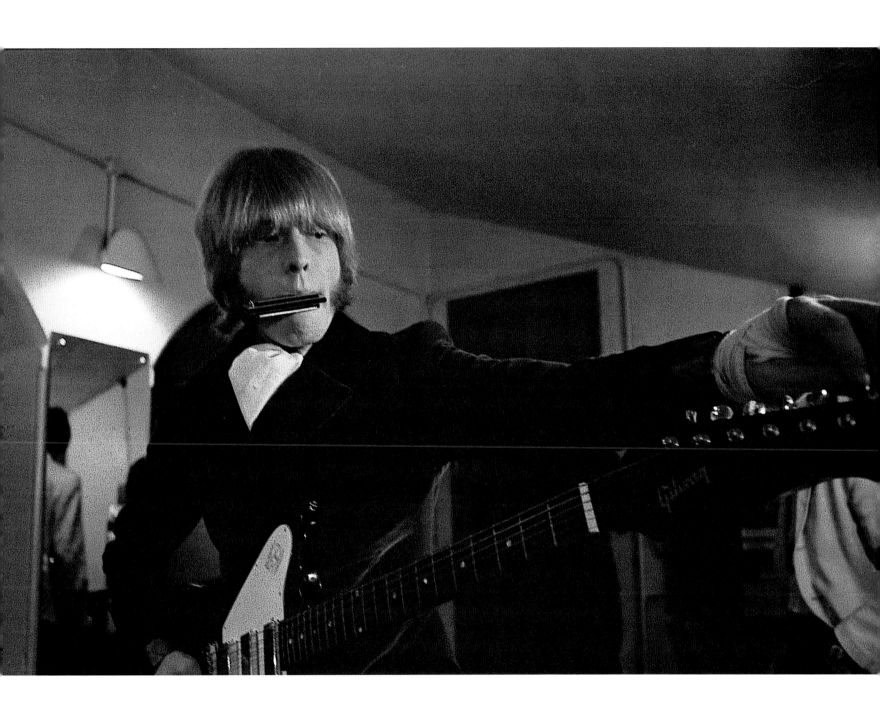

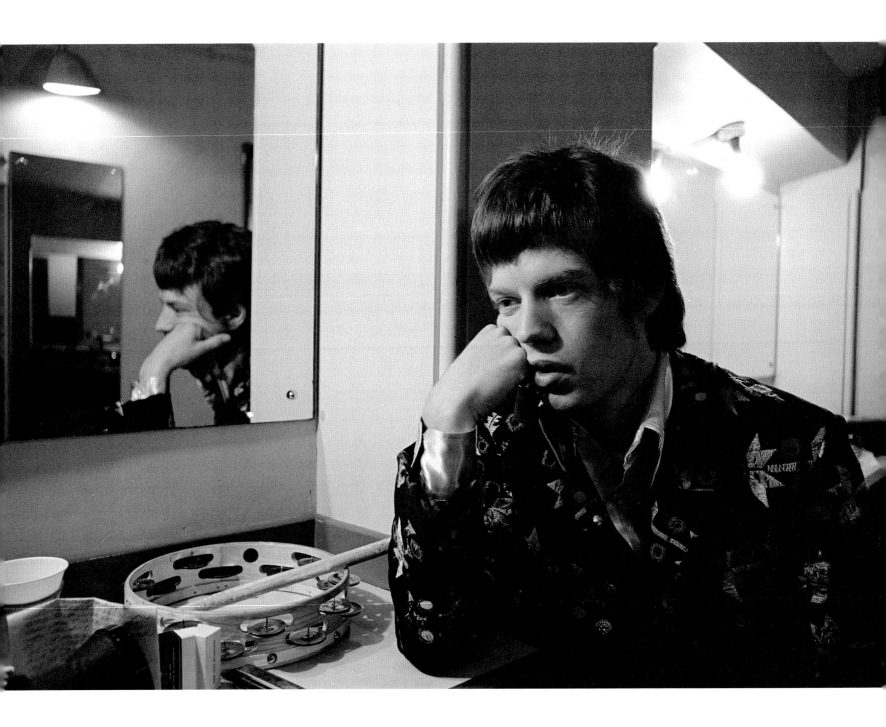

ABOVE AND OPPOSITE: Mick and Keith in the bandroom.

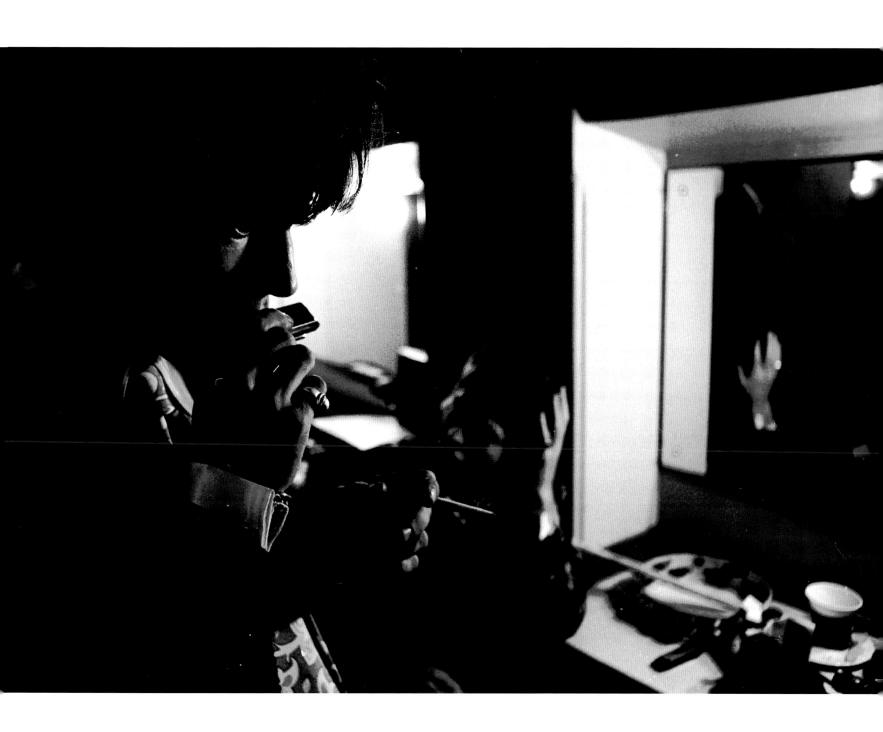

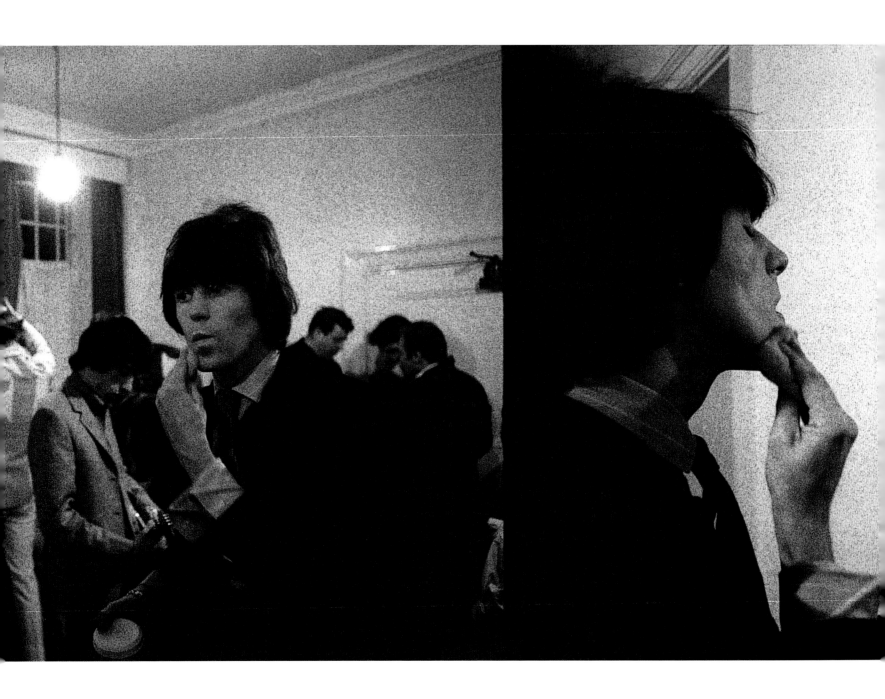

ABOVE: Keith and Brian in the bandroom.

OPPOSITE: Keith touches up his makeup in the bandroom.

FOLLOWING PAGES: Mick on stage.

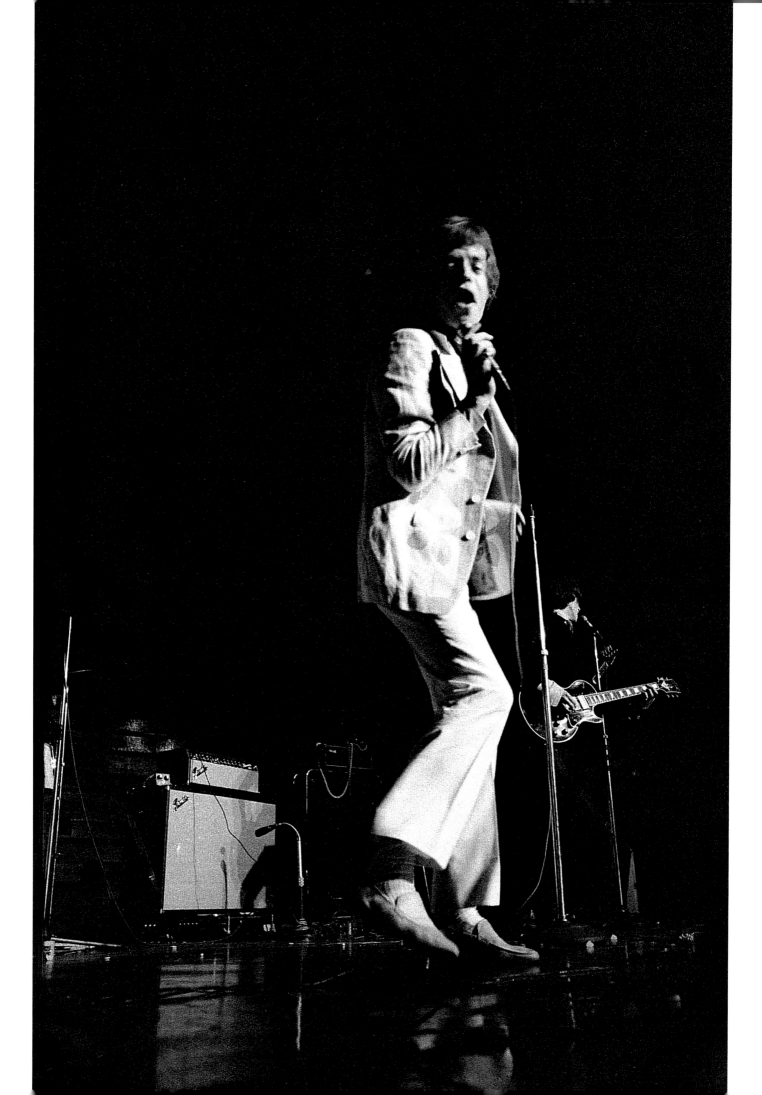

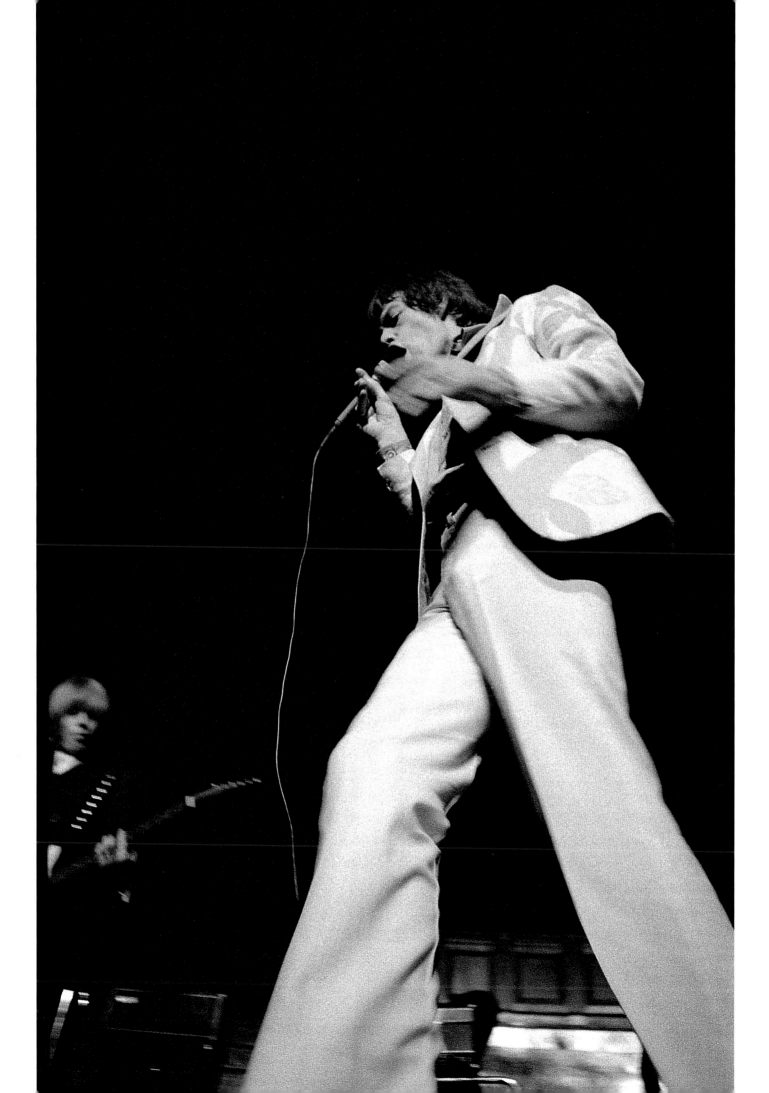

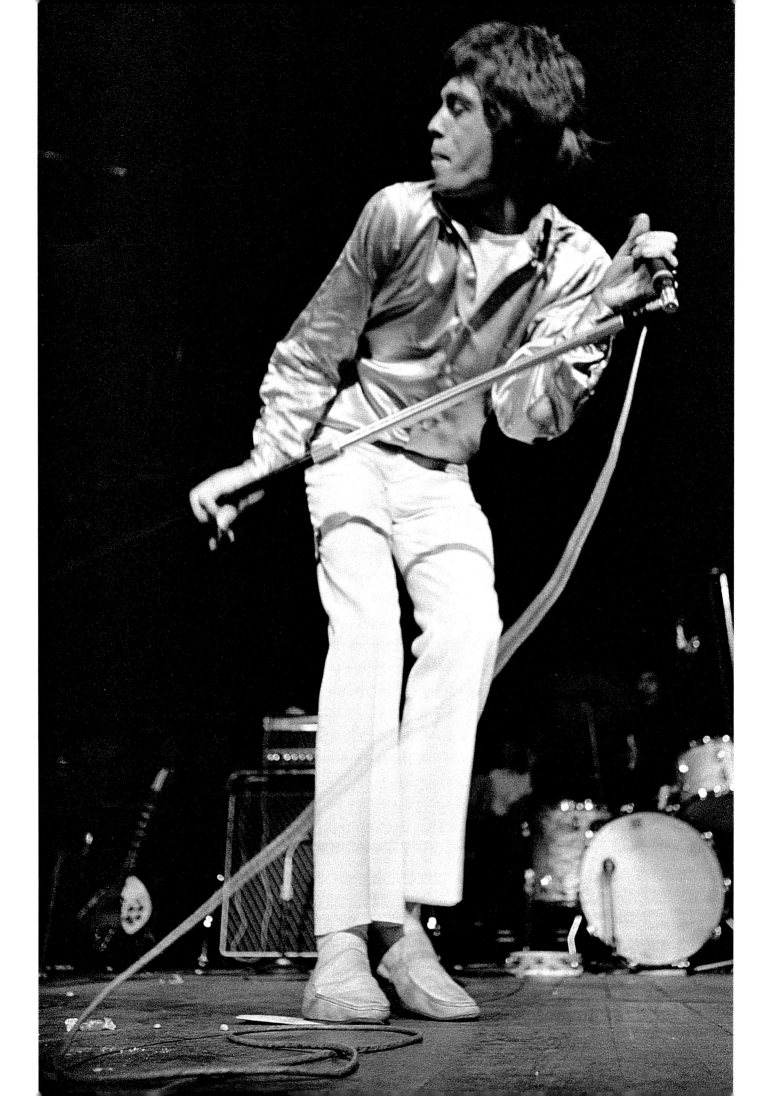

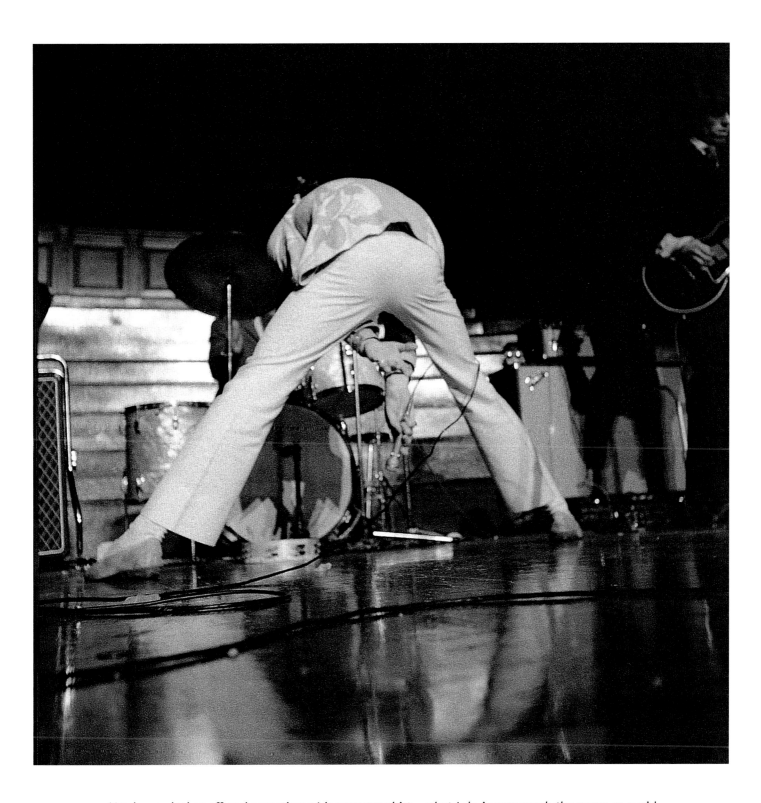

'I take my jacket off and sometimes I loosen my shirt – what I do is very much the same as a girl striptease dancer.' Mick Jagger, *Sunday People,* 9 October 1966

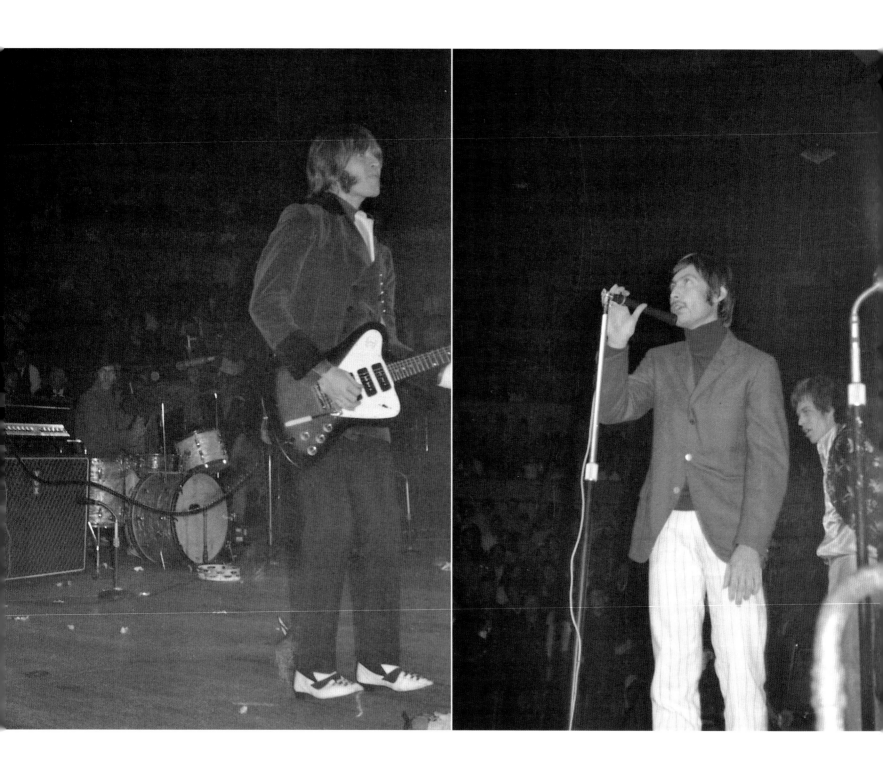

ABOVE: The set started with 'Paint It Black', followed by 'Under My Thumb' then 'Get Off My Cloud'. Charlie then walked to the front of the stage to announce '"Lady Jane" featuring Brian Jones on electric zither' before returning to his drum kit.

OPPOSITE, TOP: The 'electric zither' Charlie referred to was actually Brian playing a dulcimer.

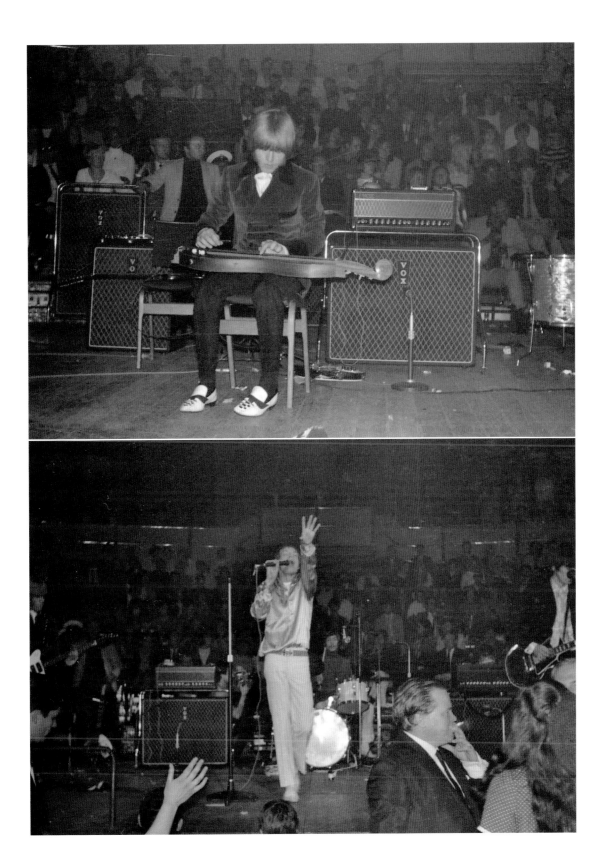

AWARD CEREMONY, KENSINGTON HILTON
FRIDAY 23 SEPTEMBER 1966

AFTER THE ALBERT HALL CONCERT the Stones and guests – including John Entwistle and Keith Moon of the Who; ex-Yardbird Paul Samwell Smith; Vicki Wickham and Cathy McGowan, director and presenter respectively from *Ready Steady Go!*; the *Top Of The Pops* presenter Alan Freeman; songwriter Lionel Bart; and Paul McCartney – crossed over the road to the Kensington Palace Hotel, where the band were to be given a total of twenty gold discs for sales in America (four gold discs to each member) presented by the Decca Records executive William Townsley. Originally planned to be staged at the concert, the presentation was moved when it was decided the hotel was a better – and, in the light of the audience mayhem, safer – option. After the presentation party, the Stones went on to the trendy 1960s nightspot, the Scotch of St James.

ABOVE: The poster for the 'Rolling Stones 66' tour, also visible in the background opposite.

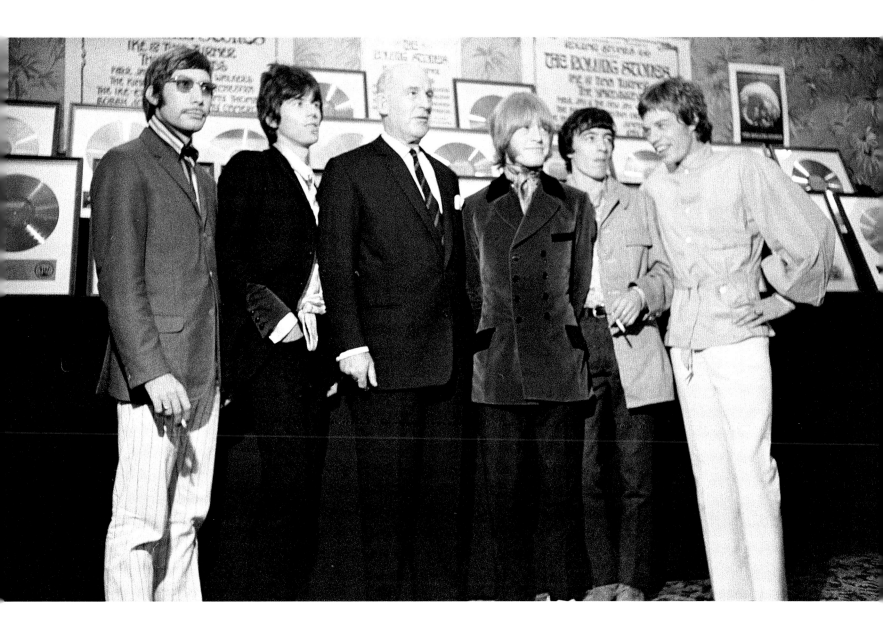

ABOVE: Decca Records boss William Townsley flanked by a triumphant Rolling Stones.

HOTEL ES SAADI, MARRAKESH, MOROCCO
WEDNESDAY 15 MARCH 1967

ON SATURDAY 11 MARCH 1967 Mick, Brian, and Anita Pallenberg flew to Tangier to join Keith Richards and his chauffeur Tom Keylock at the El Minzah hotel, where they had met up with a partying crowd that included photographer Michael Cooper and gallery owner Robert Fraser. Then the whole gang drove down to Marrakesh to continue their drug-fuelled holiday at the Hotel Es Saadi. It was here, on Tuesday 14 March, that they first met the eminent society photographer Cecil Beaton, who found the hedonistic youngsters fascinating (for an evening at least), particularly Mick Jagger. The next morning he took these pictures of the three Stones lounging around outside the hotel.

'At 11 o' clock he [Mick] appeared at the swimming pool. I could not believe this was the same person walking towards us, and yet I knew it was an aspect of him. The sun, very strong, was reflected from the white ground and made his face a white, podgy, shapeless mess, eyes very small, nose very pink and spreading, hair sandy dark. He wore Chanel Bois de Rose. His figure, his hands and arms were incredibly feminine. He looked like a self-conscious suburban young lady. All morning he looked awful. The reflected light is very bad for him and he isn't good at the beginning of a day. The others were willing only to talk in spasms. No one could make up their minds what to do or when. A lot of good humour. I took Mick through the trees to an open space to photograph him in the midday sun, thus giving his face the shadows it needs. He was a Tarzan of Piero di Cosima. Lips of a fantastic roundness, body white and almost hairless. He is sexy, yet completely sexless. He could nearly be a eunuch. As a model he is a natural.'

Cecil Beaton, from *Beaton in the Sixties* (2003)

ABOVE: A self-portrait by Cecil Beaton during his brief sojourn with the Stones in Marrakesh.

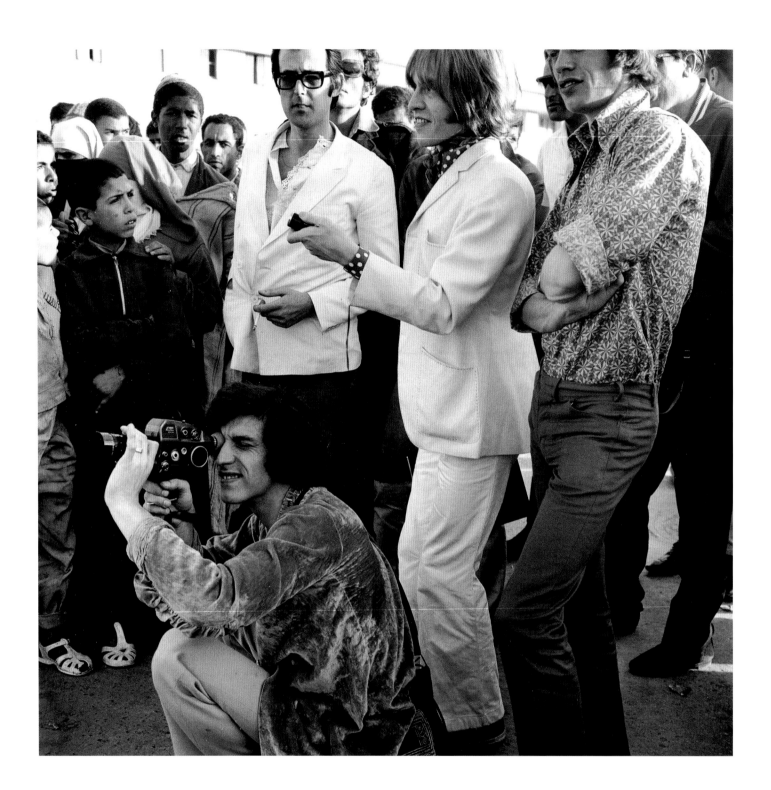

ABOVE: Brian (with microphone) and Mick, watching musicians perform in the streets of Marrakesh.

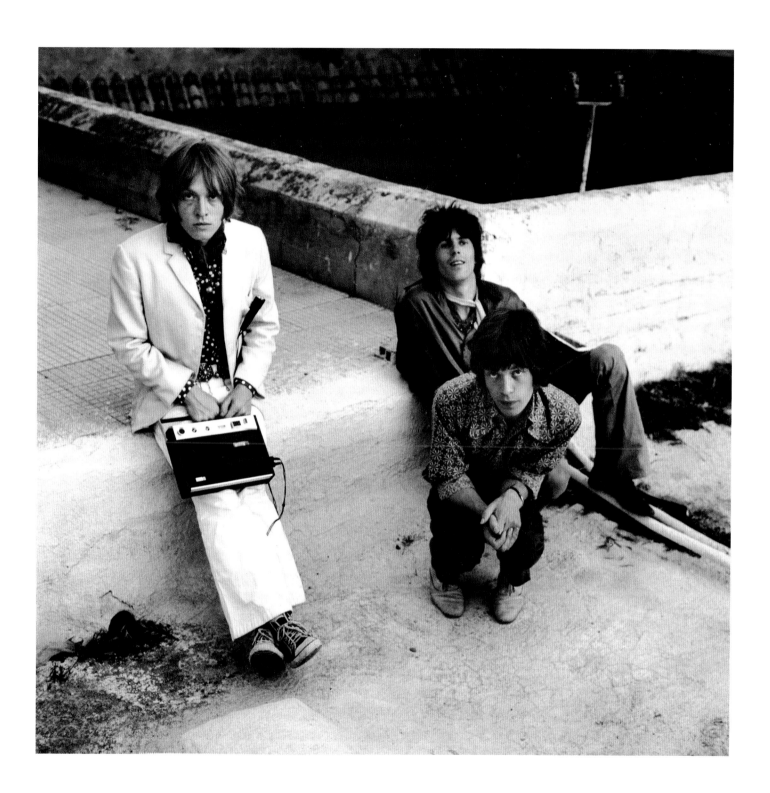

ABOVE: Brian spent much of his time in Morocco with his portable tape machine, recording local musicians, as he became increasingly interested in North African and Eastern music.

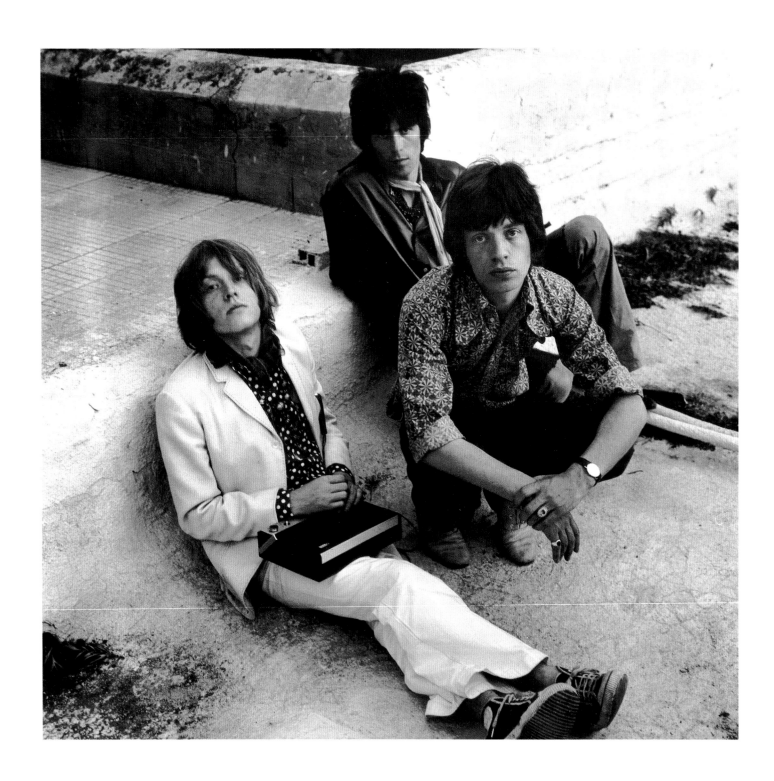

ABOVE: Brian, Keith, and Mick in the grounds of the Hotel Es Saadi.

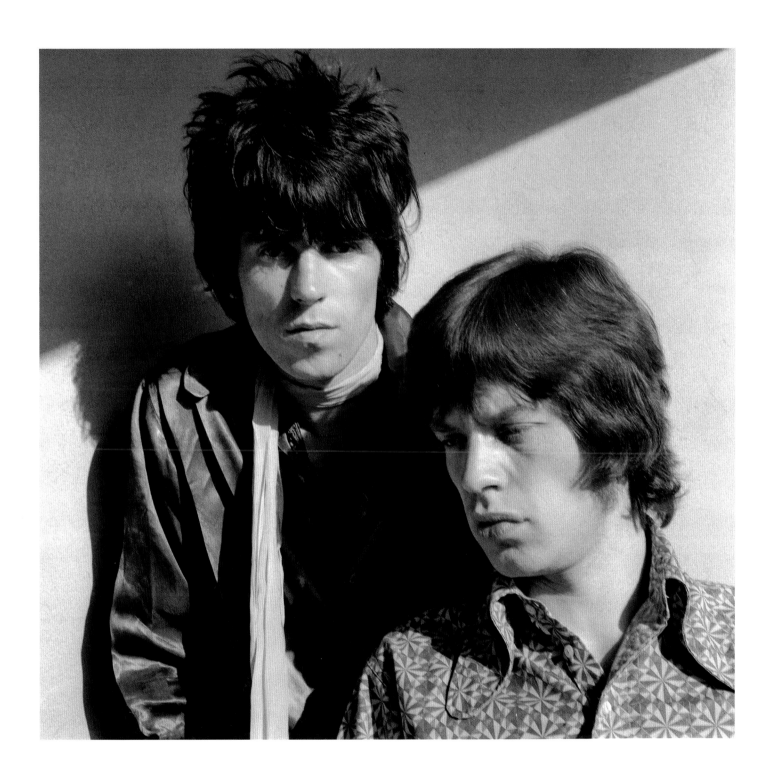

ABOVE: Beaton's seemingly casual mastery of portraiture is evident in this study of Keith and Mick.

GEORGE HARRISON'S HOUSE, ESHER, SURREY

MARCH 1967

ON A CLOUDY DAY IN MARCH 1967 these rare photographs were taken with a Nikon camera with a fish-eye lens attached. They feature Brian Jones with his girlfriend Anita Pallenberg standing by George Harrison's swimming pool at the Beatle's home in Esher, Surrey. Just a half-hour's drive south of London, Esher was *the* place to live for pop stars and other successful entertainers in the 1960s.

George, who lived there with his wife Patti Boyd, can be seen in the foreground of the first picture (opposite) reaching for the camera, with Jones and Pallenberg in the background.

Overleaf, the shot on the left is of the Rolling Stone and Anita by the poolside, Harrison's shirt can just be detected in the bottom right-hand corner. The picture on the right, just of Brian Jones, includes a white cat on the diving board.

These photographs are the only pictures that I know of featuring Brian by a swimming pool – he would die in his own pool only two years later. They are also the last photographs of Brian with Anita as his girlfriend, before she started to date Keith Richards. I purchased them at Sotheby's in New Bond Street, London, in the early 1990s. This was before Sotheby's decided to stop selling rock and pop memorabilia, following the departure of their expert in the field, Hilary Kay, who went on to evaluate items on BBC Television's *Antiques Road Show*.

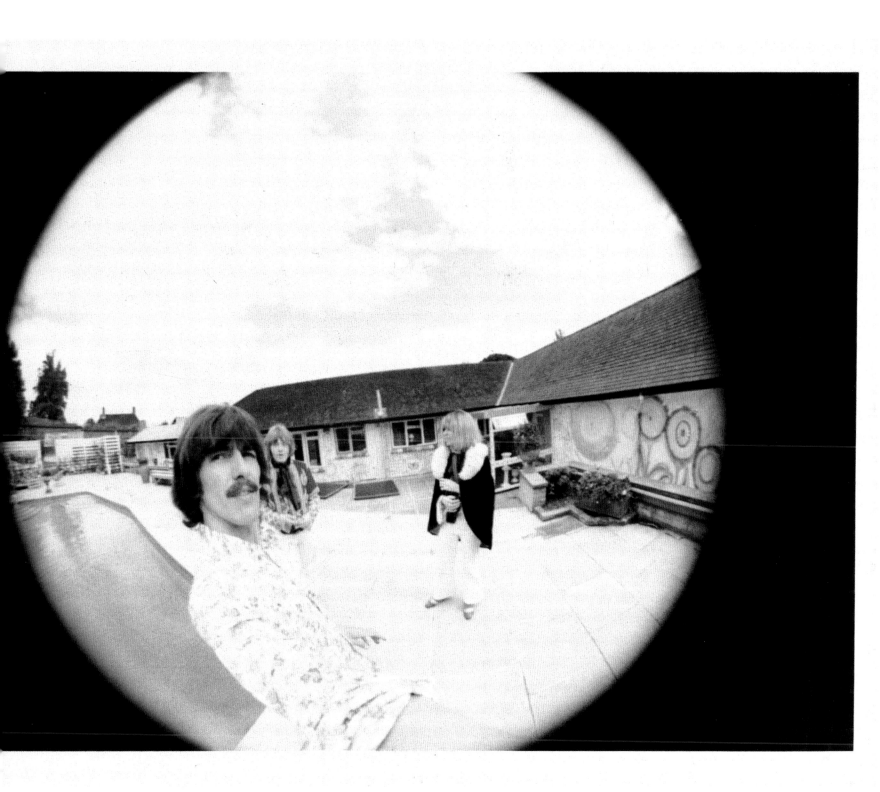

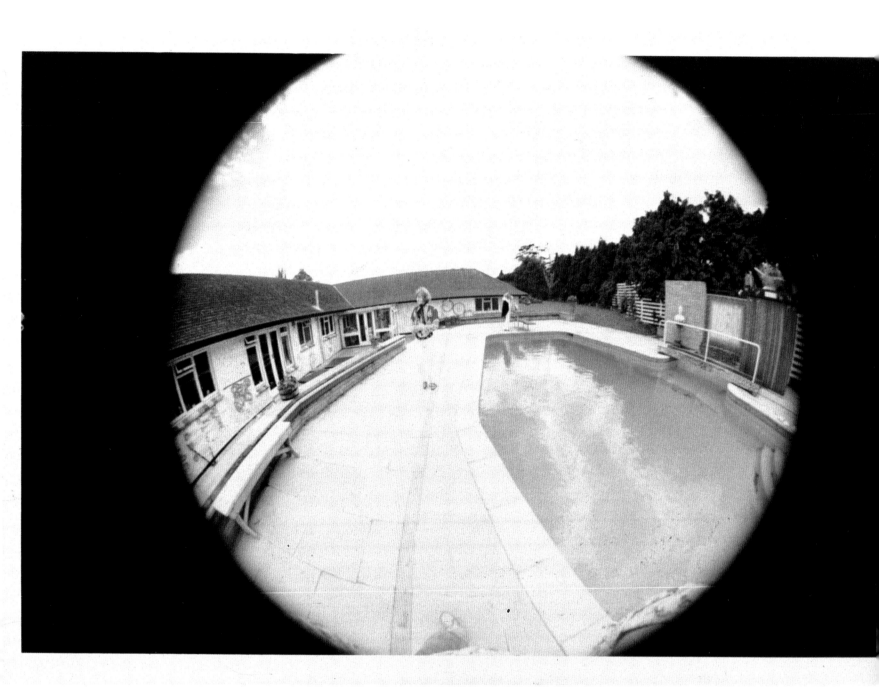

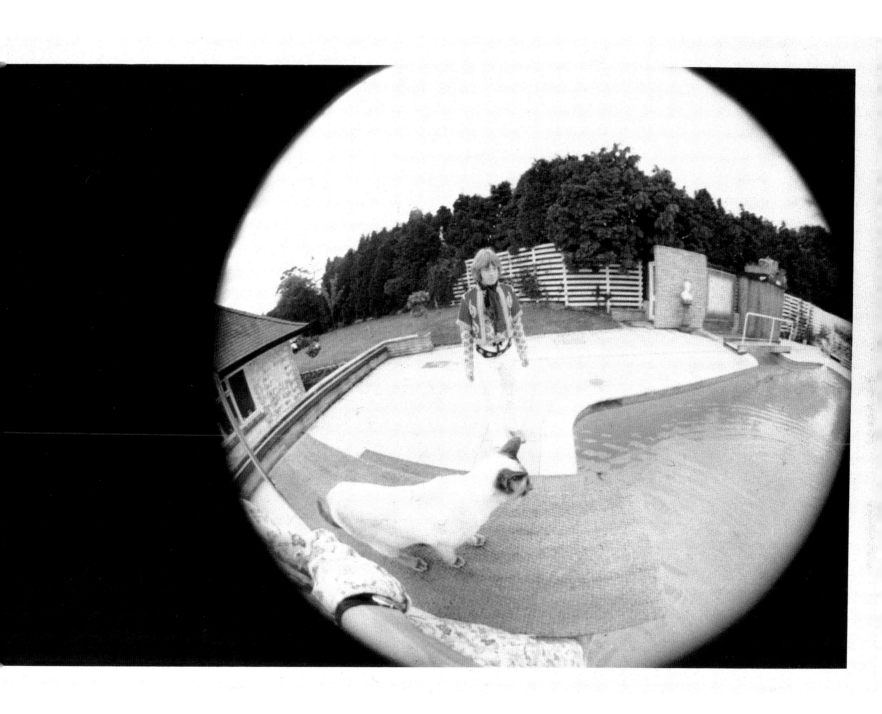

ROME, ITALY
THURSDAY 6–7 APRIL 1967

THESE FASCINATING PHOTOGRAPHS OF THE STONES on a day off in Rome were taken by Ronnie Thorpe, a guitar player with the Italian band Noise. The Noise were regulars at Rome's famed Piper Club, supporting bands like Spencer Davis, Pink Floyd, and the Small Faces. Many felt Ronnie was a much better photographer than a guitarist.

The Stones were on a sixteen-date European tour, which had started in Sweden on 25 March. On 5 April they flew to Italy to play two shows at the Palazzo Dello Sport in Bologna, then the following day they flew to Rome, where they played another two-concert gig at that city's Palazzo Dello Sport.

After a riotous performance – where the police foiled an attempt by 200 fans to storm the band's dressing room after the show, with one youngster being injured in the process – the Stones repaired to the Piper Club with their friend Prince Stanislaus 'Stash' Klossowski de Rola. Stash, singing with Noise at the time, was a flamboyant character on the trendy London scene who had residences worldwide, including a castle just north of Rome.

The next day, before flying on to Milan for a gig the following day, Charlie Watts went sightseeing in Rome with his friends from the Noise, visiting the Coliseum, St Peter's, the Forum, and other landmarks. That same evening, Bill and Brian returned to the Piper Club, where they are seen here relaxing with Prince Stash and others.

Ronnie Thorpe caught all of the main rock acts when they visited Rome, including of course the Stones. Ronnie sold his negatives and prints at Christie's – where I acquired them in the early nineties – including some great Hendrix colour backstage photos and Cream at Windsor pop festival, which I also purchased. A mutual friend, Alex Locchi, claims that Ronnie still has copies of all the negatives he sold at the auction, but had sold any interesting memorabilia except for a massive collection of tickets of all the Italian concerts.

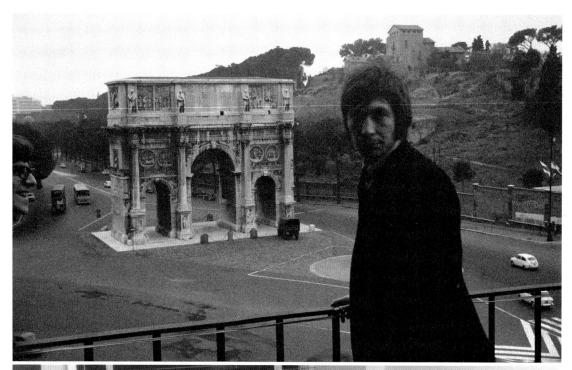

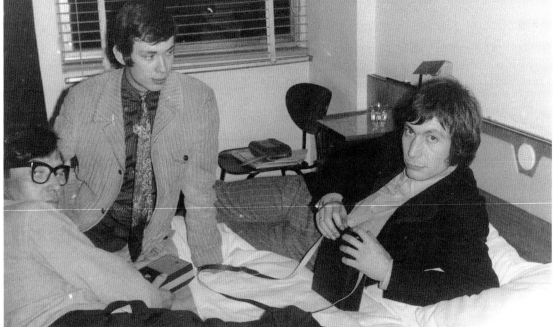

TOP: Charlie overlooks the Arch of Constantine during his sightseeing trip around Rome.
ABOVE: Relaxing in his hotel room, Charlie with Stones' chauffeur Tom Keylock (left) and Noise guitarist Ronnie Thorpe.
OPPOSITE: In front of St Peter's Basilica in the Vatican.

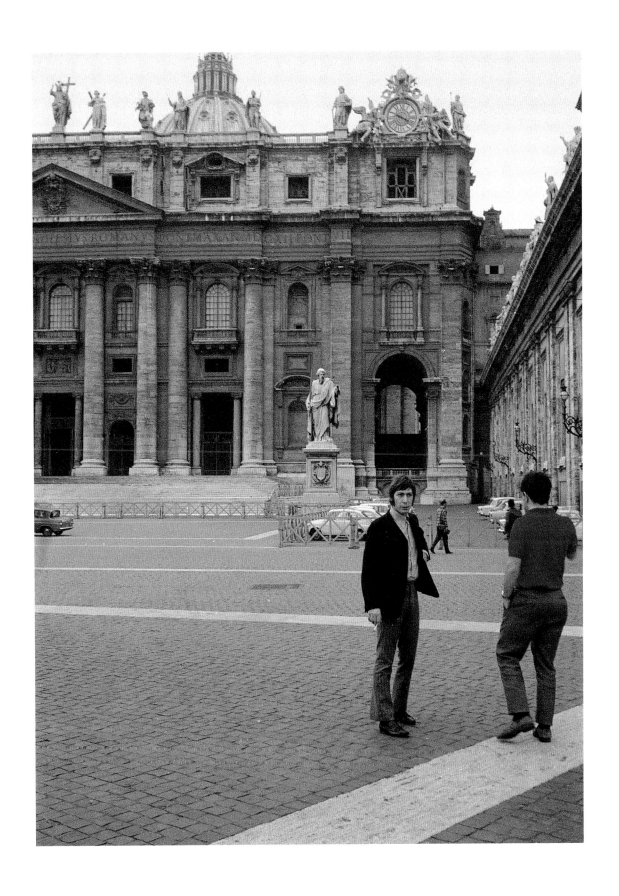

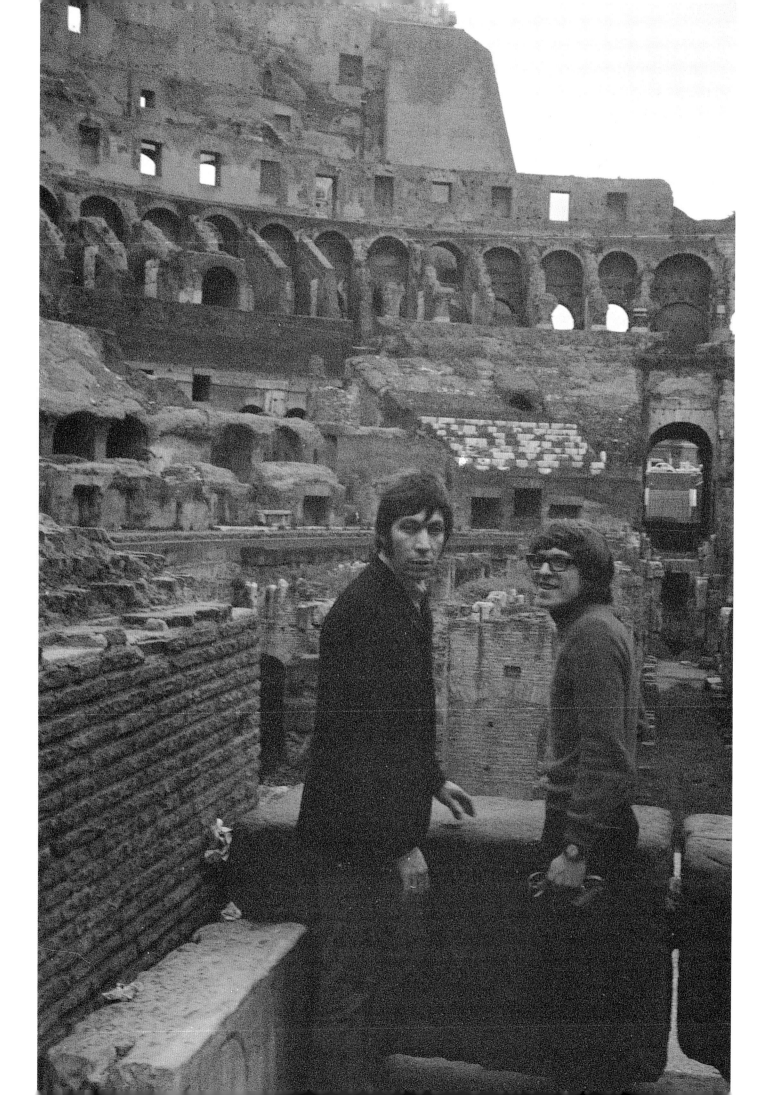

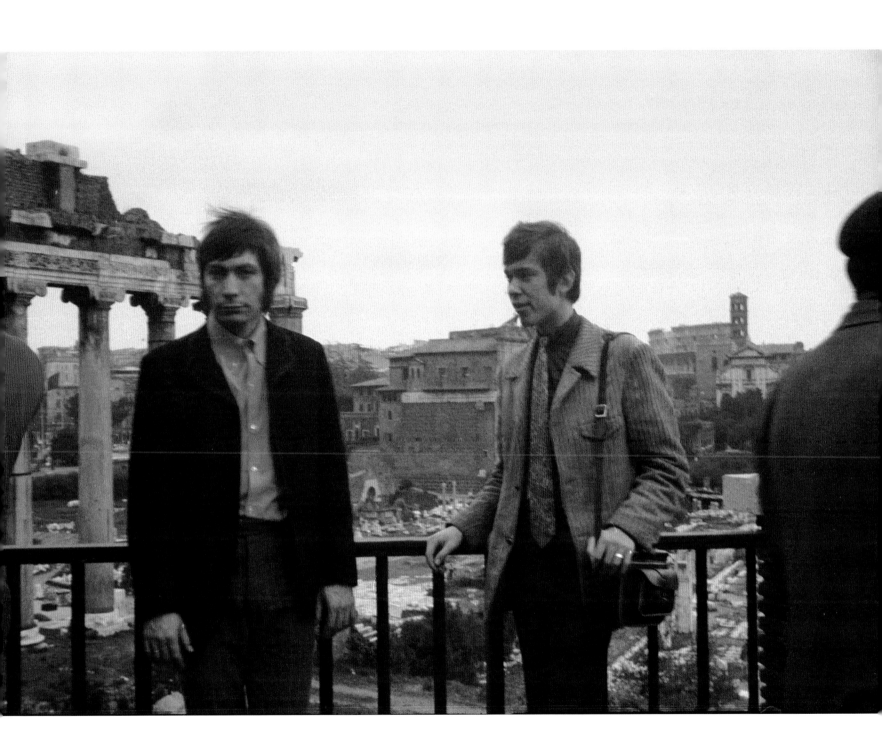

ABOVE: Charlie with Noise guitarist and photographer Ronnie Thorpe, at the Roman Forum.

OPPOSITE: With Noise drummer Alberto Marozzi, Charlie takes in the Coliseum.

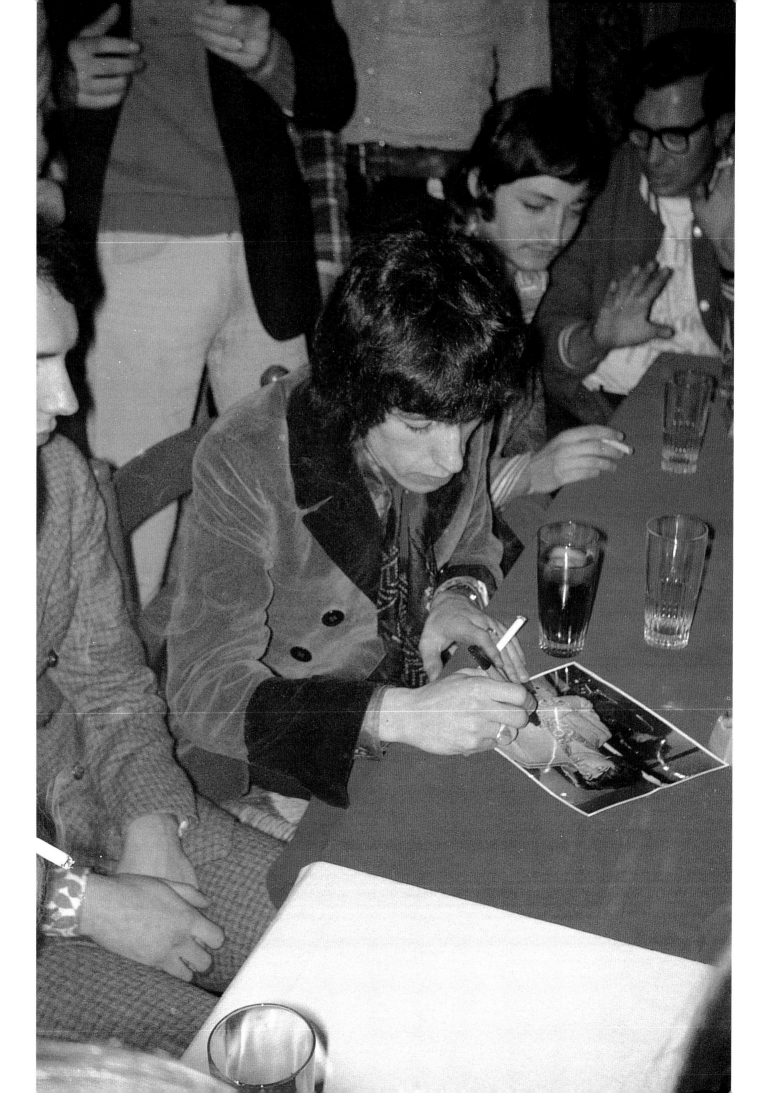

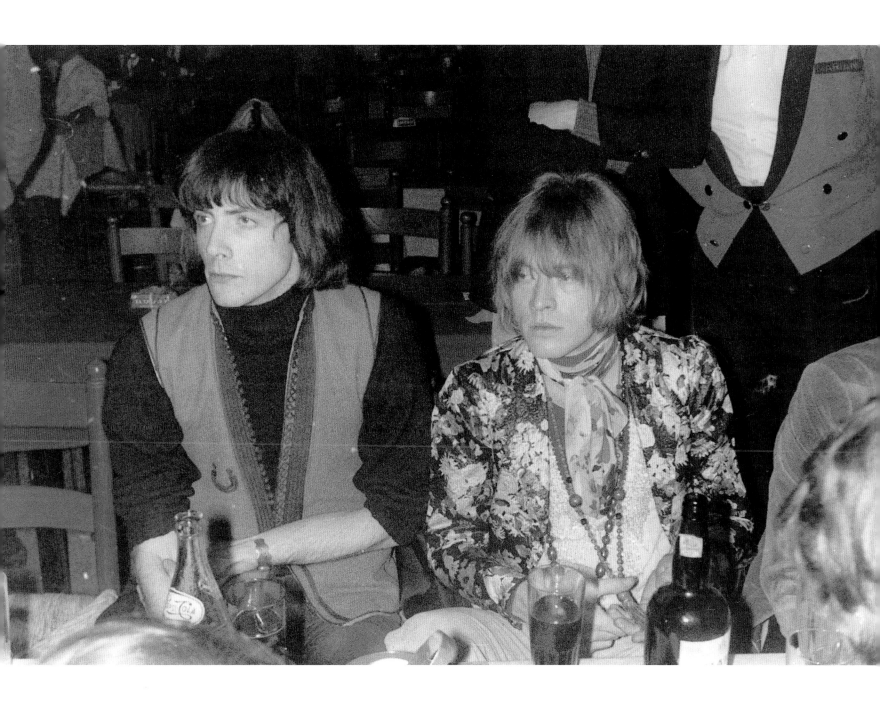

ABOVE: Brian relaxes with the Stones' friend Prince Stanislaus Klossowski de Rola, known to all of the hip 'beautiful people' as Stash.

OPPOSITE: Bill Wyman in the Piper Club, signing a print of a photograph taken by Ronnie Thorpe of him backstage at the Royal Albert Hall (see page 96).

'WE LOVE YOU' VIDEO, KING'S CROSS, LONDON
SUNDAY 30 JULY 1967

ON 28 JUNE, MICK JAGGER WAS FOUND GUILTY at Chichester Crown Court of possession of four drugs found in his jacket at Keith Richards' house. Richards had also been found guilty of allowing his house to be used for smoking hemp. This was the result of the now-notorious police raid on Richards' home, which famously involved the presence of a girl (presumed to be Marianne Faithfull) wrapped only in a fur rug.

In his summing up, the judge told the jury: 'The issue you have to try is comparatively a simple one. You have to be satisfied that cannabis resin was being smoked in the house when the police went there... and you have to be satisfied that Richards knew of it... finally I would ask you to disregard the evidence of the lady who was alleged by the police to be in some condition of undress, and not to let that prejudice your minds in any way.'

After they were found guilty, the judge sentenced the Stones and their friend, gallery owner Robert Fraser: 'Keith Richards, the offence of which you have been very properly convicted carries a sentence imposed by parliament of up to ten years. This is in view of the seriousness of the offence. As it is, you will go to prison for one year, with costs of £500. Michael Phillip Jagger, you have pleaded guilty to possessing a highly dangerous and harmful drug. You will go to prison for three months, with costs of £100.' Fraser received six months, and £200 costs. Jagger stumbled out of the dock, almost in tears as he headed off to Brixton jail, and Keith to the prison at Wormwood Scrubs.

Jagger and Richards were subsequently granted bail on £7000 pending appeals, meaning they could leave prison. After public protests and an influential article in *The Times* newspaper, Mick and Keith received a conditional discharge on appeal on 31 July, which meant Mick did not have to serve his

three-month sentence, and Keith had his conviction squashed as the judge had failed to instruct the jury on all the points in the case.

On release from the charges, Mick and Keith decided, along with filmmaker Peter Whitehead, to recreate and film a similar ordeal experienced by Oscar Wilde in 1895. Wilde had all his possessions taken from his house at 16 Tite Street, Chelsea, to pay for the court fees after he was tried and found guilty of homosexual behaviour. The film was to be used to promote their new single, 'We Love You', and was inspired by the 1960s movie *The Trials of Oscar Wilde*.

' Homosexuality was no longer considered a crime in 1967, but Oscar was convicted. We were luckier than Oscar. As for any connection between his life and the record – well it's all there isn't it?'
Mick Jagger, *New Musical Express*

A series of photographs taken by Anthony Stern for Peter Whitehead show the preparation work for the video, which was finally seen in its entirety in the video and DVD titled *25 x 5 Years of the Stones*. The pictures were taken in a church at the back of London's King's Cross station – not in Essex as was reported at the time. Keith, Marianne Faithfull, and Mick arrived in their Bentley at the park outside the church, with Peter Whitehead, Anthony Stern and his girlfriend ready there to film the event. The photo shoot and video shoot took just one afternoon. These photographs, extremely rare and printed for the first time, are a record of that unusual event. And they are probably the only photos ever taken of Keith on the 'other side' of the law!

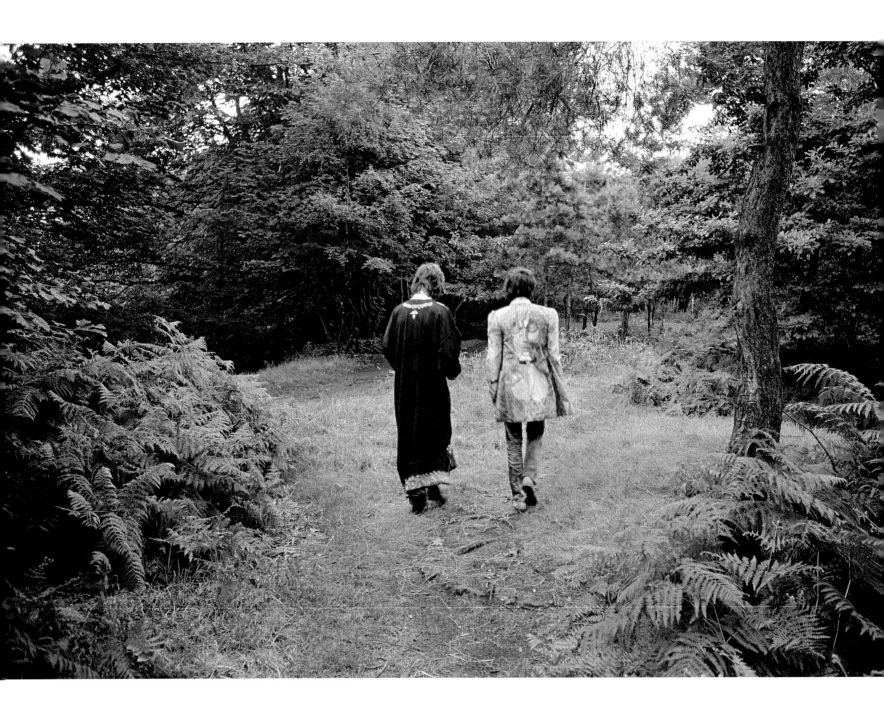

ABOVE AND OPPOSITE: Mick and Keith in the grounds of the church where they shot the 'Oscar Wilde' video with Peter Whitehead (carrying camera). Keith was wearing a coat painted by Mick's brother Chris Jagger. One of these (of which few exist today) was worn by Jimi Hendrix on the American album cover of his album *Are You Experienced?*

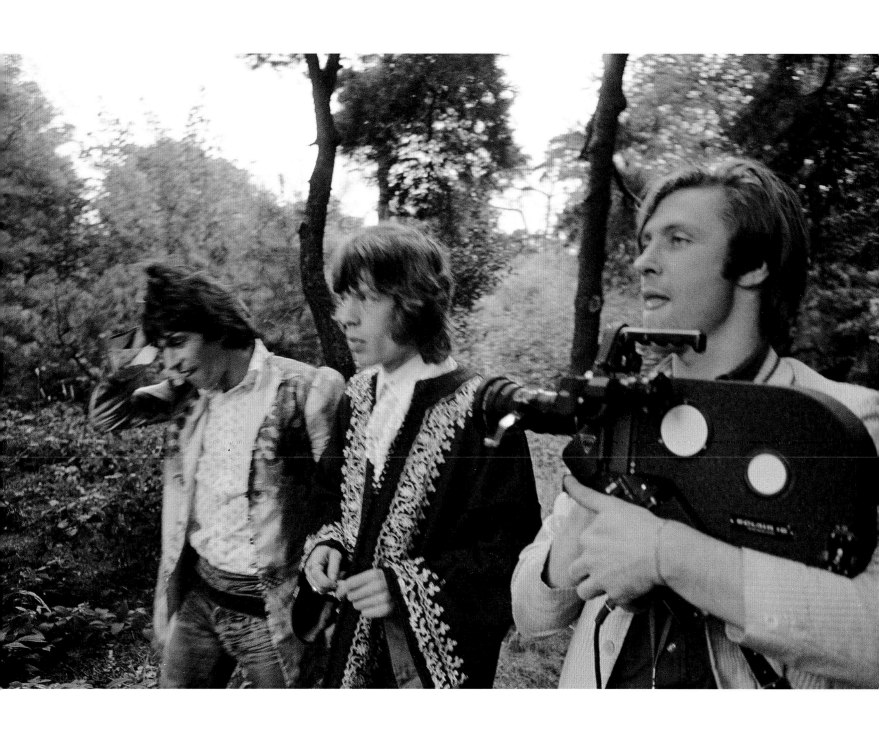

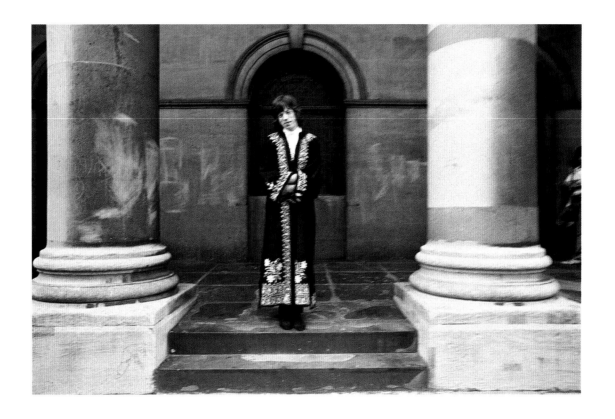

ABOVE: Mick, playing Oscar Wilde, in the navy blue velvet long coat he wore for the 'trial'.

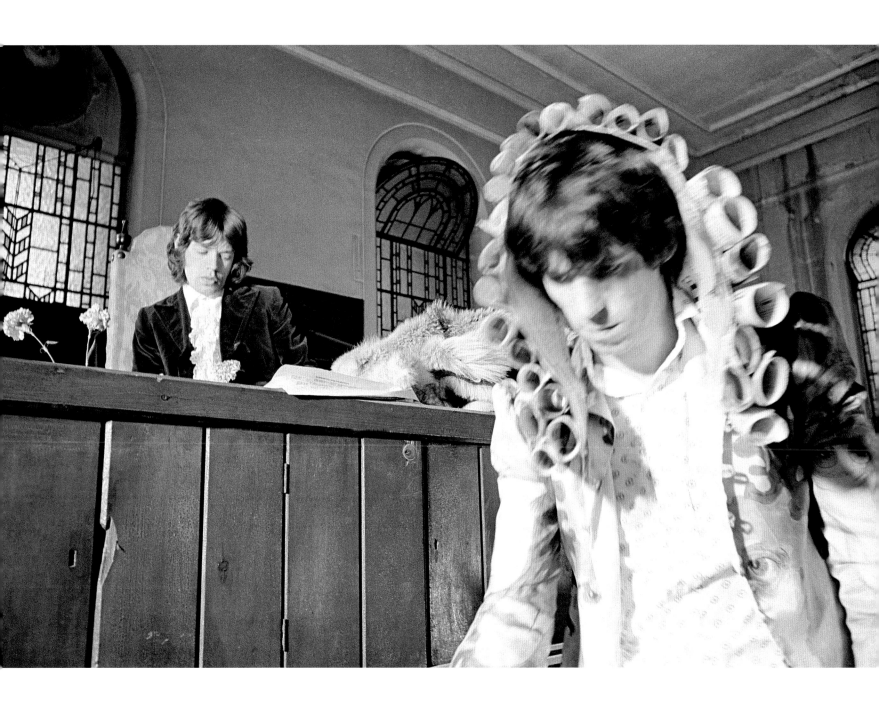

ABOVE: Keith Richards had a wig made up of the *News of the World* newspaper reporting the arrest of the Stones.

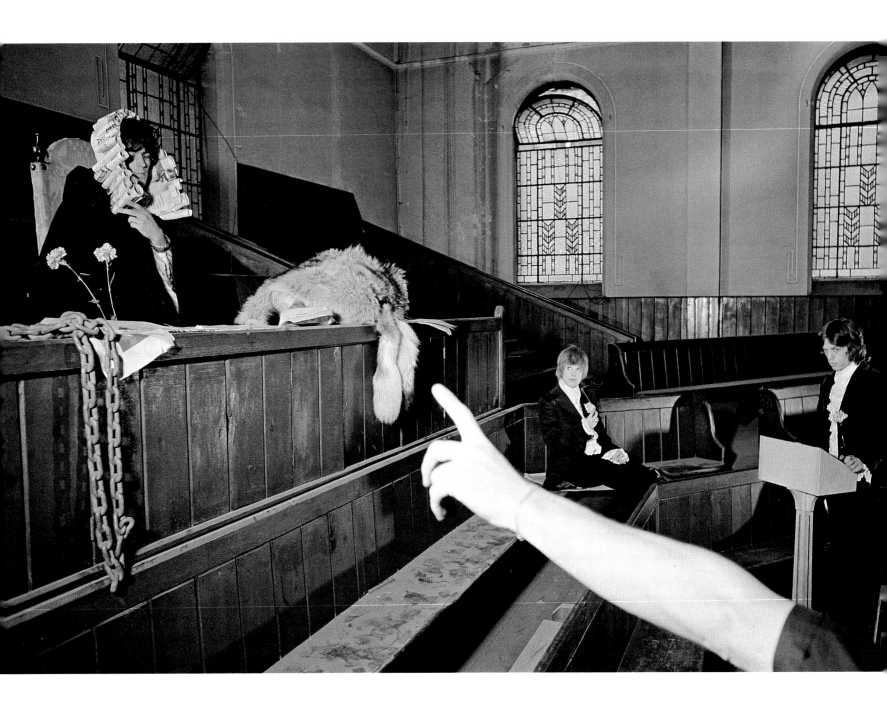

ABOVE: On entering the church Whitehead and the cast set about using the pews, altar and such for the 'accused', 'judge', and other characters in the reconstructed Wilde case.

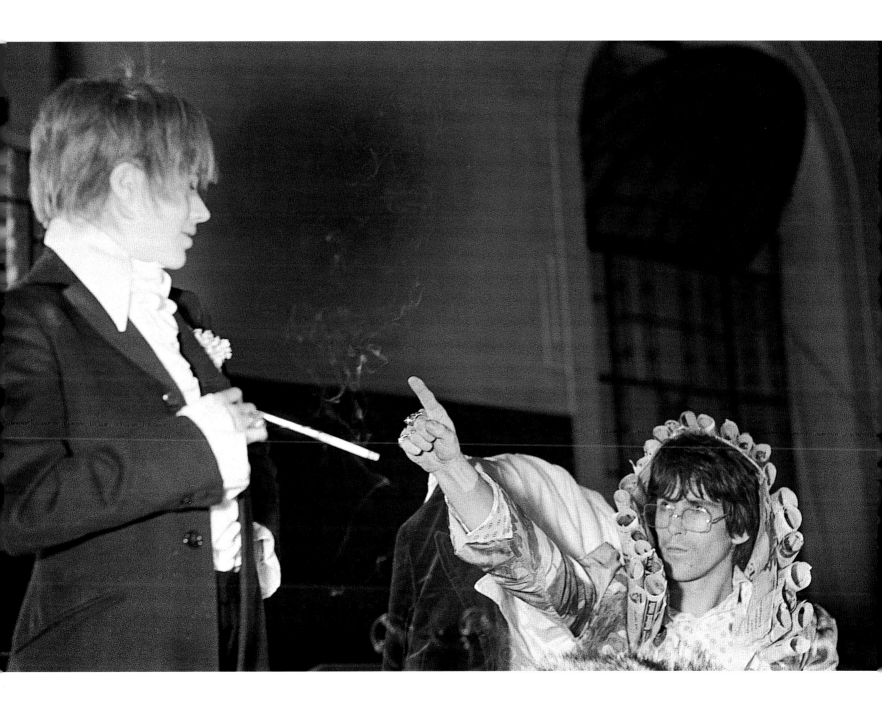

ABOVE: Marianne Faithfull as Oscar Wilde's friend 'Bosie', and Keith Richards as the High Court judge.

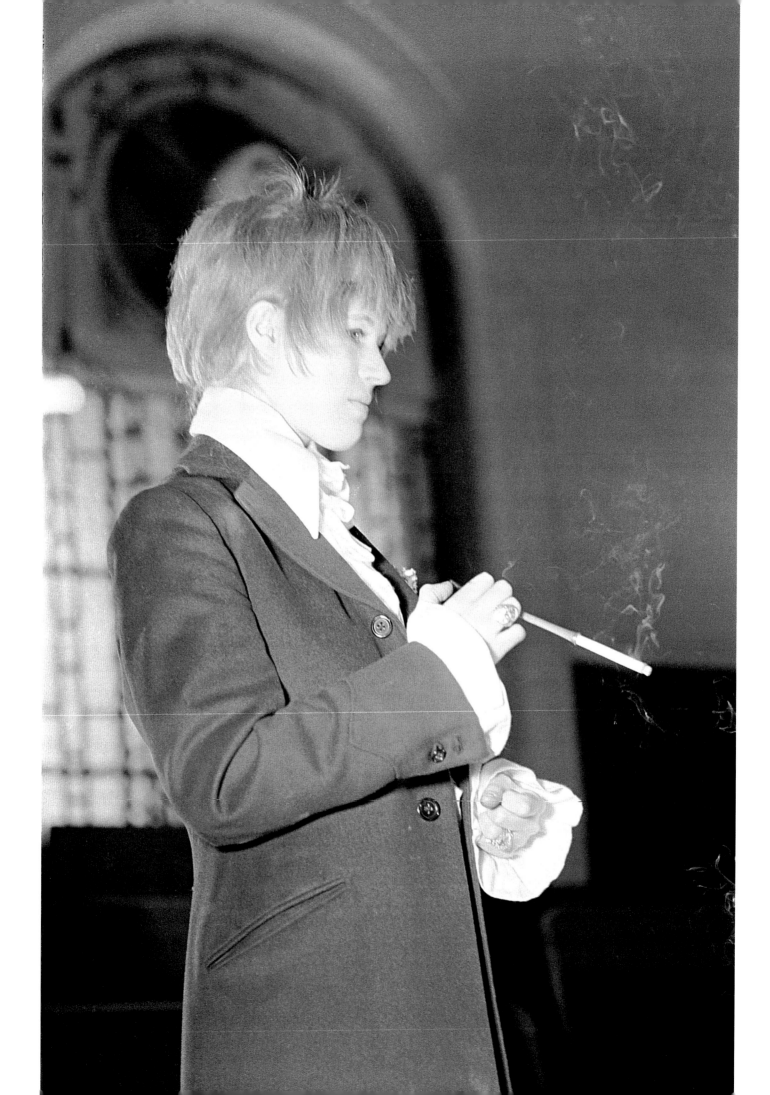

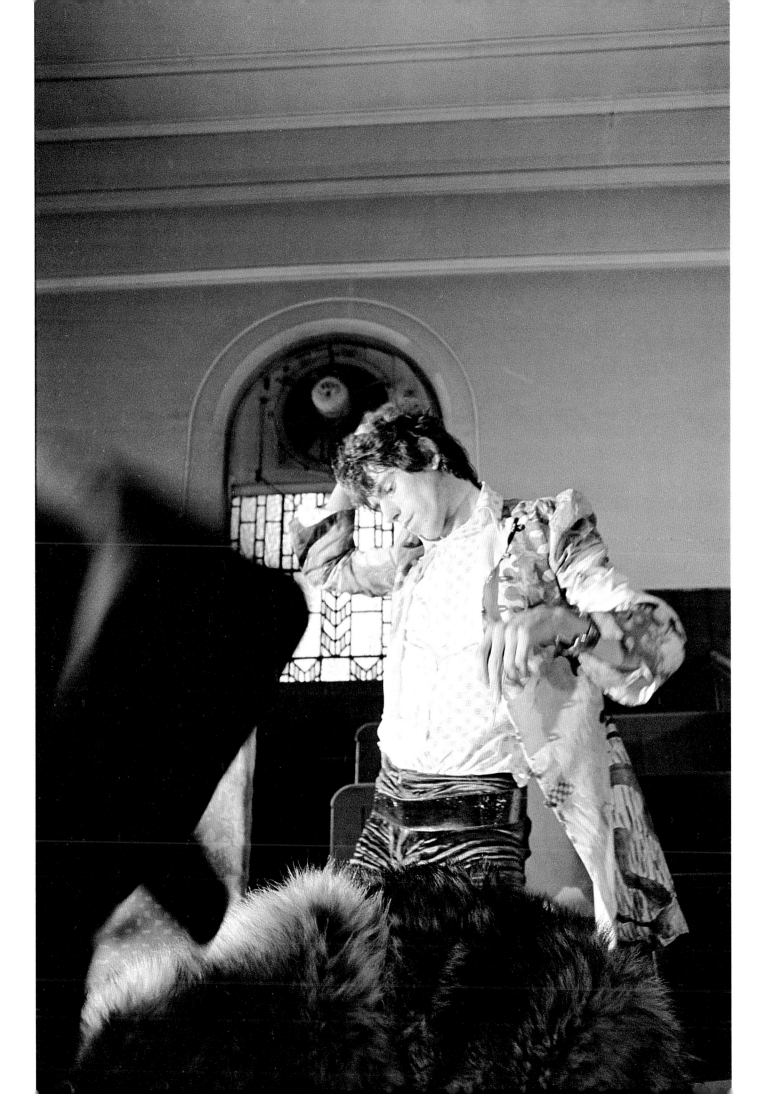

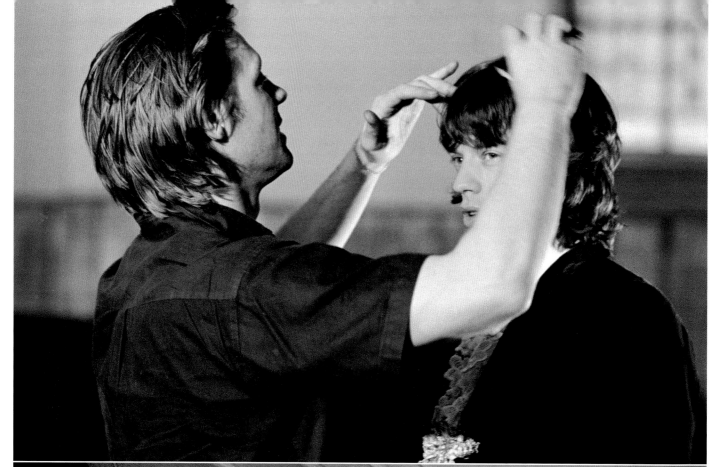

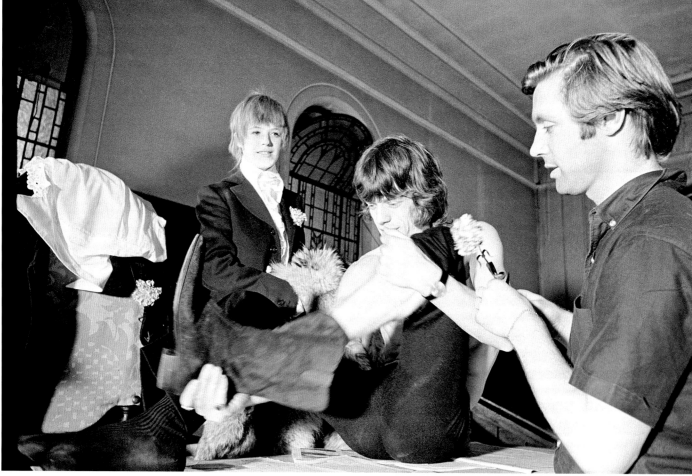

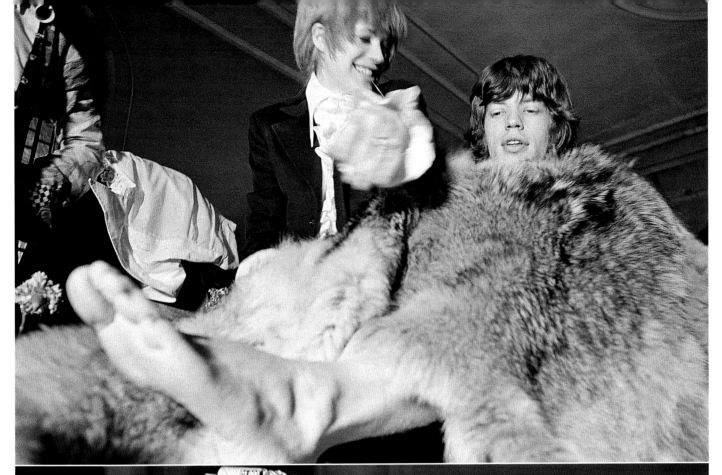

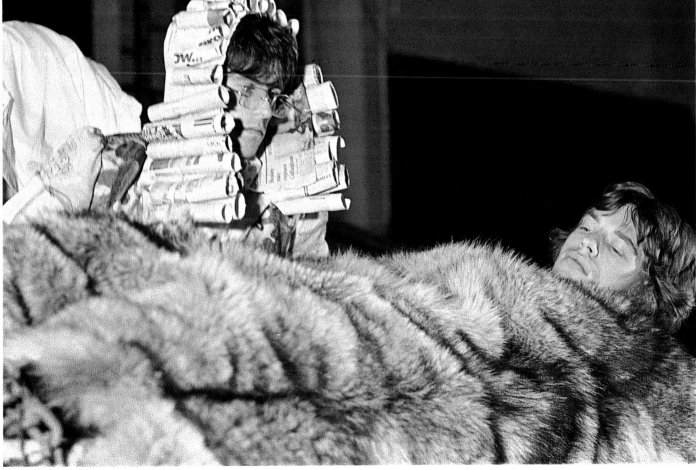

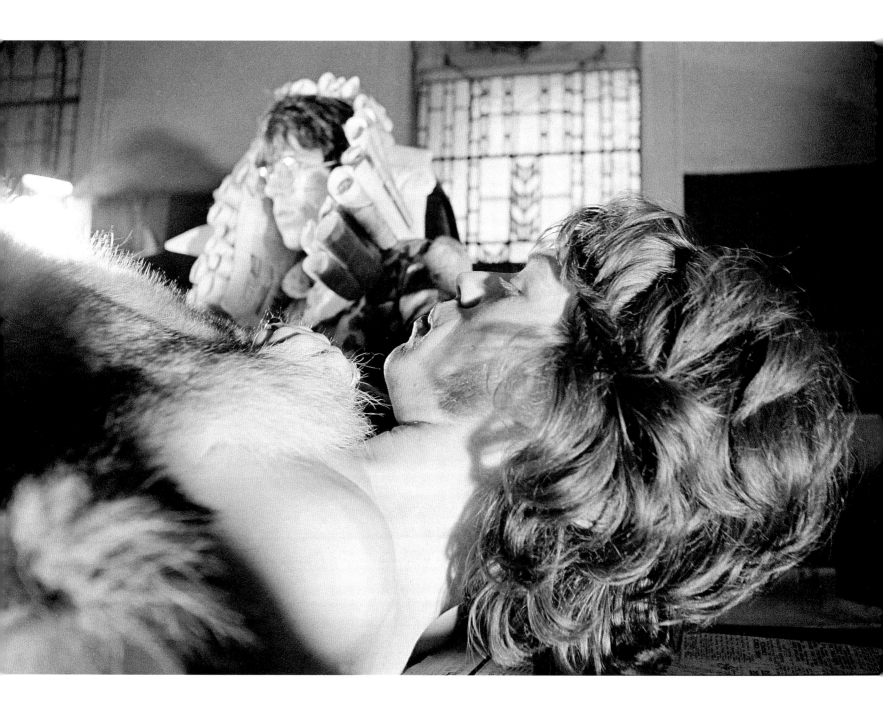

ABOVE: At one stage in the proceedings Mick took his clothes off, covering himself in the infamous rug which, wrapped around a naked girl, had been a big talking point in the actual Stones court case.

ABOVE: Marianne Faithfull, playing Oscar's friend Lord Alfred Douglas (also known as 'Bosie'), looked every bit the male dandy with her boyish haircut (a wig!), tailored jacket, and emerald- coloured carnation in her lapel.

FAN PHOTOGRAPHS
JANICE PALMER
AUGUST–DECEMBER 1967

A LETTER FROM JANICE PALMER to Keith Richards, sent in May 1966 to the *Rolling Stones Book*, and published in the June 1966 issue:

Dear Keith,

I do know that you yourself are very interested in clothes, and that it is very fascinating to listen to you talking about clothes. I won't keep you in suspense about where I have read that, well Marianne Faithfull wrote a great paragraph about you and your ways. It was really good, and I think she must have a great liking for you. Talking of other artistes, Chris Farlowe and Patti la Belle spoke very well of the Stones, which I was very glad to hear. Sarah of the Belles [Patti la Belle's group] told me (and it cheered me up) how lovely you really looked when you grew your moustache. They told me this at Lucky Stars.

Lots of love to you,

Janice Palmer

To which Charlie Watts replied underneath:

I'd just like to say that Patti la Belle and her girls are great, but I disagree with them about one thing – I didn't like Keith with his moustache.

Another letter from Janice to Keith, published in the *Rolling Stones Book* in October 1966:

Dear Keith,

By now I should have thought that you would have started to complain over the small amount of credit different Disc-Jockeys have given you. 'Out of Time', for example, was given a great deal of plugging, and at the end of the disc, Mick's name was mentioned for both writing and producing the record, but not poor old your's. Don't you think this is mean, after all you do write part of the records don't you. I say give credit to both of you!

Lots of love to you,

Janice XXXXXX

Bill replied:

I showed your letter to Keith, Janice, and he said he doesn't really mind so long as the royalties keep flowing in, and he also said that anybody who is in the know realises that he wrote it with Mick.

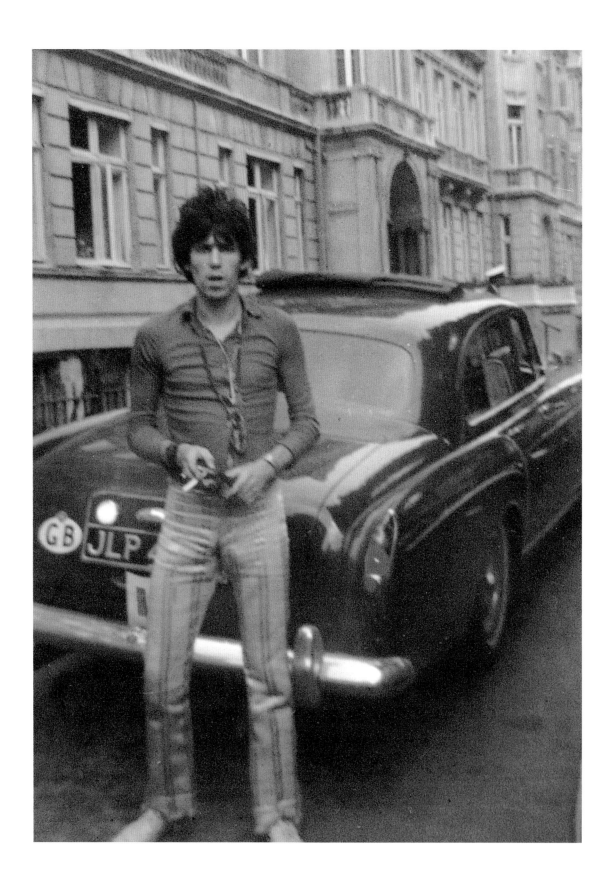

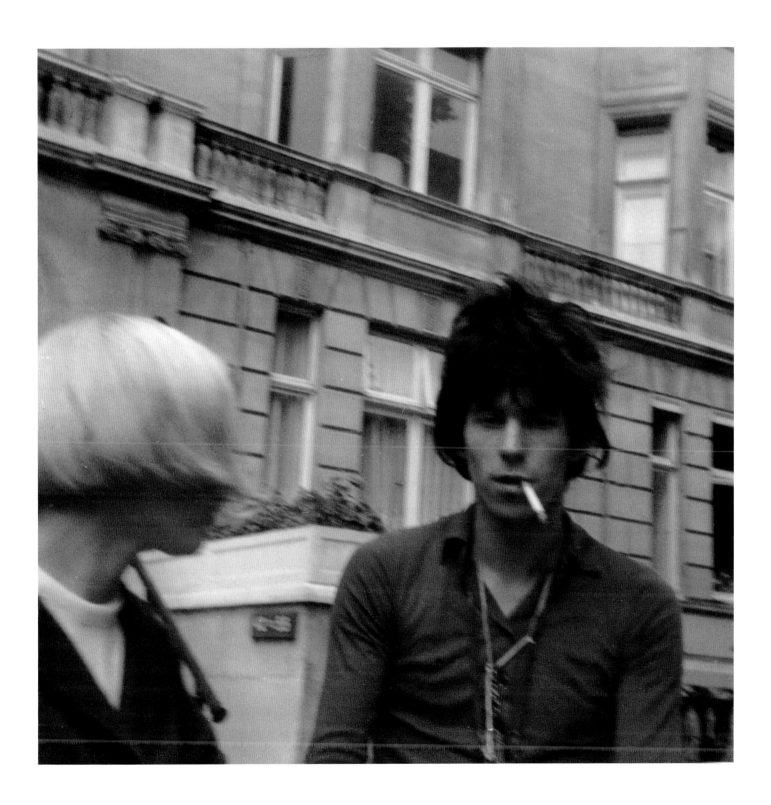

ABOVE AND OPPOSITE: Keith – with his Bentley, and a blonde fan – outside Mick's residence, Harley House in Marylebone Road, London.

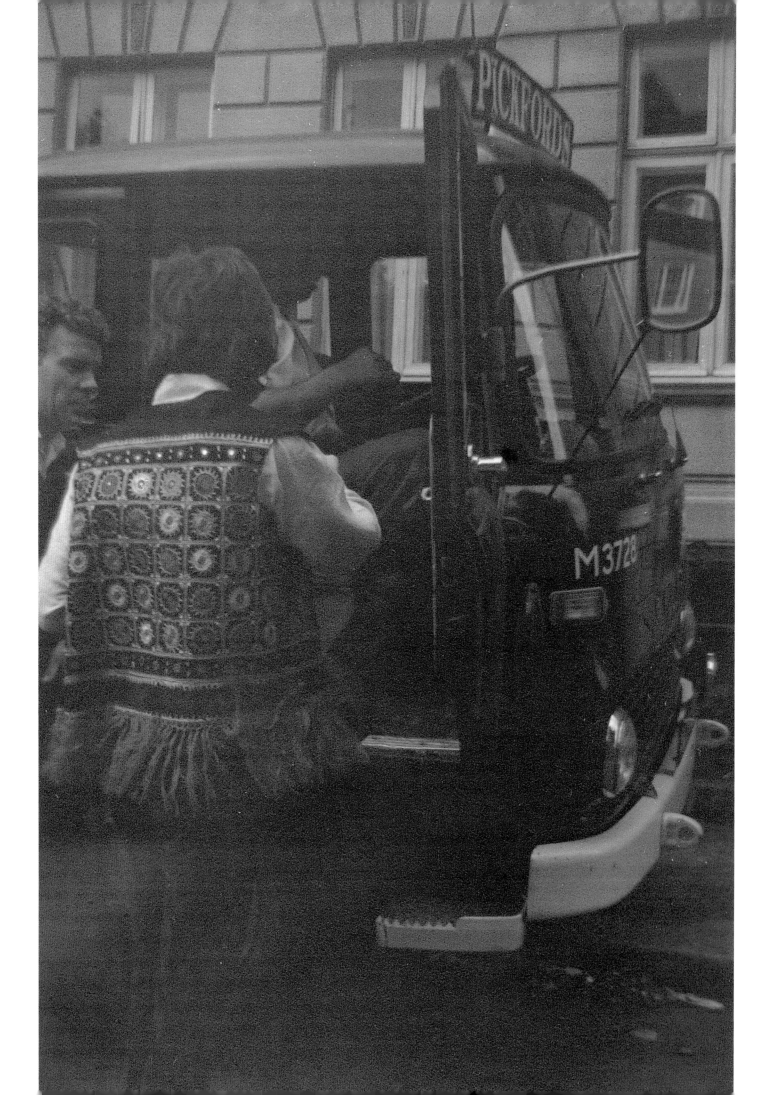

OPPOSITE: Returning from a trip to America, Mick heard via his solicitors that he had to move from his residence at Harley House, in London's Marylebone Road, due to complaints from the neighbours. He moved to his new house Stargroves in Newbury, which he had bought in June 1967. This paparazzi-style shot was taken by Janice Palmer as Mick (with back to camera) supervised the removal of his furniture.

ABOVE: Keith and a fan snapped by Janice Palmer in a hotel elevator in New York, November 1967.

ABOVE: Anita Pallenberg and Keith at the Bell Sound Studios, New York City, 4 November 1967.

OPPOSITE: Keith and Tom Keylock at Heathrow Airport, 12 December 1967.

DELL ARETUSA CLUB, CHELSEA, LONDON

SUNDAY 28 JANUARY 1968

On 28 JANUARY 1968 THE SUPREMES made their cabaret debut at a small club in the Kings Road, Chelsea. Their promoters Rogers and Cowans decided to throw an after-show party – hosted by the Duke and Duchess of Bedford – which was duly attended by Mick Jagger, Marianne Faithfull, and Brian Jones. Other guests, as well as The Supremes themselves, included the actor Michael Caine. These great photographs were taken by Tony Gale, who now runs a photographic agency, and show a lighter side to the chemistry enjoyed between Mick and Brian. Gale would use a 35mm single-lens reflex Pentax for most of his pictures. Mick and Brian were sporting beards for the first time – in fact the only time a photographer captured images of any bearded Stones throughout the band's 1960s career.

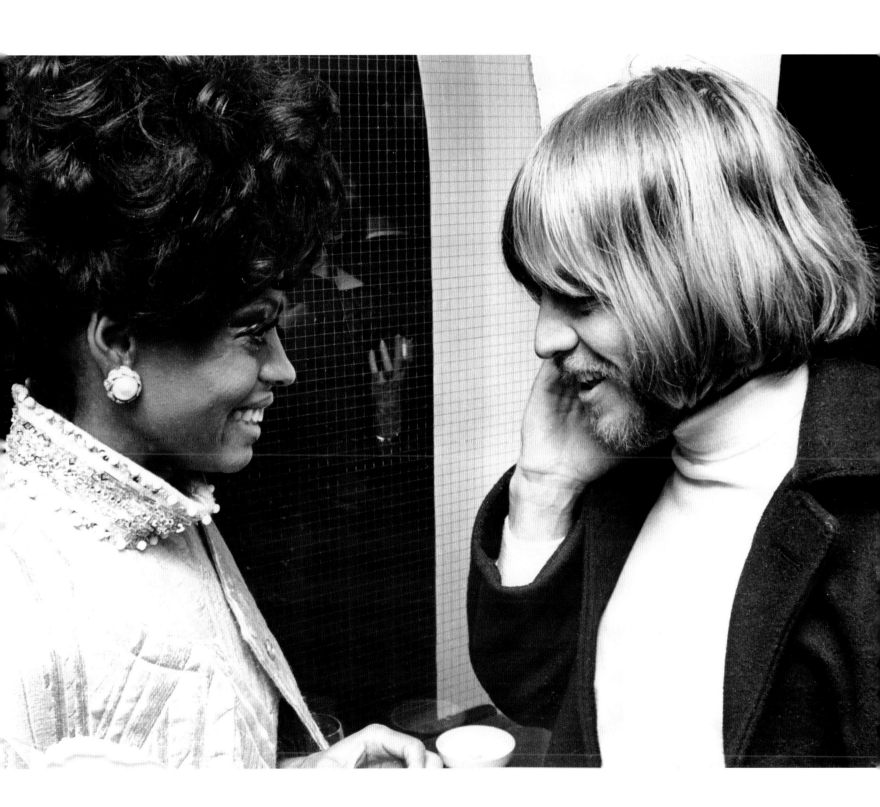

ABOVE: Brian Jones, with beard, chats with The Supremes' lead singer Diana Ross at the party.

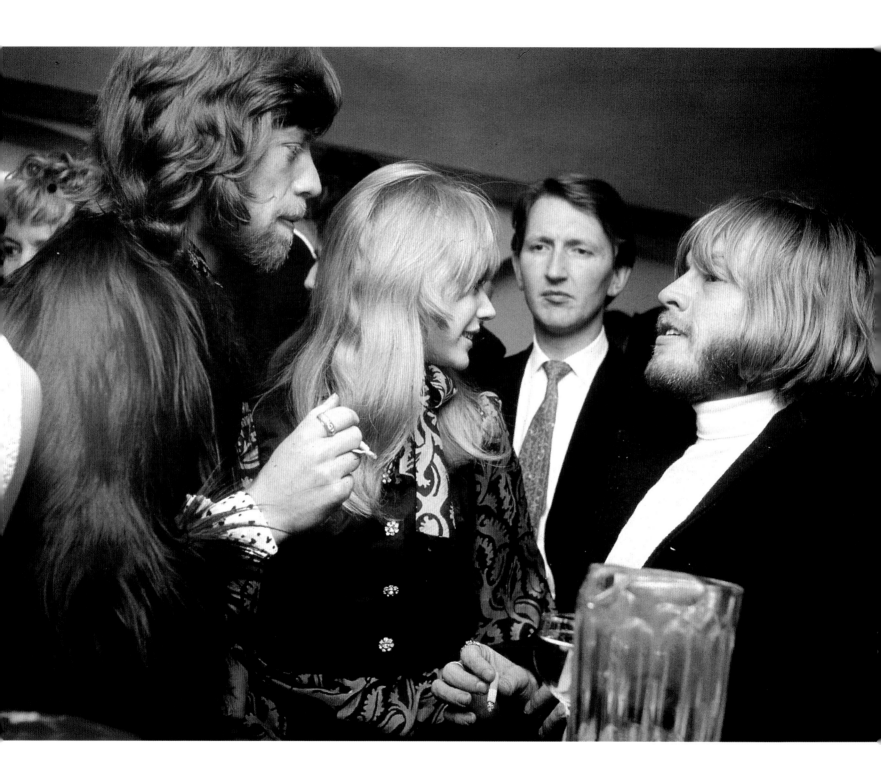

ABOVE: Mick, Marianne, and Brian at The Supremes party.

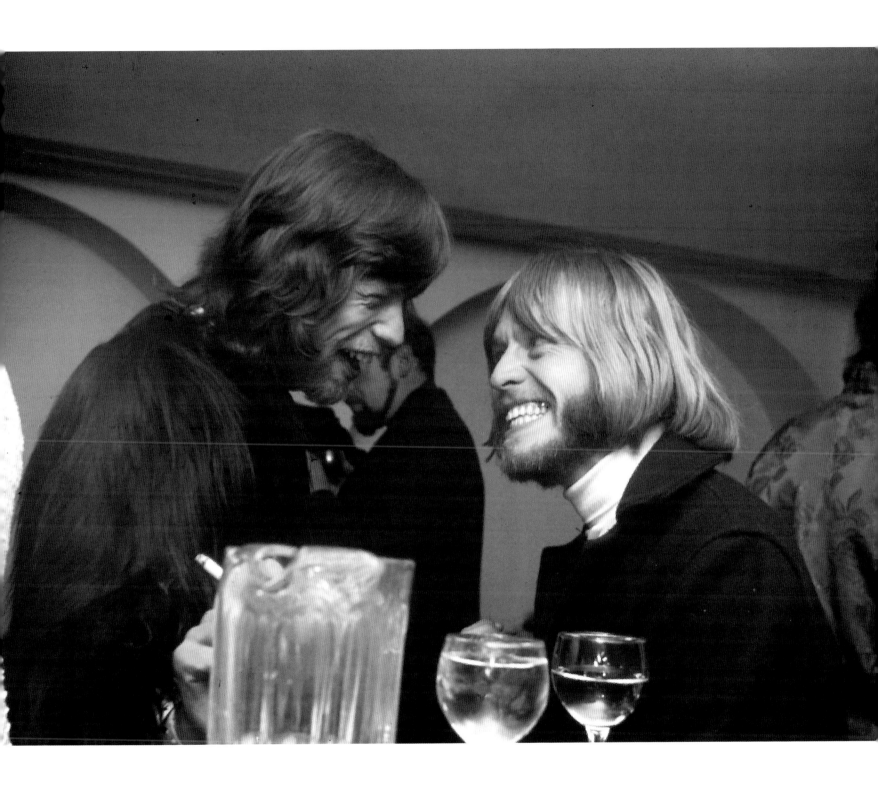

ABOVE: Mick and Brian enjoying a joke together.

SWARKESTONE HALL, DERBYSHIRE
SATURDAY 8 JUNE 1968

THE FAMOUS 'MEDIEVAL BANQUET' PICTURE that graced the inner gatefold sleeve of the *Beggars Banquet* album was created during two shoots by the South African-born photographer Michael Joseph. The first took place in London on 7 June 1968 at Sarum Chase House, Hampstead, overlooking Hampstead Heath, followed by one in the ruins of Swarkestone Hall in rural Derbyshire, the following day, where a cricket match had also been arranged (Mick Jagger in particular being an enthusiastic fan of the sport).

Meanwhile the photographer David King had received a call from Brian via *The Sunday Times*, asking if he could cover the match and the second day of the *Banquet* shoot. King (born 30 April 1943) was a freelance photographer and art editor on *The Sunday Times* for ten years, from 1965 to 1975.

On the morning of 8 June, the Stones rushed up the M1 motorway to Derbyshire. Joined by David King en route they assembled at Balcony Hill around the Swarkestone ruins. Several medieval costumes that had been rented from the theatrical costumiers Angel and Bermans for the previous day's shoot were brought up for the band to wear. The resulting photos, of which only two have ever been published, in *Top Pops* magazine in the UK, tell a story.

The photographs taken by David King lay buried in the photographer's house until he came to my shop Vinyl Experience in central London's Hanway Street. Luckily I was behind the counter at the time. I purchased some Beatles posters, and the negatives to 132 different shots of the Rolling Stones in Swarkestone, sold with full copyright. King decided to put the money (£4,000) into the trading of Russian icons, which had become his passion by that time.

OPPOSITE: After the previous day's shoot, Michael Joseph had rushed home to print the images, in order to show the Stones the next day in Derbyshire.

ABOVE: Mick and Brian sort through the 'medieval' clothes.

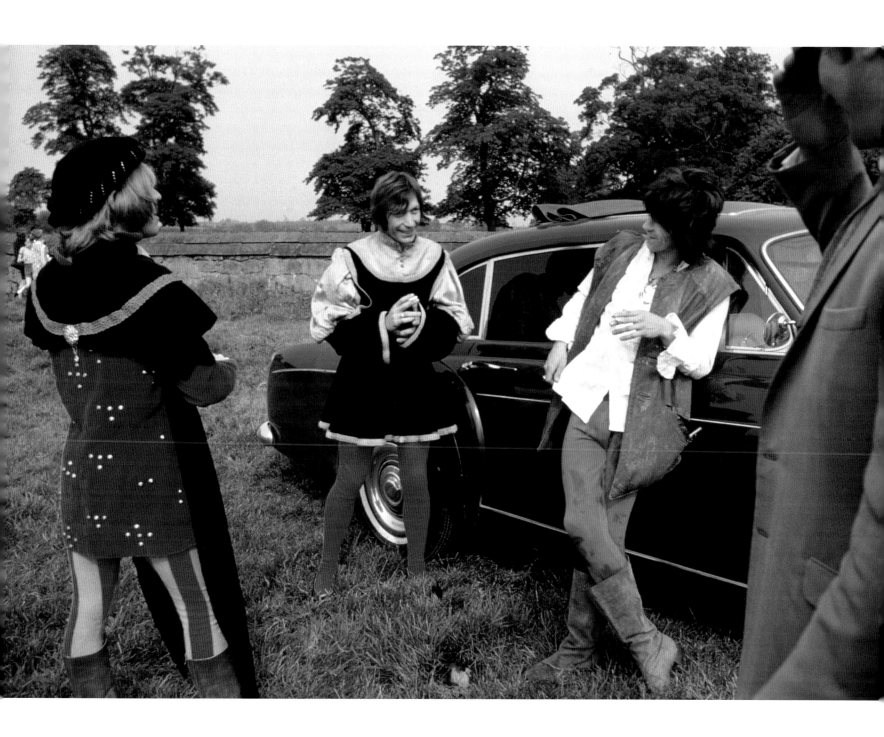

ABOVE: Brian, Charlie, and Keith admire each others' 'ye olde' outfits.

Climbing up onto the Swarkestone pavilion was a precarious business. The Stones edged their way across the building's façade looking very uncomfortable, although a ladder was also provided.

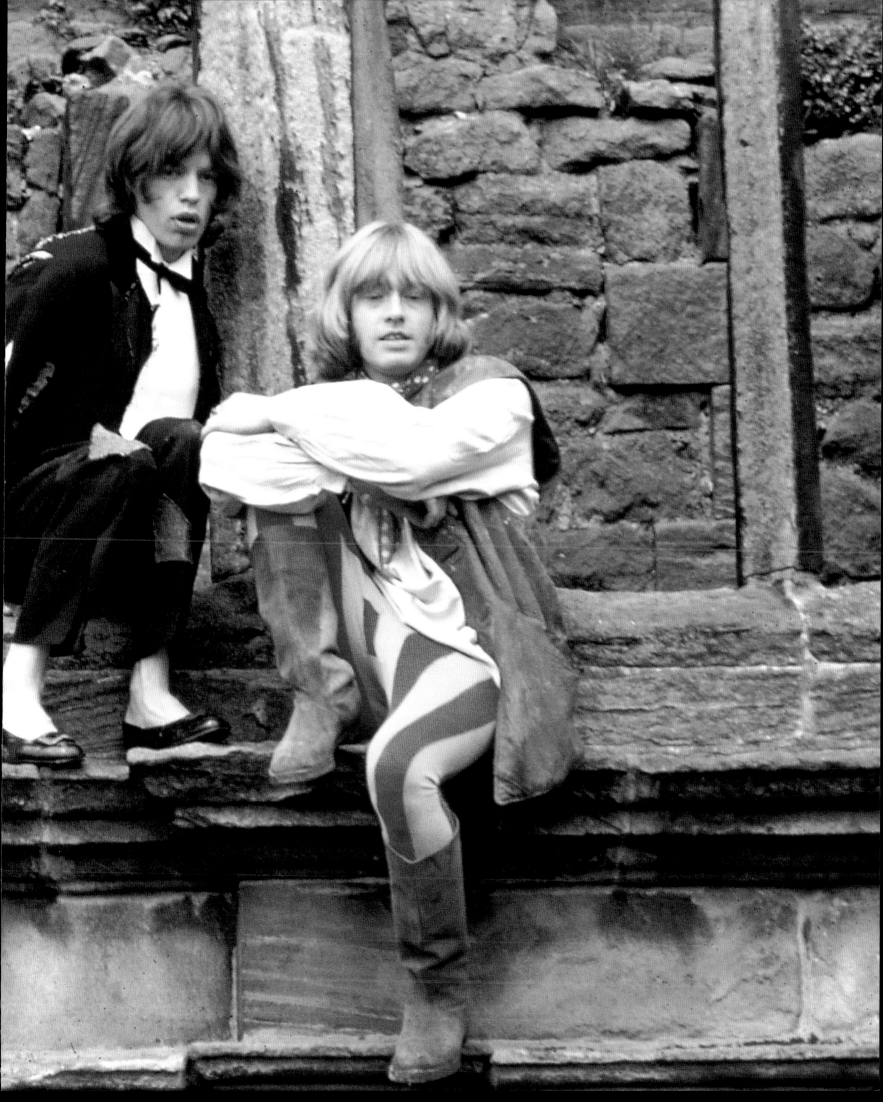

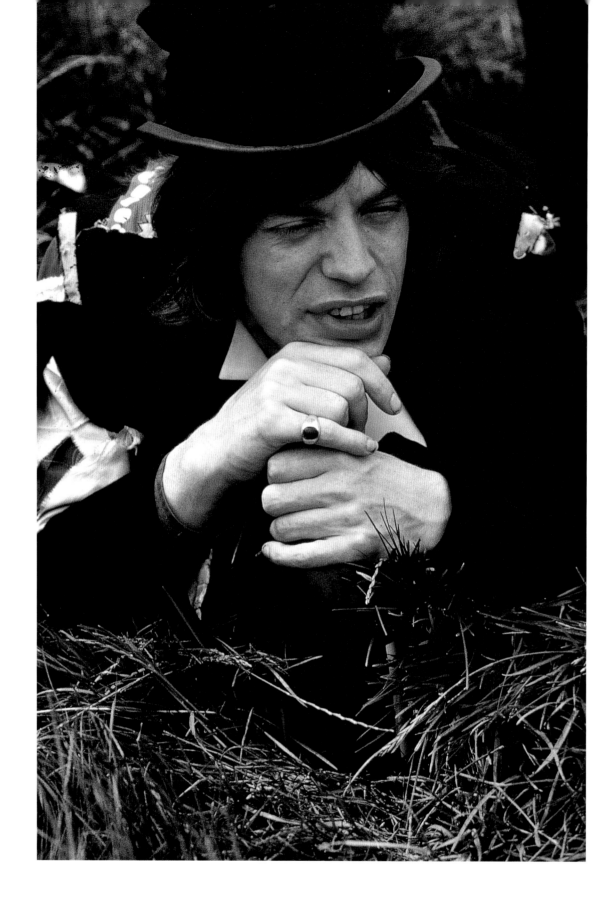

ABOVE AND FOLLOWING PAGES: Like most film shoots and photo sessions – and cricket matches for that matter – the day seemed to involve a lot of sitting round doing nothing.

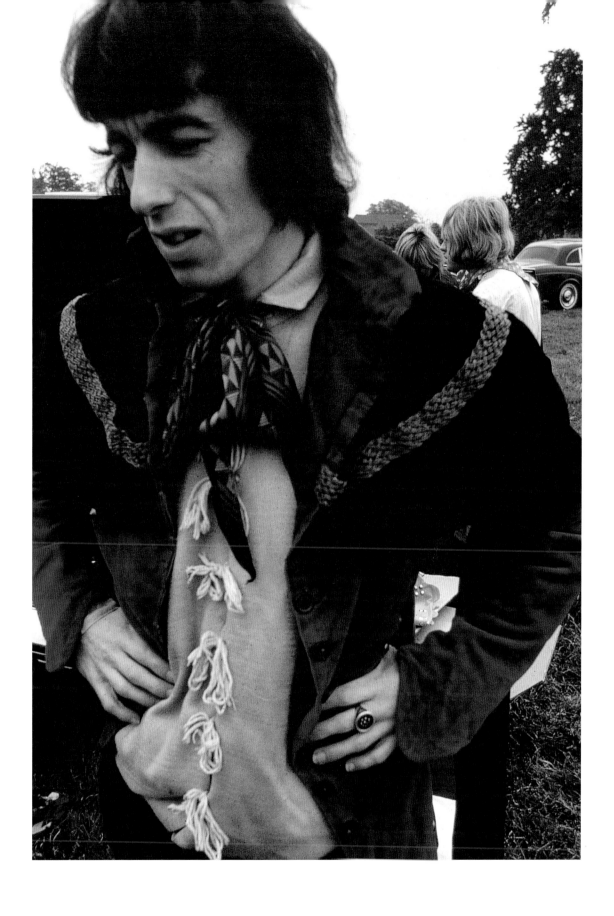

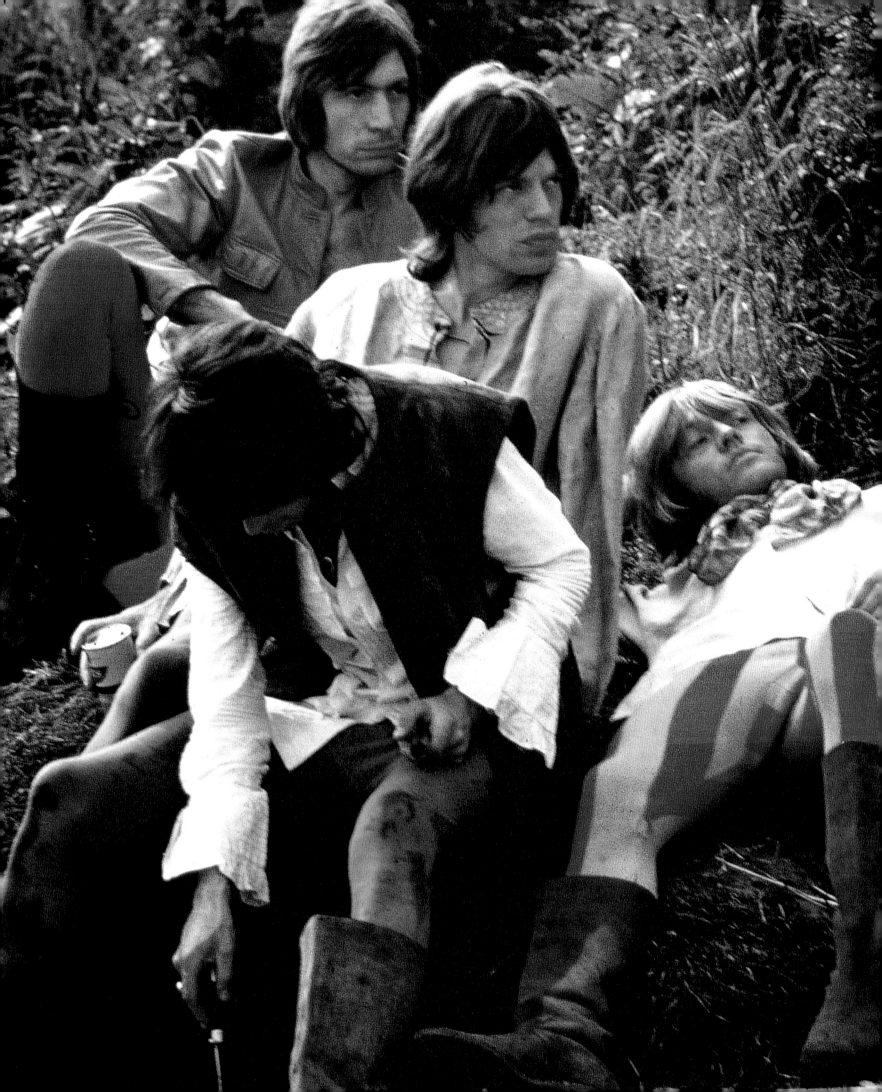

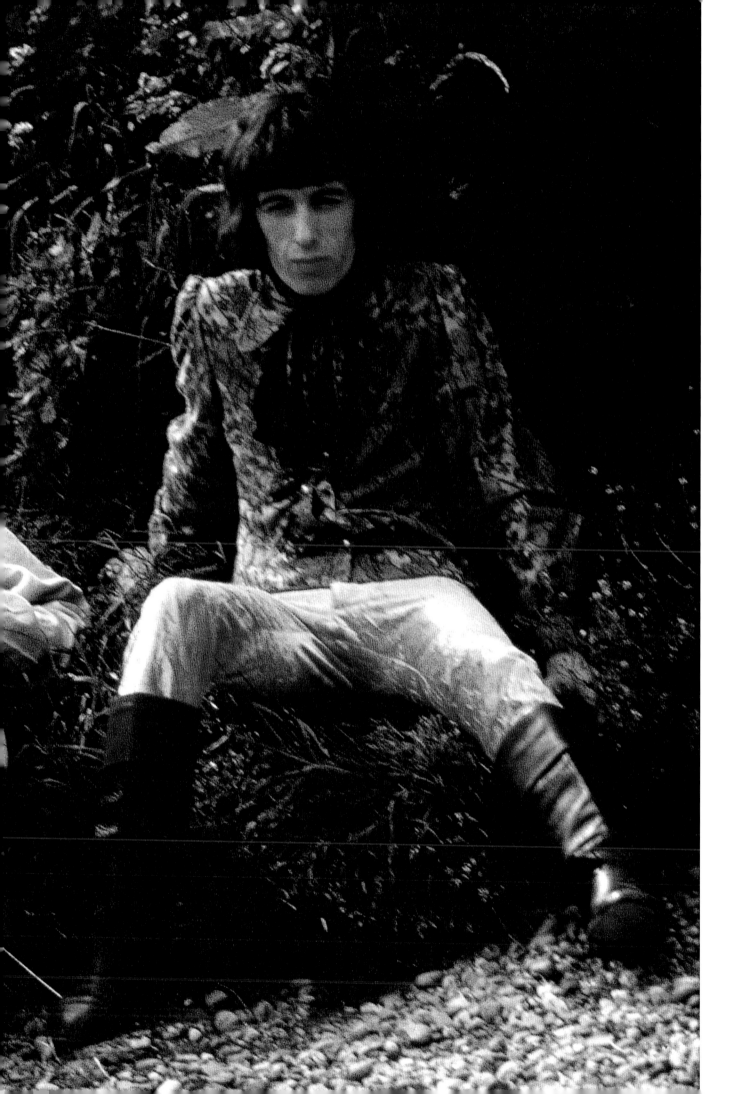

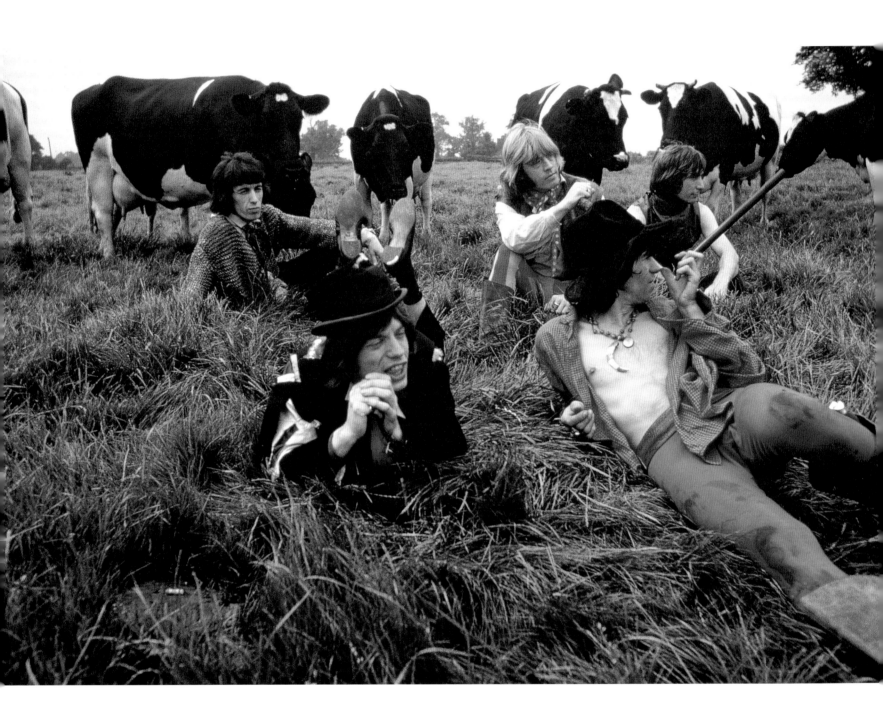

OPPOSITE: Mick in the same outfit he'd worn the day before on the *Beggars Banquet* indoor set.

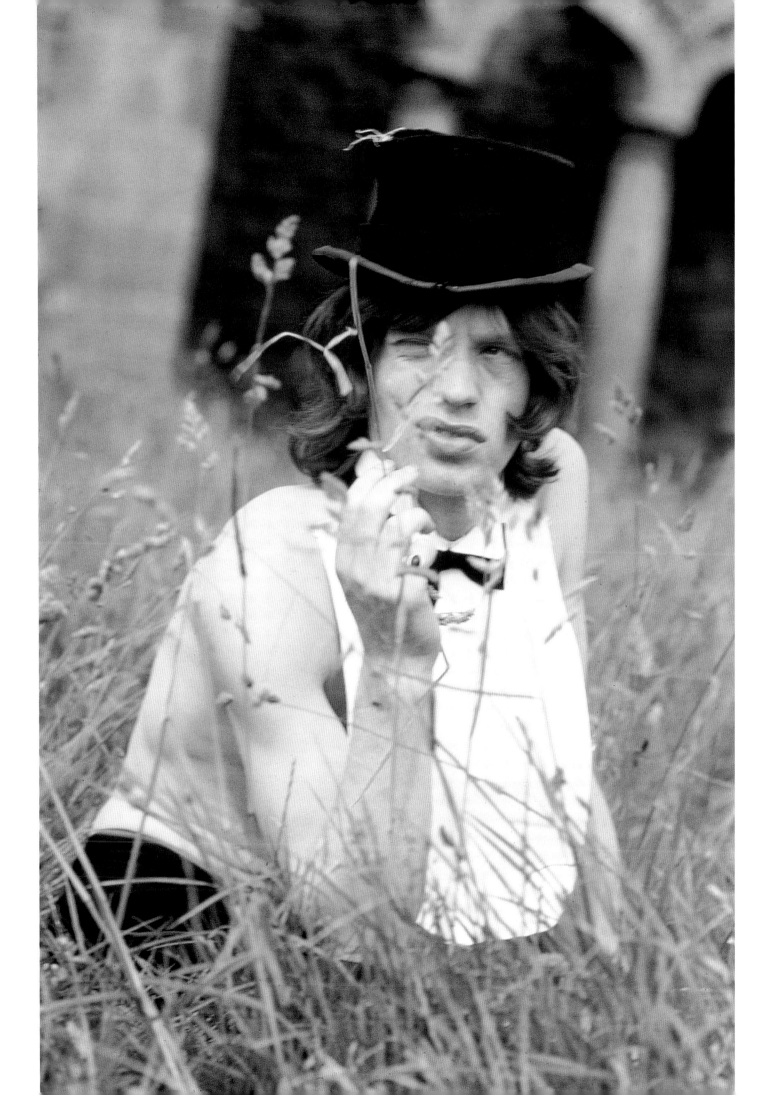

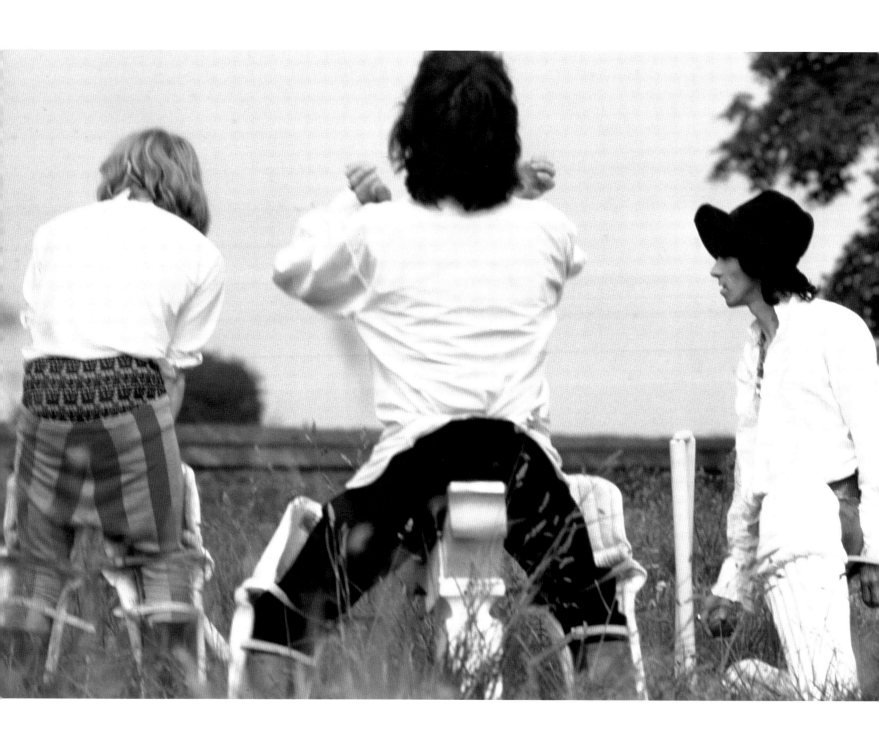

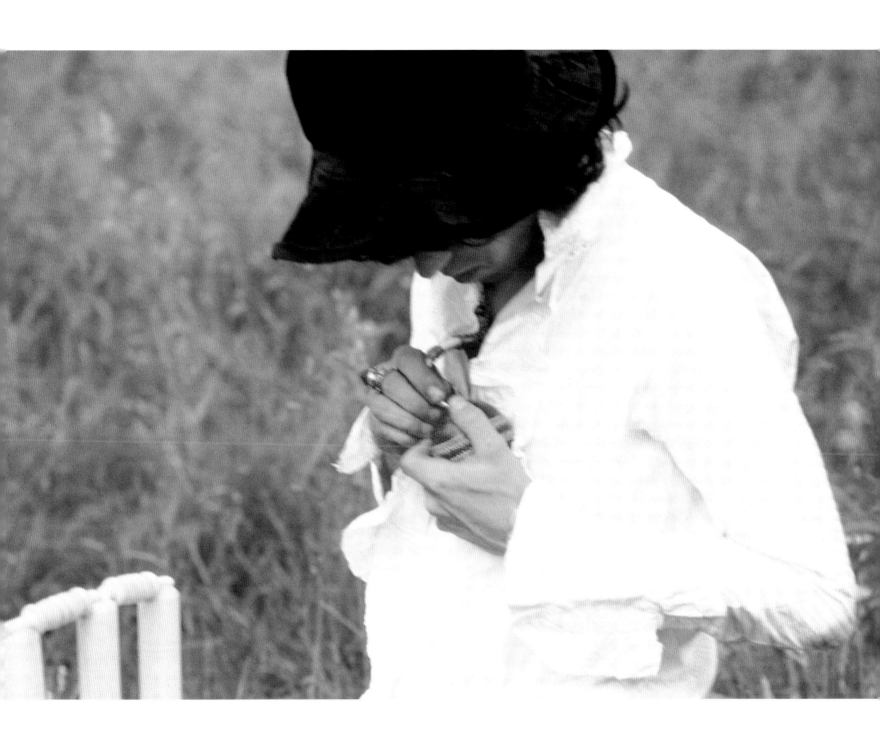

OPPOSITE AND ABOVE: Brian, Mick, and Keith indulging in Mick's favourite sport – although the grass seems a lot longer than on a conventional cricket pitch!

OLYMPIC STUDIOS
117 CHURCH ROAD,
BARNES, LONDON
MONDAY 10 JUNE 1968

PHOTOGRAPHER TONY GALE WAS INVITED to Olympic Studios to take pictures while the Rolling Stones were recording the track 'Sympathy For The Devil' with producer Jimmy Miller, and were also being filmed for a movie called *One Plus One* (which was later re-titled *Sympathy For The Devil*) by the avant-garde French director Jean-Luc Godard.

' I felt privileged to be allowed access to the Rolling Stones recording what became one of their all time classic recordings.' Tony Gale

Tony does not remember too much from the session itself other than to say it was late at night. His notes from the photo session, however, state that the Stones were recording and listening to playbacks of a new song called 'I'm A Man', which became a working title for 'Sympathy For The Devil'.

Just a matter of hours after these photographs were taken, the studio roof caught fire at 4.15 am on 11 June after an arc lamp overheated. Mick Jagger commented in the *NME* dated 15 June 1968: 'The fire brigade was so thorough in extinguishing the blaze, our Hammond organ and all our electrical equipment was completely drenched. The film sequence will have to be retaken.' But luckily, Bill Wyman and Jimmy Miller salvaged the all-important master tapes.

OPPOSITE: Brian listens to a playback during the 'Sympathy For The Devil' session.

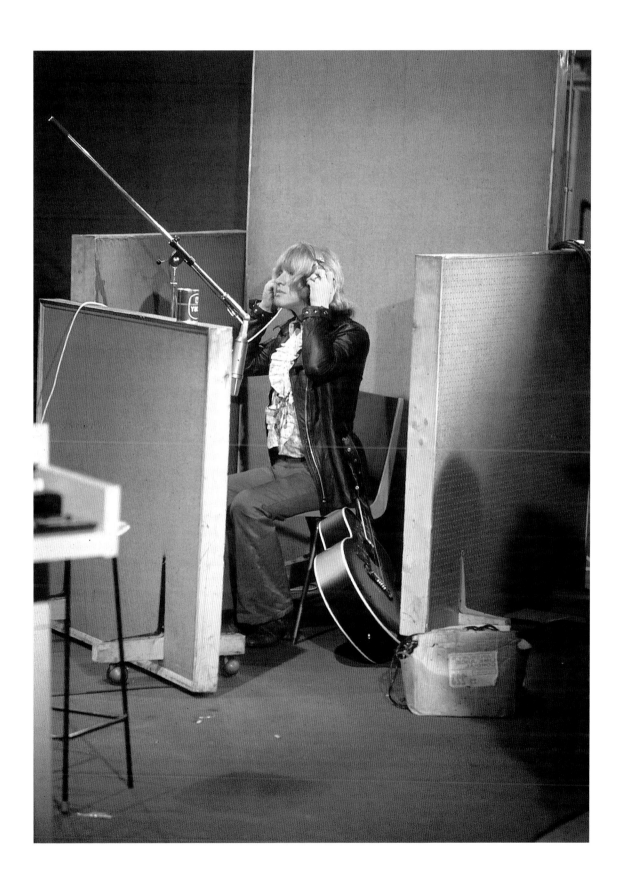

While Mick's girlfriend Marianne Faithfull (seen above in the studio control room) seemed content to play a relatively subordinate role, Anita Pallenberg was far from passive around the group. During one session Jagger played Anita a new song the group had recorded, 'Stray Cat Blues', expecting the usual complimentary response, but was surprised when Keith's new girlfriend responded with 'Crap – the vocals are mixed up too high, and the bass isn't loud enough!'. Jagger would return to the control room to have the track remixed and his ego boosted at a later date .

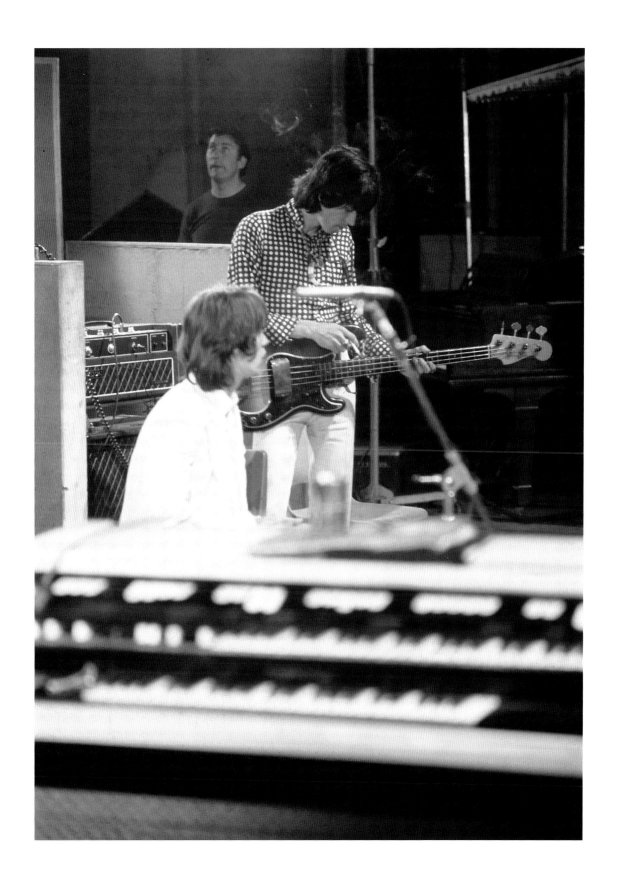

PERFORMANCE
TUESDAY 3 SEPTEMBER 1968

ON 3 SEPTEMBER FOR A PERIOD OF TEN WEEKS, Mick Jagger was contracted to play in the film *Performance*, a Sanford Lieberson production which also starred James Fox, Michele Breton, and Keith Richards' girlfriend Anita Pallenberg. Filmed at the Powis centre in London's Notting Hill Gate area, the movie was directed by Nicolas Roeg and Donald Cammell, and the celebrated society photographer Cecil Beaton was invited to take some pictures on the set. Beaton was commissioned by Sandy Lieberson, whose then wife, Marit Allen, worked for *Vogue* magazine and was a friend of the photographer. Warner Bros, the film's distributors, refused to pay for Beaton's services, so Lieberson paid the fee out of his own pocket. Aged 63 at the time, Beaton was hired specifically to shoot the love scenes between Jagger and Pallenberg, enacted on a bed decorated with Afghan rugs supplied by Christopher Gibbs and lying under a mirrored ceiling. 'Mick began to make love in earnest' according to Beaton.

The famed photographer described Pallenberg as 'Beatnik-dressed Anita Pallenberg, dirty white face, dirty blackened eyes, dirty canary drops of hair, barbaric jewellery' while confessing that, regarding Jagger, he 'could not decide whether he is beautiful or hideous... I was fascinated with the thin concave lines of his body, legs, arms, mouth almost too large, but he is beautiful and ugly, feminine and masculine, a sport, a rare phenomenon.' He added that the session 'Really is all part of a days work to me.'

OPPOSITE: Mick Jagger and Anita Pallenberg in the controversial love scene.

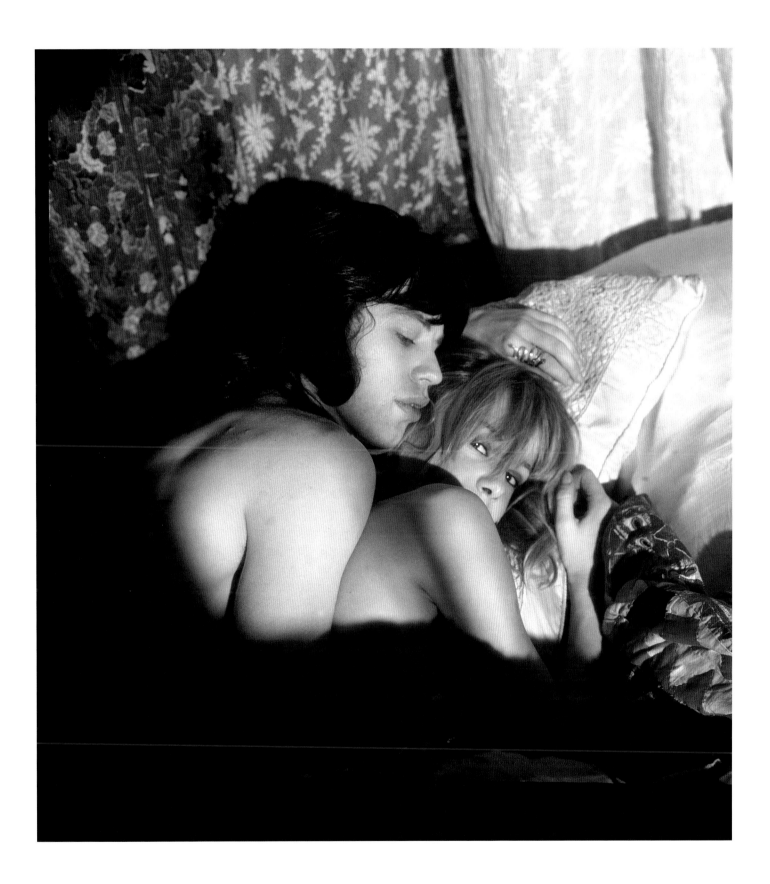

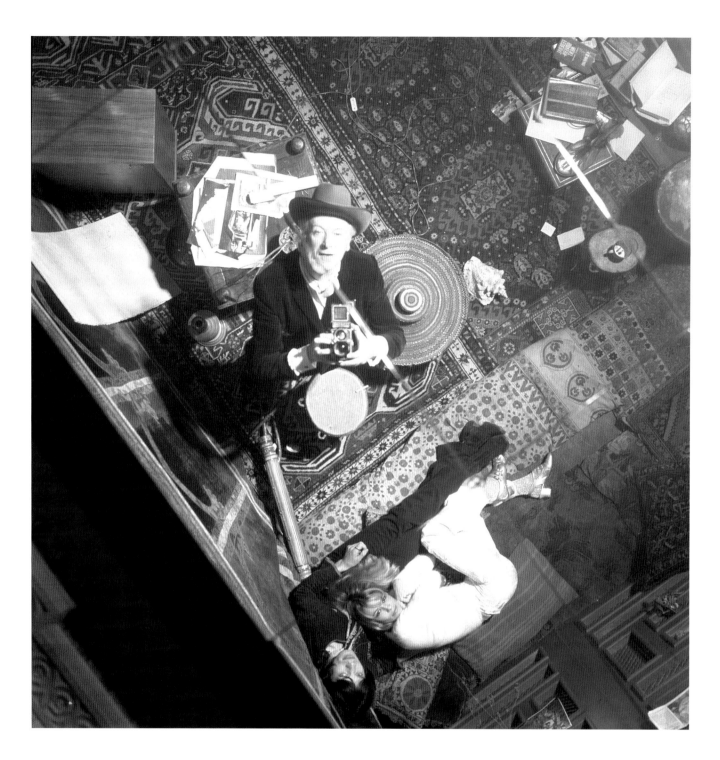

ABOVE: Cecil Beaton photographs himself with Jagger and Pallenberg, through the mirrored ceiling on the *Performance* set.
OPPOSITE: The love-making scene between Jagger and Pallenberg would lead to a rift rarely seen in the 1960s between Mick Jagger and Keith Richards.

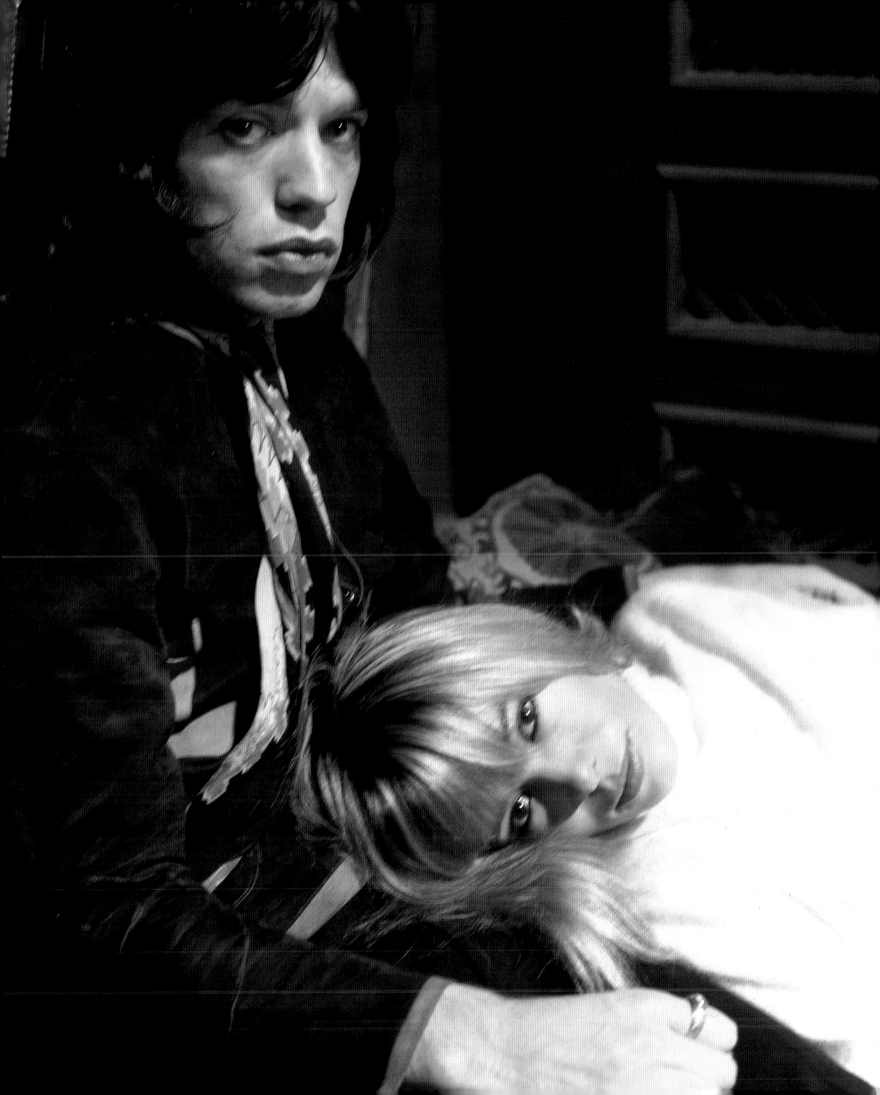

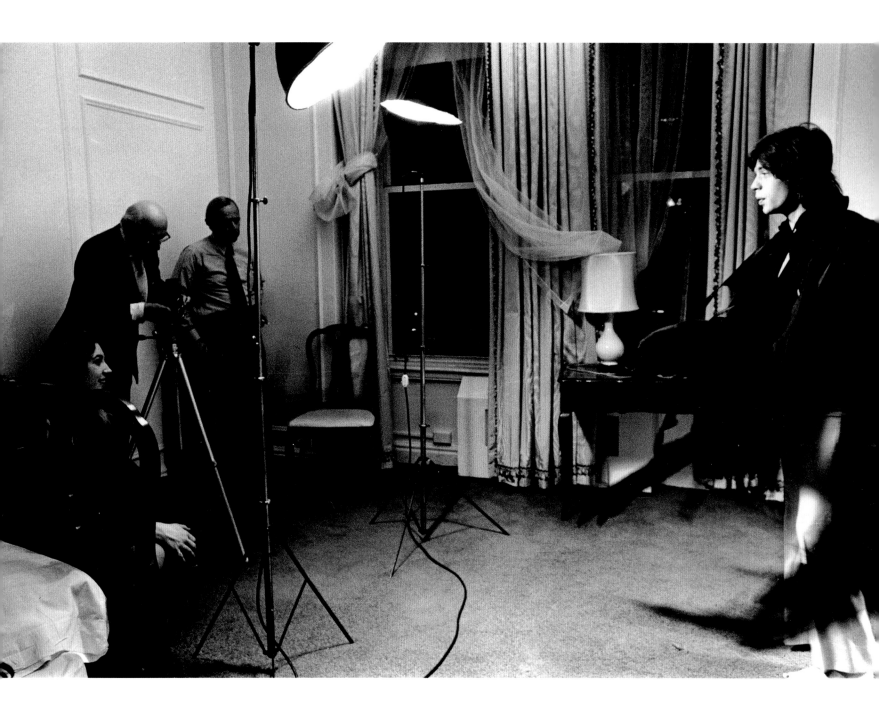

ABOVE: The master at work: Beaton shoots Jagger.

OPPOSITE: Mick in the flamboyant cape he wore as the character of the jaded pop star Turner in *Performance*.

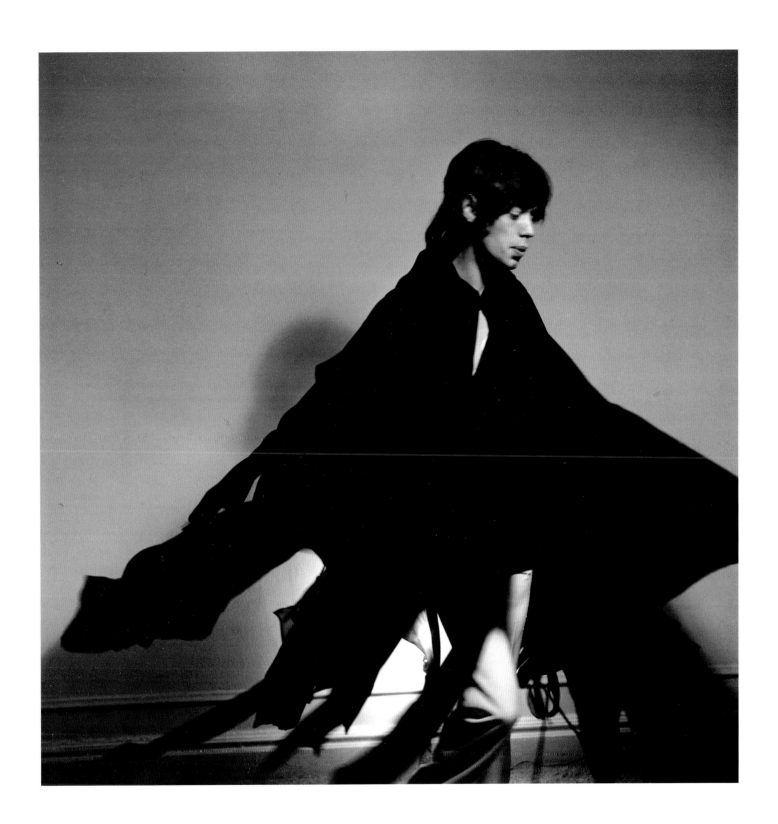

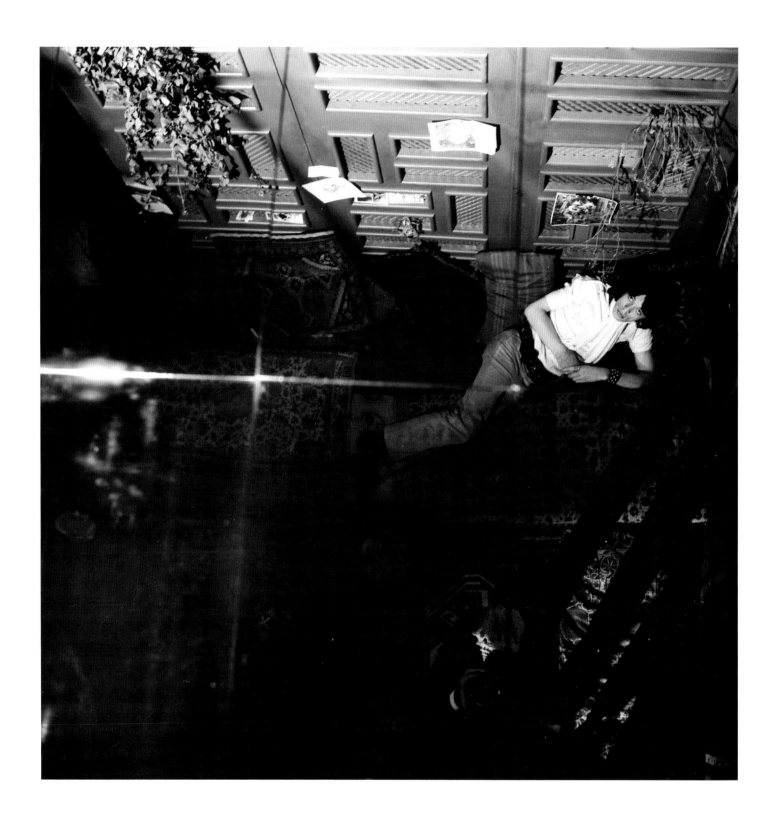

ABOVE: Through the looking glass – Mick lying under the mirrored ceiling.

ABOVE: Beaton captures Mick in an almost balletic pose on the sumptuous Afghan rugs.

ROCK 'N' ROLL CIRCUS
INTERTEL TV STUDIOS, WEMBLEY, LONDON
TUESDAY 10–11 DECEMBER 1968

THE STONES HADN'T BEEN LUCKY IN 1968, with the drugs bust and the inter-fighting of managers (with Allen Klein eventually coming out on top). Then came an announcement in the press:

'*The Stones are to produce their own TV spectacular for sale all over the world. They will star in an hour-long show, which will cost £20,000 to make. Worldwide sales are likely to earn them about £250,000.*' Daily Mirror, 13 November 1968

During November Mick had secured for their planned TV show *Rock 'n' Roll Circus* the Who, Eric Clapton, Mitch Mitchell of the Hendrix Experience, Jethro Tull, Taj Mahal, and Marianne Faithfull. Brigitte Bardot was already contracted elsewhere, so could not be ring master, Johnny Cash was also invited but declined, and the Isley Brothers and Traffic were appearing elsewhere. Another proposed act which didn't happen was Anita Pallenberg appearing as a bearded lady, so Jagger took the part himself.

Finance of over £31,000 was provided by Allen Klein, and Michael Lindsay-Hogg was to direct with his friend Tony Richmond. The cameras, which would allow film and video footage to be shot at the same time, were imported from France, 400 ponchos and hats were ordered, a circus tent and ring were organised. With band rehearsals organised at the Londonderry Hotel two days before filming started, the actual event took place on 10 December at the Intertel TV studios in Wembley, north London.

Two trapeze artists arrived, followed by the bands and fans, and a few hours were spent assembling stages and getting the sets right while circus acts kept everyone amused. The whole day was very unpredictable. Taj Mahal was to be filmed first, but the British Musicians Union would not allow him

to take part legally – so he appeared as 'a.n.other', his presence kept quiet throughout filming. John Lennon made it on the day too. Marianne Faithfull performed 'Something Better', the B-side of her single 'Sister Morphine'.

After a two-hour break for dinner, on came the Dirty Mac, a supergroup pieced together for the day. Lennon and Jagger started with Mitch Mitchell on drums and Keith on bass (not giving Bill the pleasure of participating in the stellar lineup), playing 'Yer Blues'. This was followed by Yoko Ono and Lennon playing 'Whole Lotta Yoko' with Ivry Gitlis on violin, and Jethro Tull with 'Song for Jeffrey'. The Who played at 11.00 pm, performing 'A Quick One, While He's Away', and at midnight Ian Stewart set up the Stones' equipment.

'Jumpin Jack Flash' was played three times according to Bill Wyman's book *Rolling With The Stones*, and other numbers included 'Parachute Woman', 'No Expectations', and 'You Can't Always Get What You Want'. Three and a half hours later another break was taken at 5.00 am, followed by six takes of 'Sympathy For The Devil' and finishing off with 'Salt Of The Earth'. They also rehearsed 'Route 66', 'Confessin' The Blues', 'Walkin' Blues', and 'Love In Vain'.

The *Circus* showed the Stones at their most relaxed, their chemistry just worked. Plans were made to re-record elements of the *Circus*, organised by their old friend from Italy, Stash, at the Coliseum in Rome on 25 and 26 June 1969, but were cancelled as the production company Colourtell had not been paid for the original filming. After various delays and postponements, the film was never televised, and the video and album were not released until 1996.

The main stills were shot by photographer Dick Polak, who worked extensively in the music field, his commissions including publicity shoots and album cover photography for the Sutherland Brothers & Quiver, Luther Grosvenor, Rory Gallagher, and many more. He married the actress/fashion designer Edina Ronay, and that is how I came to meet him. When my wife was choosing her wedding dress, the name Edina Ronay came up, followed by a visit to Ronay's house in Putney. There I was introduced to her husband, Dick Polak, and I mentioned how I had seen some of his photographs of *Rock 'n' Roll Circus* (which at that time had not been released), his name appearing on the border of the transparencies.

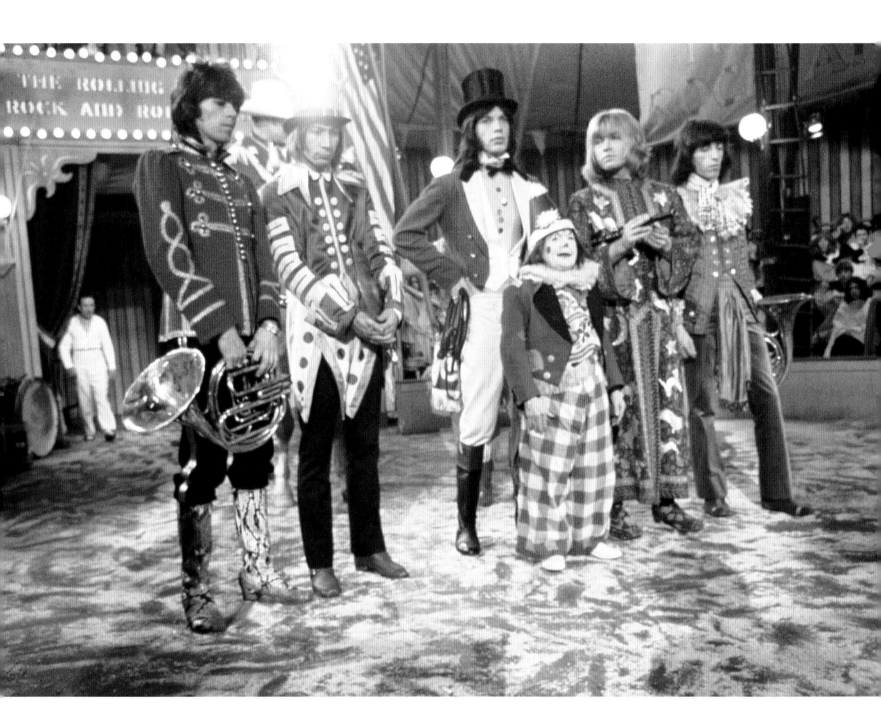

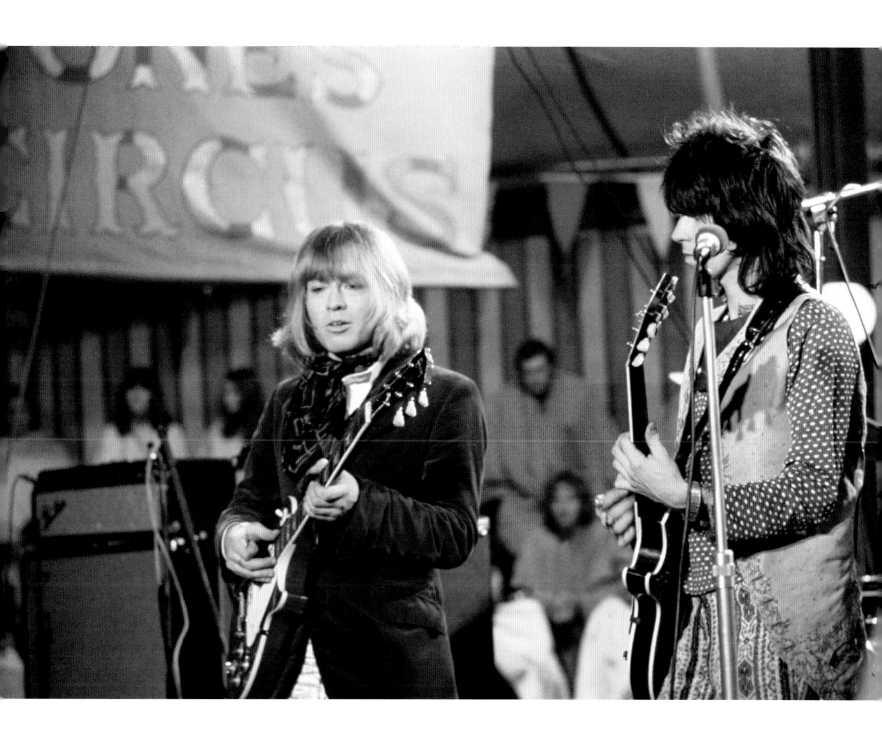

OPPOSITE: As setting up between acts took longer than planned, and the cameras kept breaking down, by the time the Stones began filming they'd already been in the studio for nearly 14 hours.

ABOVE: The *Rock 'n' Roll Circus* would be the last public performance of Brian Jones with the Rolling Stones.

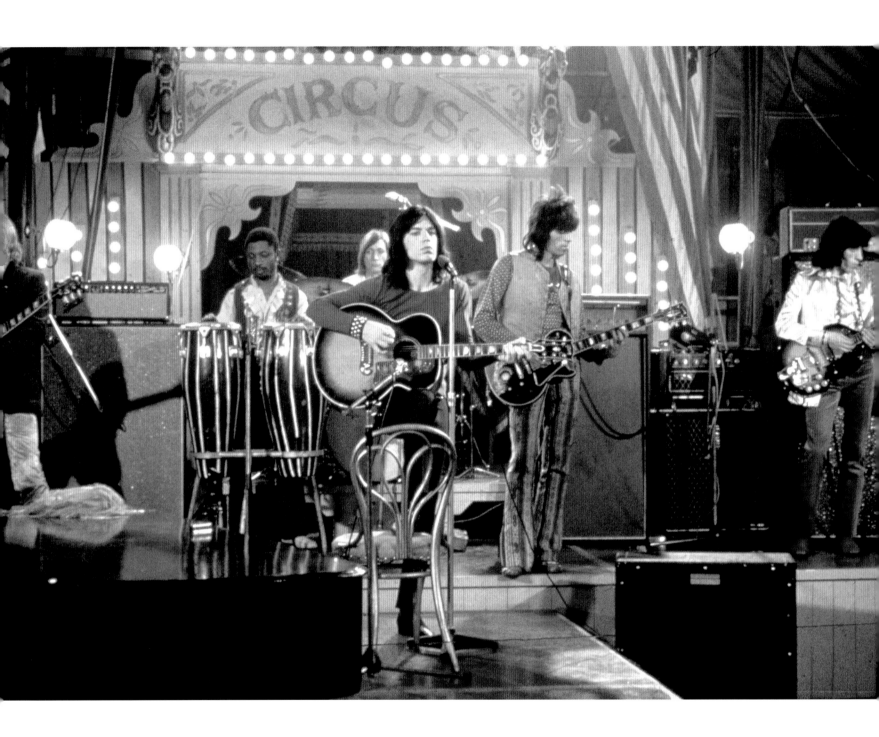

ABOVE: By the time the Stones came on, the audience and most of the band were visibly exhausted; only Mick's stamina managed to keep them going until the end.

OPPOSITE: Some of the footage of the concert was thought to be lost until 1989, when it was found in a dustbin in a cellar. A significant segment of footage of The Who performing in the film appeared in the documentary *The Kids Are Alright* (1979), the only public viewing of the film until its eventual release.

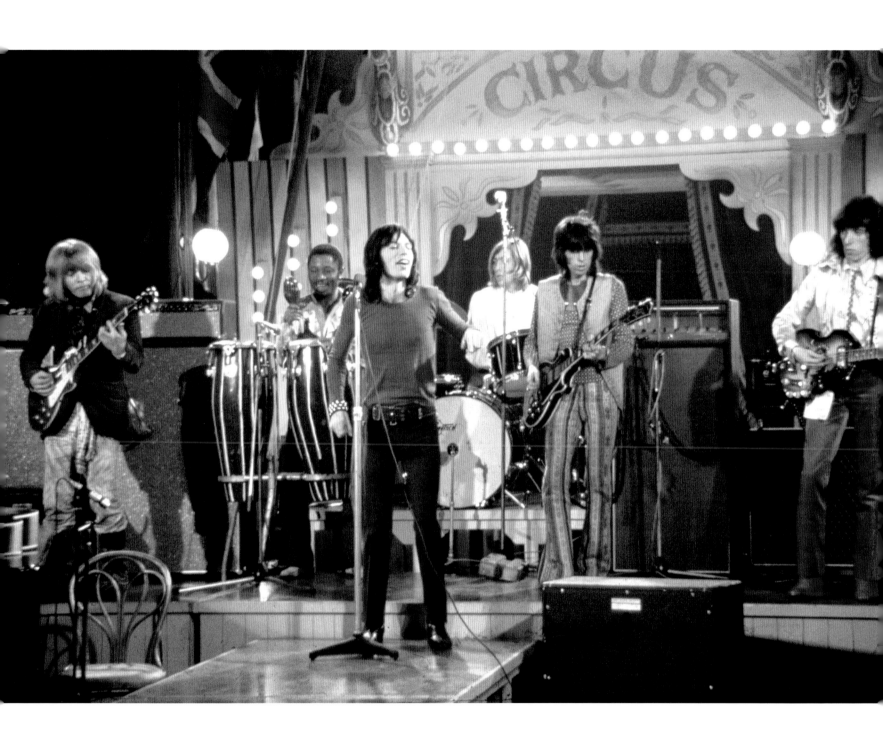

THE STONES ON CAMERA

187

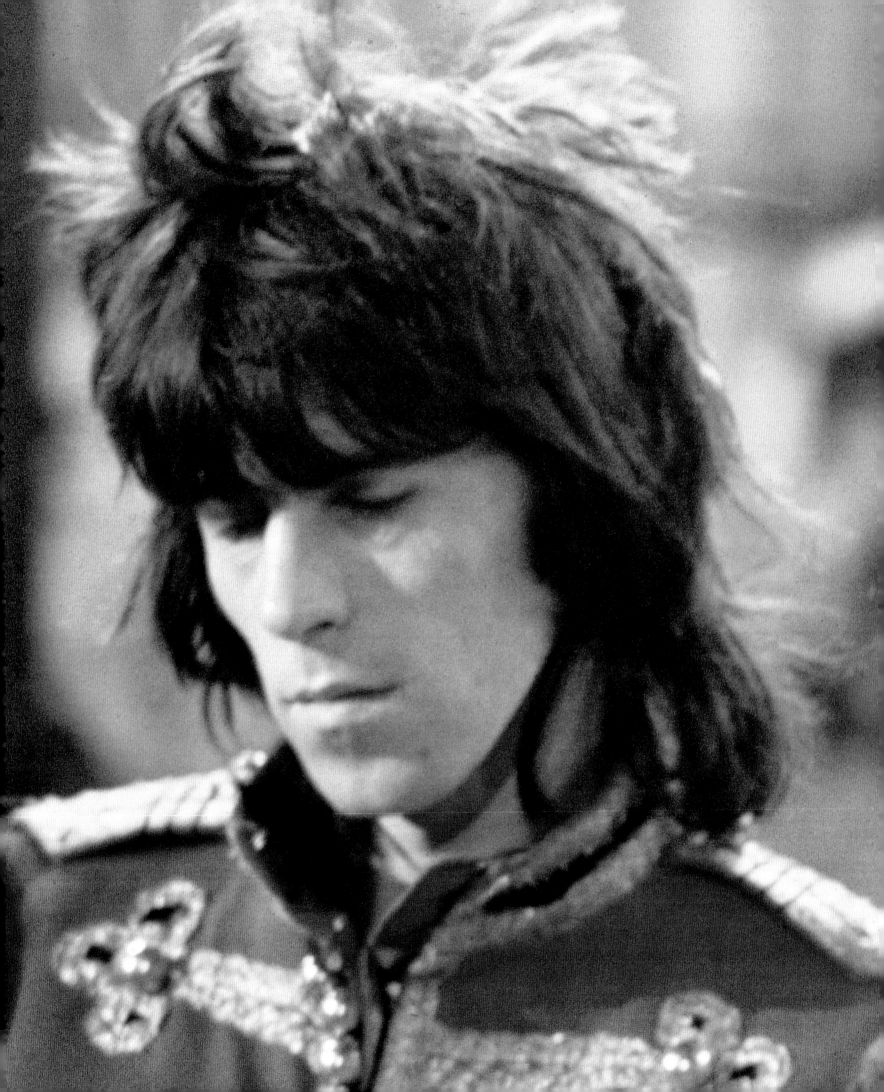

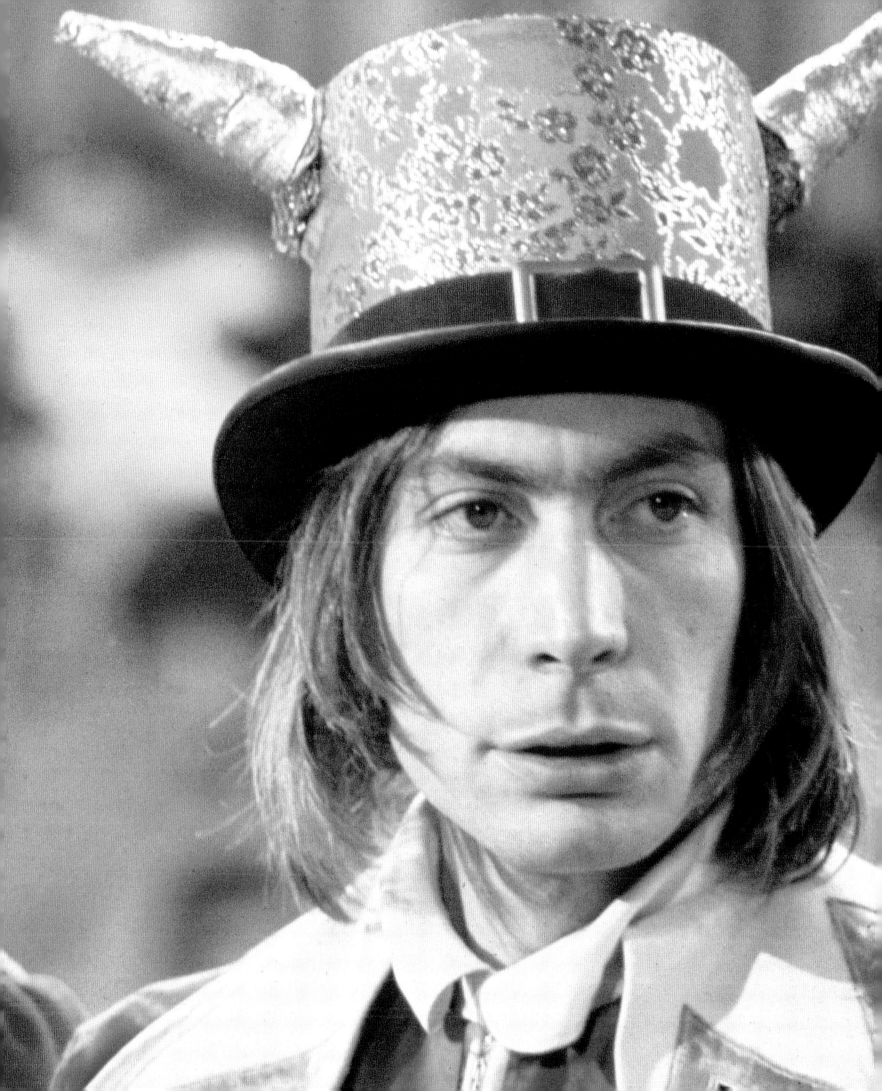

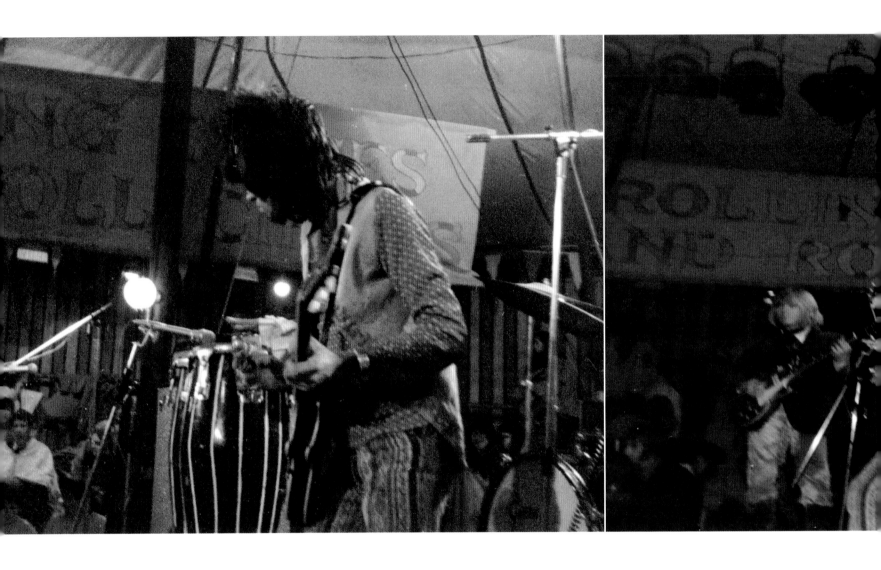

ABOVE, CENTRE, OPPOSITE: All the previous *Rock 'n' Roll Circus* pictures were taken by professional photographer Dick Polak. These three, by contrast, were shot by an amateur, fan Janice Palmer, who happened to be in the audience.

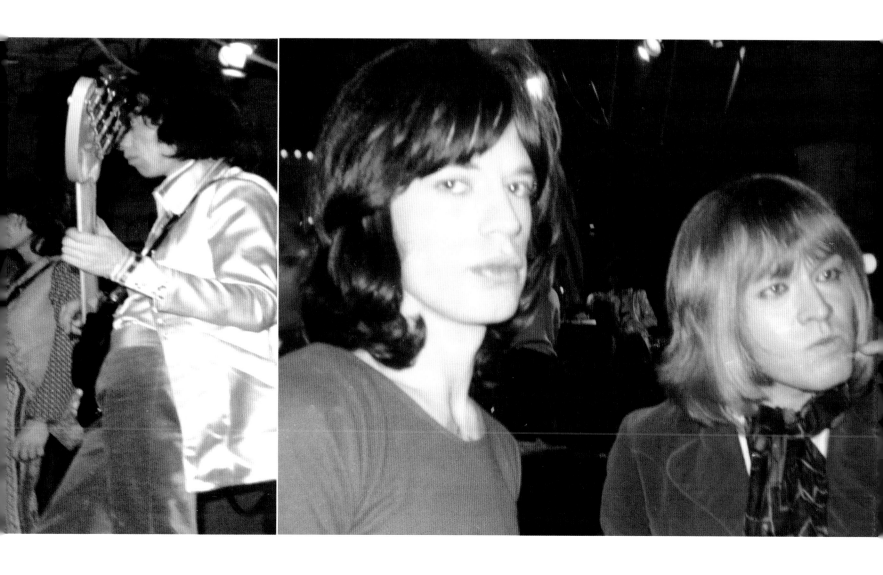

ETHAN RUSSELL
NOVEMBER 1968, MARCH AND MAY 1969

ALL THE PICTURES IN THIS SECTION WERE TAKEN BY the renowned rock photographer Ethan Russell. In 1968 Russell was a young American with a Nikon camera living in London, with ambitions to become a writer. Only a few years later he was one of the foremost rock photographers in the world, and is the only photographer to have shot album covers of the Beatles, the Rolling Stones, and The Who. More recent photo shoots have included working with the supergroup Audioslave and country singer Rosanne Cash. He is also an award-winning creative director and the author of two books, *Dear Mr. Fantasy* (1985) and *Let It Bleed: The Rolling Stones 1969 U.S. Tour* (2007).

Not long after Brian Jones moved into his home at Cotchford Farm, which he purchased in November 1968, Russell visited the Rolling Stones guitarist and took some memorable pictures in the garden of the quintessentially English house. Driving to the house through winding country lanes, he found Brian alone when he got there – Russell remembers him saying how the home was his new love. While the photographer took some preliminary shots of the house, Brian disappeared, and came back wearing a spectacular shirt made from an American flag. He started fooling around for the camera, sneering in at it and so on, before going outside and 'attacking' a statue in the garden, pretending to kick it, aiming a pellet gun at it, and grabbing it by the neck as if to strangle it. The statue was of Christopher Robin from the Winnie the Pooh books – their creator, the author A.A. Milne, was a previous occupant of Cotchford Farm.

On 15 March 1969, the Rolling Stones were at London's Olympic Studios finalising one of their most memorable tracks, 'You Can't Always Get What You Want', the substance of which they had recorded with producer Jimmy Miller the previous November. Mick Jagger decided that he'd like to include a choir as part of the backing, possibly a gospel choir, but at that point they couldn't find one suitable. In March, however, producer Jack Nitzsche was adding the finishing touches to the song, and said he could get the London Bach Choir. The result of the session, at which Ethan Russell was present, was stunning – a classic in the making.

Another Russell shoot with the Stones took place on 21 May 1969 at St Katherine's Dock near the Tower of London, resulting in part of the cover photography for their September '69 'greatest hits' compilation *Through The Past, Darkly*, which was originally released in an octagonal (eight-sided) sleeve. The Stones, lying on the ground in a star shape, were photographed from a hydraulic platform giving Russell the height he needed for the shot, which was used on the inside of the album sleeve. He also photographed them behind glass, at the George Nichols studio in Old Brompton Road in West London, one shot of which became the front cover illustration, another the back. It also turned out to be the last photo session of the Stones with Brian Jones.

Most of Ethan Russell's photography of the Stones was taken with a Nikon camera and 105mm lens; for the *Through The Past, Darkly* shoot, however, he used a large-format Sinar 8x10, and a Hasselblad.

ABOVE AND OPPOSITE: Brian, resplendent in his Stars and Stripes shirt, fooling around in front of the camera in the garden of his Cotchford Farm home.

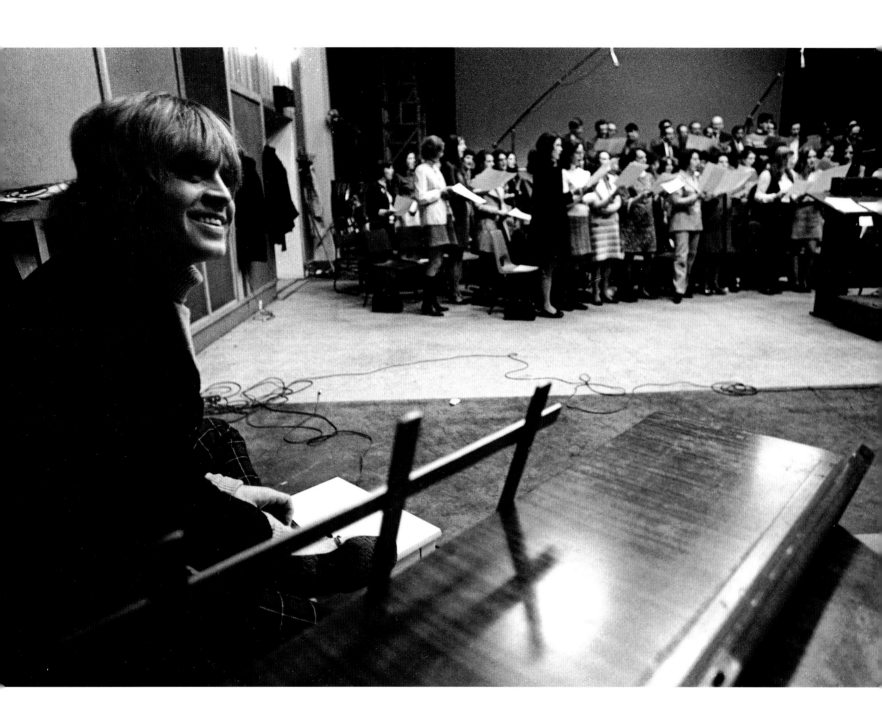

ABOVE: Brian Jones looking elated as he listens to the massed voices of the Choir.

OPPOSITE: Mick Jagger 'conducting' the London Bach Choir through 'You Can't Always Get What You Want'.

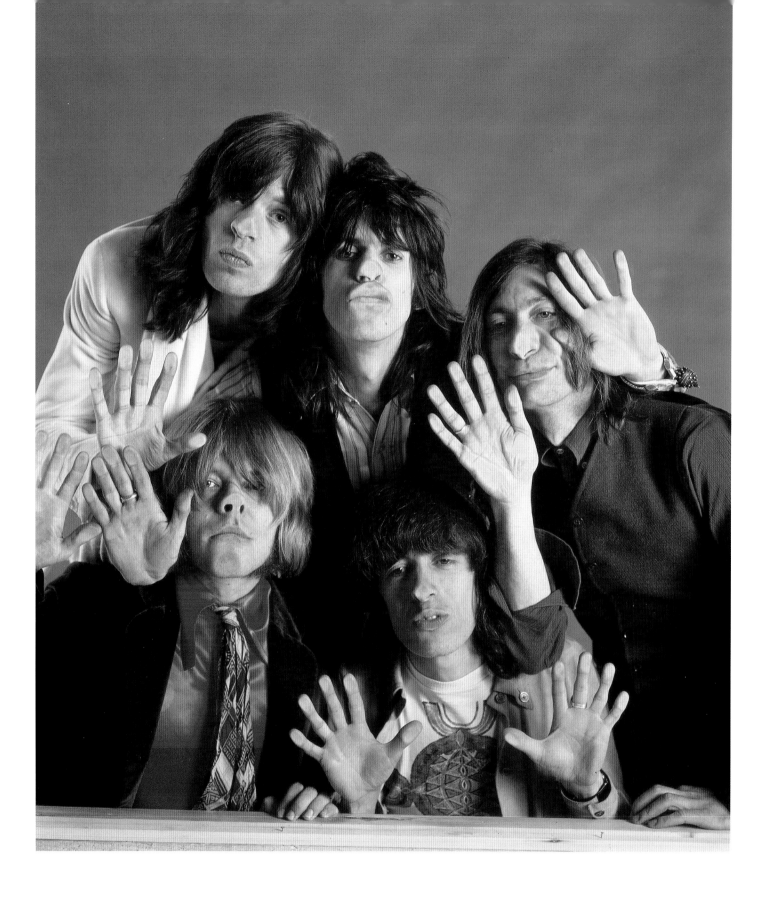

ABOVE: The Stones press their noses against glass for what would become the *Through The Past, Darkly* cover image.

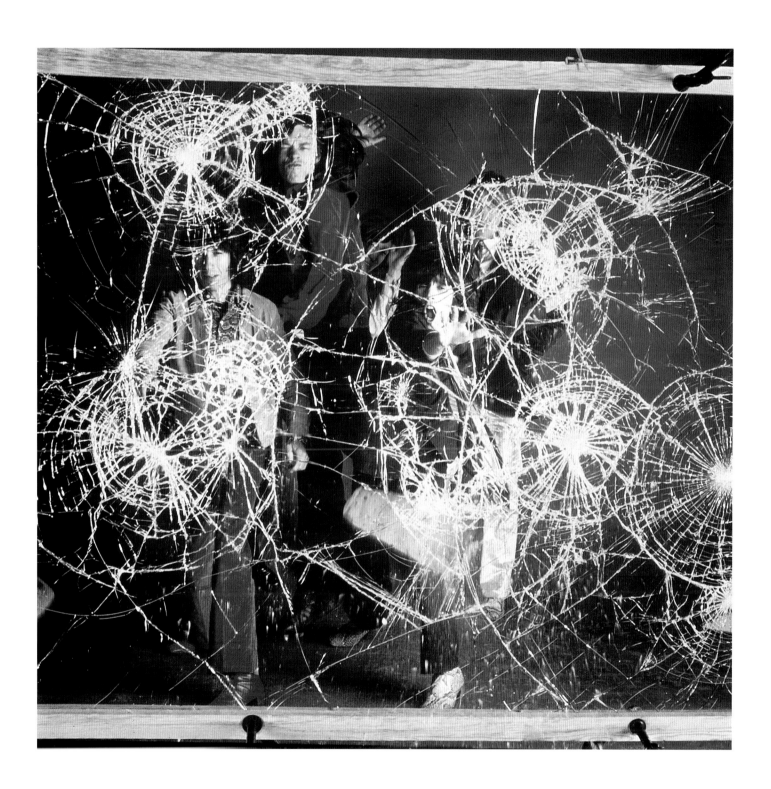

ABOVE: Another slightly disturbing image of the Stones, this time through shattered glass, and used for the back of the *Through The Past, Darkly* sleeve.

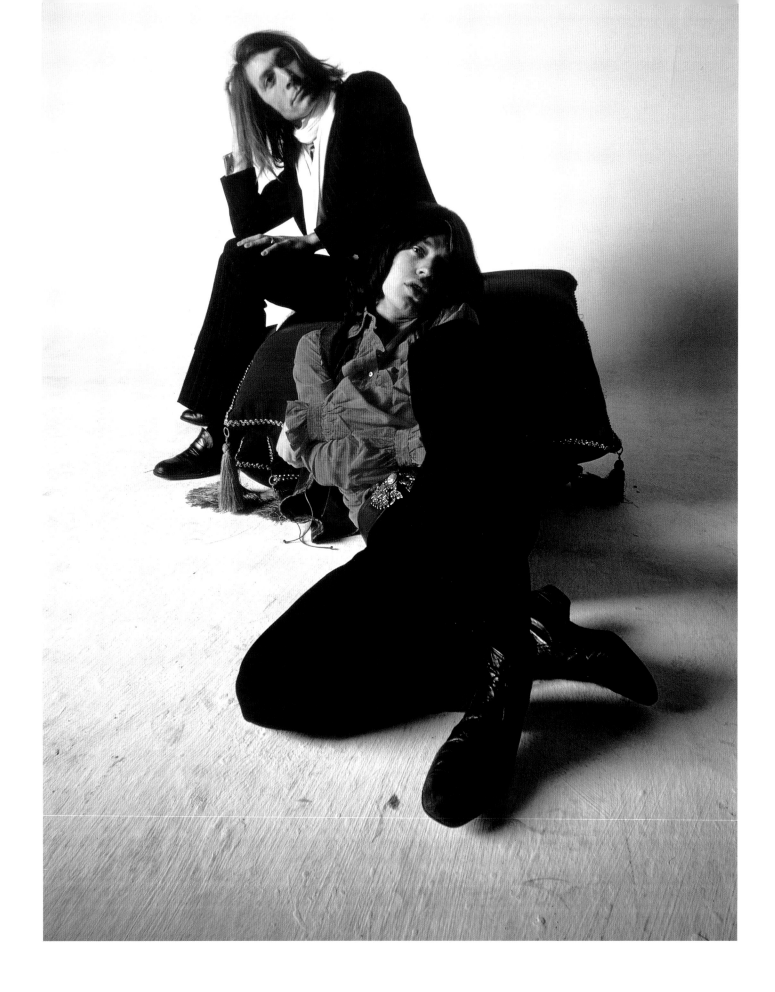

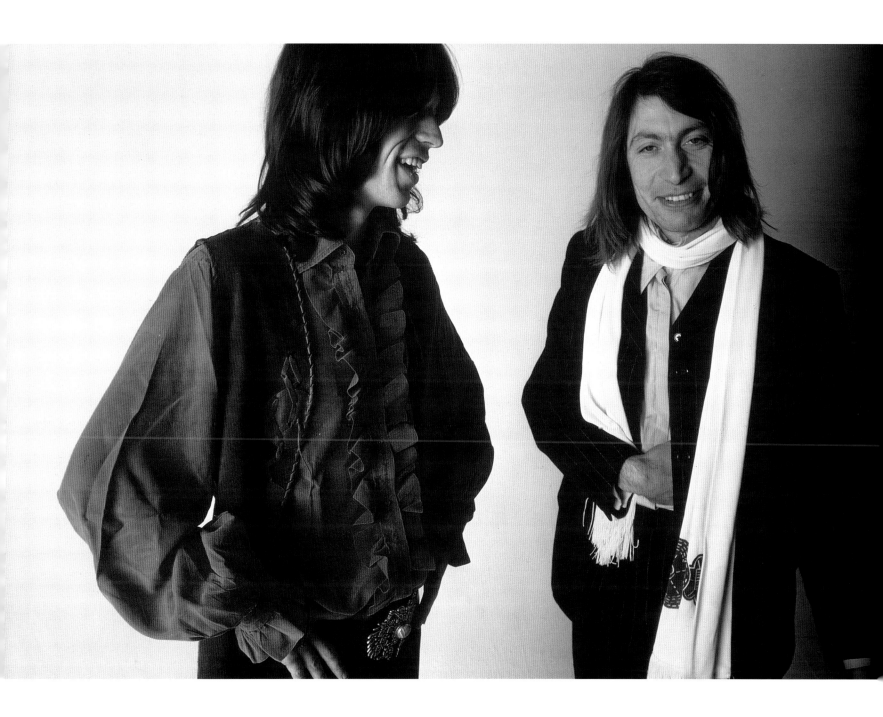

ABOVE AND OPPOSITE: After the first shot behind glass, but before the Stones started throwing objects to break the glass and achieve a shattered effect, Ethan Russell took these relaxed looking pictures of Mick and Charlie.

BRIAN JONES' FUNERAL
CHELTENHAM PARISH CHURCH
THURSDAY 10 JULY 1969

ON 2 JULY 1969, BRIAN JONES WAS FOUND DEAD at the bottom of the swimming pool at his Sussex home, Cotchford Farm. He had been drinking all evening with his girlfriend Anna Wohlin, Frank Thorogood, who was doing some building work on the property, and his friend, a nurse, Janet Lawson. Five days later, after hearing that there were also large quantities of drugs in his system, an inquest returned a verdict of death by misadventure.

'*I just say my prayers for him. I hope he becomes blessed. I hope he is finding peace, and I really want him to.*' Mick Jagger, *New Musical Express,* 12 July 1969

Brian's funeral took place on Thursday 10 July, at the parish church in his home town of Cheltenham. Of the Stones, Charlie Watts and Bill Wyman attended, as did the band's long-time driver Tom Keylock and ex-manager Eric Easton. Mick Jagger and Marianne Faithfull, who were in Australia filming, sent a wreath. Brian was buried in a bronze and silver casket shipped in from America, reputedly paid for by Bob Dylan. He was wearing a powder blue jacket, white shirt and black tie, his hair had been lightened and was in its trademark bob, and he looked as if he were asleep. Although his parents wanted it to be a simple, quiet affair – the service itself took only 15 minutes – the crowds that gathered, and attendant press, made it the biggest funeral the Gloucestershire town had ever seen.

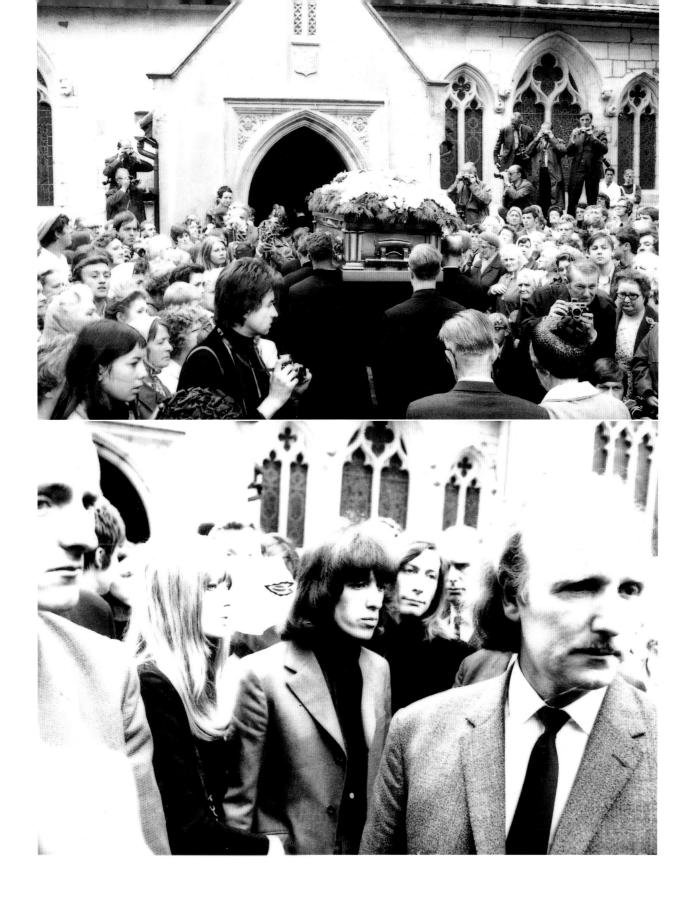

TOP: Crowds watch Brian Jones' casket entering the church, surrounded by a phalanx of photographers.

ABOVE: Bill Wyman and Charlie Watts among the mourners at Brian's funeral.

INDEX

BIBLIOGRAPHY AND SOURCES

Betts, Graham *Complete UK Hit Singles* (Collins), 2004

Clarke, Donald (Ed) *The Penguin Encyclopedia of Popular Music* (Viking), 1989

Clayson, Alan *The Rolling Stones Album File & Complete Discography* (Cassell Illustrated), 2006

Nash, Will *Stu* (Out-Take Limited), 2003

Phelge, James *Phelge's Stones* (Buncha Asshole Books), 1998

Sandison, David *Making of the Rolling Stones' Beggars Banquet* (UFO Music), 1997

Vickers, Hugo *Beaton in the Sixties: More Unexpurgated Diaries* (Weidenfeld & Nicholson), 2003

Wyman, Bill *Rolling with the Stones* (Dorling Kindersley), 2002

Wyman, Bill with Coleman, Ray *Stone Alone:The Story Of A Rock 'n' Roll Band* (Viking Press), 1990

Selected editions: *Disc*, *Mirabelle* magazine, *New Musical Express*, *Melody Maker*, *The Rolling Stones Book Monthly*, *Rave* magazine

PHOTOGRAPHY CREDITS

First published in the United Kingdom in 2009
by PAVILION BOOKS
10 Southcombe Street, London, W14 0RA

An imprint of Anova Books Company Ltd

Design and layout © Pavilion, 2009
Text © Mark Hayward, 2009
Photography © see acknowledgements on page 207

Editor: Mike Evans
Designer: Ros Holder
Proofreader: Alyson Silverwood
Indexer: Patricia Hymans
Production: Rebekah Cheyne
Associate Publisher: Anna Cheifetz

ISBN 978-1-86205-868-2

A CIP catalogue record for this book is available
from the British Library.

10 9 8 7 6 5 4 3 2 1

The moral right of the authors has been asserted.

Reproduction by Dot Gradations Ltd, UK
Printed by 1010 Printing International Ltd, China

www.anovabooks.com

AUTHOR'S ACKNOWLEDGEMENTS

Number 1, thanks to my wife Colleen (the most drop–dead gorgeous lady in the universe, and I'm not just saying that), who has stuck with me and given me support and loving in everything I do. My children – Grace (winner of Windlesham school 'Have I got talent?'), Alice (the Audrey Hepburn lookalike and pianist, who always gives her undivided attention to everyone she meets) and Eve (the Diana Rigg lookalike and smiling drummer virtuoso) – without their combined joy and laughter it would not have been possible to finish this book. To my in-laws Frank and Phyliss Lees, who are always on hand to help, no home should be without them. I'd also like to thank my two brothers and their families: Anthony, Elizabeth, William (rock god at Nottingham university), Toby (the rock drummer) and Holly Hayward (the next Annie Leibowitz); and my newly found eldest brother's family in Vancouver – skipper Jonathan and devoted wife Jane, Jessica (at British Columbia), Juliette (the soon to be new Speaker for Canada), and Jeremy Levine (the best actor to come out of Canada for years); my late mother Eve, who loved her children and music – sorry that she is not here to see her daughter-in-law and grandchildren; and my father John who is finally back on the scene.

For their help in making this book possible, I would also like to thank: Anna Cheifetz for her enthusiasm, support and blast-from-the-past email which kick-started this project; the photographers Ethan Russell, Anthony Stern, David King, Les Chadwick, and Richard Rosser; Irene Holmes, Gillie and John Coughlin, and Martyn Fenwick for his day-to-day calls giving nothing but encouragement and words of wisdom; Jordi Tarda for his rock 'n' roll inspiration; Mike Evans for applying the glue and scissors to the text; Alex Locchi all the way from Thailand for his help on the Rome chapter; and for their support and faith in difficult times Anil and Enid Simi and Sierra Prassad. Big thanks to life-long Stones friends Harry, Yvonne, Jamie Lee, Colin and Chantel Meurer, and Ali from Stone Museum for the Richmond Jazz Programme. Thanks to Stones fan Matt Lee at the Stones vault for the memorabilia; to Peter Whitehead for his early inspiration in the film-making; and to Charlie Watts, Sherry and Stephen Daly for the best two years of my working life way back in the early 1990s.

Finally, we tried to locate many people in course of researching these photos; anyone who has any information to add or wants to sell memorabilia or photos and film please email mark@mpc–inc.co.uk

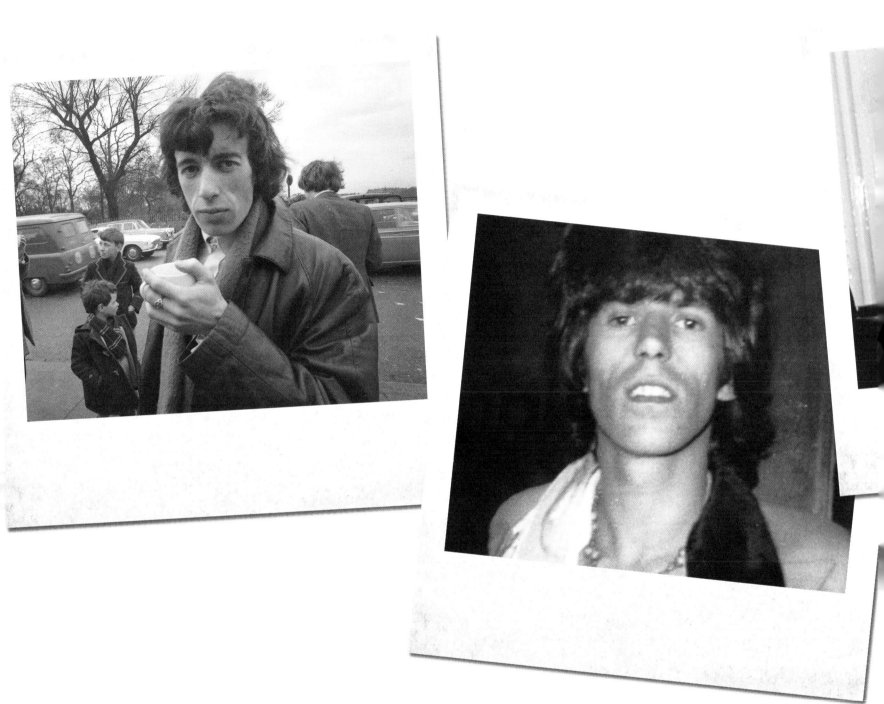